Exhibiting Photography

WITHDRAWN

Exhibiting Photography

A PRACTICAL GUIDE TO CHOOSING A SPACE, DISPLAYING YOUR WORK, AND EVERYTHING IN BETWEEN

Shirley Read

AMSTERDAM • BOSTON • HEIDELBERG • LONDON
NEW YORK • OXFORD • PARIS • SAN DIEGO
SAN FRANCISCO • SINGAPORE • SYDNEY • TOKYO

Focal Press is an imprint of Elsevier

ELSEVIER

Focal Press

Acquisitions Editor: Cara Anderson
Developmental Editor: Valerie Geary
Publishing Services Manager: George Morrison
Project Manager: Kathryn Liston
Editorial Assistant: Robin Weston
Marketing Manager: Marcel Koppes
Interior and Cover Design: Alisa Andreola
Cover Illustration: Arno Denis

Focal Press is an imprint of Elsevier
30 Corporate Drive, Suite 400, Burlington, MA 01803, USA
Linacre House, Jordan Hill, Oxford OX2 8DP, UK

 Recognizing the importance of preserving what has been written, Elsevier prints its books on
acid-free paper whenever possible.

Library of Congress Cataloging-in-Publication Data
Application submitted

British Library Cataloguing-in-Publication Data
A catalogue record for this book is available from the British Library.

ISBN: 978-0-240-80939-7

For information on all Focal Press publications
visit our website at www.books.elsevier.com

08 09 10 11 12 10 9 8 7 6 5 4 3 2 1

Printed in China

Contents

Introduction

This book originated in workshops taught initially at the University of Westminster and subsequently at Photofusion and the City Lit. The aim of the workshops was to empower students by opening up the processes and practices of exhibiting. What the workshops taught me was that, although students are increasingly working towards a career aim of exhibiting their work, they too frequently leave college with inadequate exhibition experience or the knowledge to be ready to start showing their work professionally.

My aim, then, has been to write a book that can be used as a guide to exhibiting so that any potential exhibitor can take some control of the process. Providing an overview of this kind inevitably means that the process can be oversimplified; it suggests there is a right and wrong way to approach exhibiting, that all exhibiting photographers will follow the same route and that all photographs are part of a single discipline with standard methods of presentation. Of course none of this is true and I have attempted to include enough dispute and contradiction to make it clear that the photographers or artists have to make the choices that suit them, their work, and their showing circumstances.

I have used the terms *photographer* and *artist* fairly interchangeably here and I make no apology for it. Debate about the terms rumbles on and the use of one or other usually owes as much to educational background, personal preference, and the gallery context as to ideological concerns.

It may be useful for the reader to be aware of the differences between English and American English in gallery practice. For example:

- "Marking" in English is "grading" in American English.
- "Private view" is not an expression used in the USA. "Showing" or "opening reception" might be used instead.

- "Plans chest" is an English term for a chest with shallow drawers used for the flat storage of photographs, prints, and architectural drawings.
- English people say "specialist" while Americans say "specialty."
- English people say "invigilation" for the specific job of being in the gallery during opening hours. There is no direct parallel in America where "attendants," "security personnel," or "gallery staff" might all cover this role.
- English people say "fixings" while Americans say "installation hardware."
- An Allen key in English is an Allen wrench or hex key in American English.
- A spirit level in English is a bubble level in American English.

Background

FIGURE 1.1 "These images are from a series I made over the period of a year or so when I was interested in rootlessness and the transience of urban life. Subsequently, editing them into a sequence opened up the significance of the piercing red, which, in an urban environment, stood for ideas of instruction and protection. Sometimes the process of editing means I rethink what I have done and start taking pictures again; sometimes it confirms my original idea." Tim Youles. Image © Tim Youles

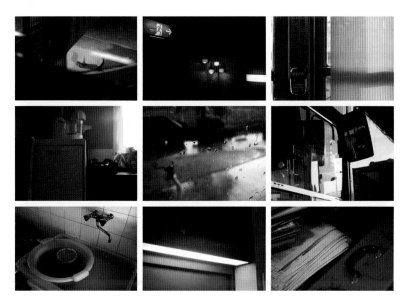

Exhibitions have become the medium through which most art becomes known. Not only have the number and range of exhibitions increased dramatically in recent years but museums and art galleries such as the Tate in London and the Whitney in New York now display their permanent collections as a series of temporary exhibitions. Exhibitions are the primary site of exchange in the political economy of art, where signification is constructed, maintained and occasionally decon-structed. Part spectacle, part socio-historical event, part structuring device, exhibi-tions—especially exhibitions of contemporary art—establish and administer the cultural meanings of art.

From *Thinking about Exhibitions* (Greenberg et al. 1996)

In the 1970s, the photography world began to evolve quickly: major museum exhibitions, the teaching of the history of photography, the incorporation of photography into art historical texts and general art periodicals, and the success of the international auction houses all enhanced and contributed to the interest in collecting photography.

From *Inside the Photograph* (Bunnell 2006)

In 1950 a professional photograph was typically a 10 × 8 in (25 × 20 cm) black and white print that was passed to a designer and then a printer to appear in a magazine. It was then discarded, filed or forgotten. In 1980 a professional photograph might also be a handsome work of graphic art, generally twice the size of its predecessor. It might be made by hand, in one of a variety of craft processes, expressly for exhibition in and preservation by museums. It was usually made to last: printing was to archival standards. Quite frequently it was issued in a signed and strictly limited edition.

Mark Haworth-Booth, From *Photography: An Independent Art*

I have never been interested in exhibitions because I think in a way you tend to be preaching to the converted. And I've always really been interested in the printed page because that way you get to more people with what you're trying to say and the sort of photography I do is trying to say something about people to other people that might just influence them—I'm not trying to change the world but it might affect the way they're thinking. But because of the downturn in the mag market if you want to be seen and get assignments one of the few ways now of having people see your work is to have exhibitions because who sees anything in the magazines?

Ian Berry, Magnum photographer, National Sound Archive interview

My biggest advice would be to take the pictures you want to take. Don't think about the marketplace, what sells or what an editor might say. And don't think about style. It's all bullshit and surface stuff. Style happens.

David LaChapelle, photographer

WHAT IS AN EXHIBITION?

There are very many situations in which photographs get seen that can come under the term *exhibition*.

Under the term *exhibition* I include:

- any conventional exhibition space (which can include commercial and publicly and privately funded galleries and museums)
- a variety of other spaces where work is sometimes shown (such as community centers, open studios, cafes, bars, restaurants, libraries, cinema and theater foyers, schools, colleges, and churches)
- temporary spaces or events (such as photo fairs and festivals, talks, workshops, and conferences)
- online galleries and web sites (such as Flickr, YouTube, MySpace, and Facebook)
- other people's homes (through sales and loans)

- the street and public art (including hoardings, projections, performances, hospitals, and other public buildings)
- photographic competitions that result in an exhibition
- exhibition catalogs, publications, and press images
- CDs

It may seem surprising that this list includes such outlets as speaking engagements and sending out press prints or CDs, but it is useful to recognize that these are exhibition opportunities of a particular kind. Such events represent a time when, just as in a gallery, the photographer's work moves out of his or her immediate control and may be seen by other people without the photographer being there to interpret it, provide background information, or answer questions about it.

The photographer needs to be sure that the work is presented well, that this information is available, and that the work is going to be treated with respect. Press photos and CDs should always have detailed information attached, and that information must include the name and contact details of the photographer and the title and date of the work. If the photographer sells work, or even gives or exchanges it with friends or colleagues, it should have the same information. Substandard prints should never go out of the work space even as press prints.

THE MYTH OF EXHIBITING

I completed a major piece of work and then sent out the usual promotional information to curators and editors. Much to my dismay I heard nothing for over a year—then out of the blue, in the space of a fortnight, I received exhibition offers from two curators. My advice to photographers is not to give up or lose confidence in the work. Don't put it away and forget it!

Grace Lau, photographer

So what do we expect from an exhibition? It is important to think about this. First-time exhibitors, in particular, tend to have several, sometimes contradictory, preconceptions about the process of exhibiting their work. These can be misleading and can lead one to build up unrealistic expectations and then be disappointed by the actual experience.

The first of these misconceptions is that exhibiting is either a simple and straightforward or a mysterious and bewildering process. Neither is true. Organizing an exhibition is a complex process, it is time consuming, and it requires careful

attention to detail, but the skills can be understood and learned by any photographer. On the other hand, an experienced curator can bring a more detailed and comprehensive level of skill and knowledge to the process than can even an experienced exhibiting photographer.

The second misconception is that the rewards of exhibiting will be instantaneous and exciting. Photographers frequently believe that their first show will make them a star overnight or, at the very least, bring them a great deal of critical attention. Perhaps because the private view or artist's reception is an absolute deadline—which feels similar in its drama to an opening night at the theater—photographers expect the same sort of applause and response. Unfortunately, although the buildup and the tension may feel the same as in the theater, the response may be very much slower in coming. New plays are often reviewed overnight, whereas new exhibitions may be reviewed only weeks later or even after the exhibition has finished. As a result, the photographer may be disappointed by what seems a tepid response to his or her work.

It helps, then, to be realistic about expectations and to recognize that an exhibition is a rewarding process in a number of very different ways, which may take time to come to fruition. It is equally useful to understand that the process, especially for first-time exhibitors, can be adrenaline-fueled and that exhibitors may feel exhausted and deflated for a few days or even weeks until their creative energy kicks in again. The experienced exhibitor may either get used to this creative low or may need to make a habit of arranging a short holiday from work immediately after an exhibition opening.

The third myth is that exhibition sales are a verdict on the work's intrinsic merit. As a colleague said to me, "It was difficult to ignore the presence—or worse, absence—of those red dots and not feel competitive angst." Over the last decade, as photography has become more popular and as sales through galleries and auction houses have boomed, selling has come to be seen as a marker of photographic excellence and students have been encouraged to develop a signature style in order to make the work marketable. This goes hand in hand with a celebrity culture in which the press is interested in the artist rather than the work. In fact, of course, people buy photographs for many reasons—from their investment value to their color coordination with the dining room curtains—and the artist is well advised to keep detached from the opinions of the marketplace. At the end of the day, a

sense of the success or failure of the work can only come from the artists themselves and from a trusted group of colleagues, critics, and curators.

EIGHT REASONS TO EXHIBIT

Most photographers take it for granted that an exhibition is a desirable outcome for a photographic project, without examining their reasons in any depth. There are, however, a number of quite different reasons to exhibit. Not all of them will be true of every exhibition prospect, and it is useful to be able to recognize which ones apply in order to evaluate what each exhibition does or does not offer and to be realistic about the rewards of exhibiting.

Reasons to exhibit include:

• getting the work seen

This is the most obvious reason to exhibit. Photographs are taken to communicate, and they cannot do so if they never leave the photographer's work space.

• selling photographs

This is important for more reasons than the obvious one. Selling work is one way of ensuring that the photographs are in circulation and continue to be seen after the period of the exhibition. An exhibition where a photographer sells work will also tell the photographer what sorts of images people buy and which are popular. There can be a danger in this: if a photographer lets the knowledge of what sells drive his or her work, it can make it hard to take risks, to experiment, or develop new ideas. On the whole, however, most photographers learn to recognize when their work starts to feel stale and when they need to develop in a new direction rather than produce more of the same.

• it's a career marking point—that is, photographers need to be seen to be showing their work

An exhibition shows that a photographer is a professional and serious about his or her work. It is the equivalent of producing an annual report or taking an exam and demonstrates, both to the exhibitor and to the worlds of photography and business, that the photographer is on track. It appears on the photographer's curriculum vitae (c.v.), and in many ways this can be as important as the exhibition itself. A good track record of exhibiting is crucial to the photographer who

wants to build an exhibiting career and is a pedigree that guarantees the work. When looking at a portfolio, any major gallery director or curator will probably also want to see the photographer's exhibiting c.v., which may well influence the decision to offer an exhibition.

- to get feedback about the work

This does not mean just waiting for reviews in the photographic press. An exhibition is a major opportunity for the photographer to get informed feedback from friends and colleagues, other photographers, and professionals in the field of photography. The audience at the private view will let the photographer know how they receive the work, if they understand it, and whether it succeeds in doing what the photographer intends. The photographer, however, must be ready to ask for responses to the work and to listen carefully to what is being said about it. Many galleries will arrange a talk by the photographer for exactly this reason. During the hours when the gallery is open to the public, the gallery staff should actively seek feedback, and it is a good idea to ask them in advance to make sure they pass this on.

It is useful for photographers to know whose comments they want to hear and will value and then be ready to seek those out. They should also be prepared for unhelpful or even positively destructive comments though, on the whole, other people's insights can be liberating. Very occasionally a life-changing insight will be offered, and the photographer needs to be aware that a complete stranger could understand and appreciate his or her work better than anyone the artist has worked with to date.

- it's good practice

Every exhibition is a learning opportunity. Each is different, and every time photographers exhibit their work they will learn something new about exhibiting, about how to show work, and how it will be received. Much of what a photographer learns is practical—for example, how long to allow for each stage of the process, which frames best suit the images, or how to write about the work. Over time it gets easier to do and becomes more rewarding, more creative, and more enjoyable as a result. Building up a store of knowledge and ideas about presenting images is also one of the things that can progress the work itself. Not exhibiting, even only occasionally, makes it much harder to start doing so at a later stage in the photographer's career.

• it marks the completion of the work

An exhibition usually marks the end of a particular piece of work. It is the moment at which photographers can stand back from the photographs, assess the work for themselves, listen to other peoples' assessments, understand the successes and failures of their work, and draw a line under it. Having learned the lessons and evaluated the project, the photographer can then let the work go and move on to a new theme or project. It is very easy for a photographer to become overly attached to a particular piece of work or style of photographing, and an exhibition is a good way of making sure not to get stuck like this.

• to build up connections and a mailing list

An exhibition is one of the times when photographers learn who is genuinely interested in their work and will support them and the work. This could be buyers, curators, galleries, critics, other photographers, or friends. It can be surprising. Photographers should not rely on a gallery mailing list but should build their own, and this is the moment to add names to it. A visitor's book is a useful starting point for this. If exhibition visitors show interest in the work, the photographer should always be prepared to ask if they would like to receive future mailings and ask for a business card or address. Most photographers are helped by having an informal support group of people who they know understand their work well and who are invited to every exhibition; it often only becomes clear who these people are when the work is being exhibited and they show their interest in it.

• it'll lead to something else

No one can predict what an exhibition will bring the exhibitor or who will see it. It might not be a major review or a huge sale, but it could well lead to an offer of some teaching, a commission, a magazine spread, a further exhibition, or new colleagues whose insights into the work will enrich it in the future.

WHEN NOT TO EXHIBIT

It is worth remembering that there are times when one should turn down an opportunity to exhibit. Exhibiting can be stressful, time consuming, expensive, and unproductive and, although it is always flattering and exciting to be asked to exhibit, it is a good idea to be able to recognize and avoid

<div style="border:1px solid">

Handout

AN EXHIBITING CURRICULUM VITAE

Selected Works, Alison Marchant

Solo Shows

Trace	Café Gallery Off-Site Projects, London	2005
East Londoners	University of East London Gallery	2000
	300 billboards across East London	
Casting Light	Leamington Spa Museum & Art Gallery	2000
Relicta	Ffotogallery, Cardiff	1999
Relicta	Cambridge Darkroom	1998
Turning Keys	Wallsall Art Gallery	1994
Charged Atmospheres	Camden Arts Centre, London	1993
Tying The Threads	Oldham Art Gallery	1992
Time & Motion	Rochdale Art Gallery	1990
House Hold	Sites/Positions, Glasgow	1990
Wallpaper History/Eradicated Pages	Central Space, London	1988

Group Shows

Mainly Unclassified	London College of Communication	2007
Re-Considered	Contemporary Projects, London	2006
On The Verge	Fourcorners Gallery, London	2005
There is always an alternative	Contemporary Temporary, London	2005
Bursary Exhibition	The Royal Society of British Sculptors, London	2003
Interior	Interim Art, London	1997
Projeckie	Tatranska Gallery, Slovakia	1994
Renegotiations: Class, Modernity & Photography	Norwich Gallery, Norfolk Institute of Art (touring)	1993/4
17th International Art Show	Tokyo Metropolitan Museum of Art, Japan	1992
Invisible City/London Project II	The Photographers' Gallery, London	1990
Heritage: Image & History	Impressions Gallery, York/Manchester Cornerhouse	1990
Heritage	Franklin Furnace, New York	1989

Audio Works

Tracing Footsteps	Resonance 104.4 fm July 5–October 30	2005
Talking Down a Microphone	New Records & Tapes Vol 7 No 5 Audio Arts	1985

Lectureships/Research Posts

Post-Doctoral Research Fellowship, Photography & The Archive Research Centre, University of The Arts, London, 2006
Visiting Lecturer, Fashion Curation MA, London School of Fashion, 2005
Visiting Professor, Bergen Arts School, Norway, 2004
Visiting Lecturer, Contextual Practice, University of Plymouth, Exeter, 2003–2004

</div>

Head of Photography & Installation, Fine Art BA, Cardiff School of Art, 1997–2003
Senior Lecturer, Contemporary Arts BA, Nottingham Trent University, 1994–1997

Writings

"The Refusal" (libretto), commissioned by Michael Nyman Ltd, London, 2005
"Fast Forward & Rewind," commissioned by Kulturhuset, Stockholm, 2004
"Naked Spaces: Patricia McKinnen-Day," commissioned by Angel Row Gallery, Nottingham, 2002
"Relicta" (theoretical & visual work), Fotogallery publication, 1999

(contact information usually at head of cv: address, telephone, email and website)

<div style="text-align:center">

Handout

MODEL RELEASE FORM

</div>

To exhibit portraits the photographer needs to provide the gallery with a model release for each one. This is a standard and general model release which could be tailored to specific usage by the photographer:

> Photographer's name and contact details/logo

MODEL RELEASE

I, ... (Please print name) give to (Photographer's name) *(insert the photographer's name here before printing the form)*, her/his *(delete as applicable)* legal representatives, and all persons acting with her/him *(delete as applicable)*, my permission to copyright and/or use, and/or publish photographic portraits of me, and the negatives, prints or digital information pertaining to them, in still, single, multiple, moving format, or in which I may be included in whole or in part, or composite or reproduction thereof, in color or otherwise, made through any media in the photographer's studio or elsewhere for art, or any other lawful purpose.

I hereby waive any right to inspect and approve the finished product or copy that may be used in connection with an image that the photographer has taken of me or the use to which it may be applied.

I further release the photographer, or others for whom s/he *(delete as applicable)* is acting, from any claims for remuneration associated with any form of damage, foreseen or unforeseen, associated with the proper commercial or artistic use of these images unless it can be shown that said reproduction was maliciously caused, produced, and published for the sole purpose of subjecting me to conspicuous ridicule, scandal, reproach, scorn, and indignity.

I acknowledge that the photography session was conducted in a completely proper and professional manner, and this release was willingly signed at its termination or soon after. I certify that I am not a minor, have read this form, and am free and able to give such consent.

Model's signature ... Date

Print name ..

Address

..

..

Telephone/email

..

situations that will be damaging to the work itself or to the reputation or confidence of a would-be exhibitor.

Before entering into a contract, even a verbal one, with a gallery or a curator, the would-be exhibitor should be asking a lot of questions. It is useful to be able to recognize potentially difficult situations early in the negotiations rather than later. Withdrawing early on, for whatever reason, is acceptable practice, and the situation can be handled politely by both artist and gallery. Once an exhibition is well advanced, however, it may be impossible or damaging to withdraw, and the exhibitor may well be letting friends or colleagues down or gaining a reputation as an unprofessional or uncooperative artist.

Two examples of this from my own experience illustrate how artists can handle this situation in exactly the right or exactly the wrong way. I once asked an artist who had just started on a major commission to show in a group exhibition planned for several months in the future. We had never met but spoke on the telephone. She said she would like to think about it and would get back to me within two weeks. When she phoned back, she said she felt she would have to decline the opportunity because she felt she needed time to let her work develop without thinking about the completed project and did not want to put that kind of pressure on herself when she was just starting new work. Although I was sorry to lose her input, I was very pleased that she had not risked the show, and I retained a great deal of respect for her as an artist who was able to make a clearly difficult decision.

A situation with the opposite result happened when I was co-curating a small group show with a colleague from another gallery. Our deadline was very short. My colleague had an agreement from a particular artist to take part in the show, but when we tried to arrange a collection of the photographs we were told that the artist was out of the country and had left no instructions. When contacted he denied the arrangement had been made, and a flurry of correspondence failed to sort this out in time for him to show. The exhibition went ahead without him, although it was too late to change the publicity material which included his name. We had the documentation to prove the arrangement had been made and realized that he had simply been too pressured to deal with it; his denial of responsibility and the embarrassment that ensued left us both resolved never to work with him again.

So, the would-be exhibitor needs to look at each exhibition opportunity before making a commitment and ask a very

simple set of questions about whether the reasons for exhibiting outweigh any possible reasons against. Basic questions to consider are:

- Is this a gallery with a reliable curator and staff?
- Will the work be shown well and professionally? Will showing enhance my reputation or might it damage it?
- Might the work be physically at risk (of damage or theft)?
- Will it be well publicized?
- How much of the work for the exhibition will be done by the gallery and how much by the exhibiting artist?
- Who pays for what, and what financial deal is on offer?
- Is there enough time to do this well? Is the proposed deadline too short?

Each exhibiting opportunity has its own particular circumstances. Only the would-be exhibitor can assess the opportunities and risks involved.

Although every situation differs, some to be wary of are:

1. *When the curator or venue is disorganized or unprofessional.* This may seem obvious, but sometimes it is difficult to recognize when a gallery will fail to take good care of its artists. Things to check include whether the gallery is properly insured and staffed so the work itself is not at risk of being damaged or stolen; that the gallery is offering a decent financial return on work sold; that the gallery looks good and can display the work well and it will do so for the whole period of the exhibition. It is worth visiting a gallery mid-exhibition; I have done this and discovered the gallery, which had been immaculate for the opening night, was dirty and untidy and the staff unwelcoming three weeks after the opening. Most important of all is to check the gallery's reputation with other photographers. A gallery that consistently fails to support its artists will soon gain a bad reputation among artists.

2. *When the work is not ready or it is the wrong time for the artist.* This can be difficult to judge. It could simply be that the deadline is too close and the work incomplete. Or the work may not be ready in a way that is harder to define but means that the artist needs time to continue to think about it. These sorts of decisions have a great deal to do with the way an artist works, and only the prospective exhibitors can decide what is right for them. Some people, of course, thrive on pressure, so a tight deadline means they produce great work while others flounder and fail. Exhibiting is a creative process which can engage the exhibitor as fully as making the work did and can leave the artist exhausted and drained if he or she is too busy to give the exhibition the level of thought it demands.

3. *When the showing situation cannot be negotiated and work could be shown unsympathetically.* If the work is hung when the exhibitor is not there, the photographer needs to know that it will be shown well. No exhibitor wants his or her work to be shown in a poorly lit corridor next to the lavatories or juxtaposed with work by much stronger or weaker photographers. Exhibitors also need to be aware of the way other artists' work impacts on theirs—it might seem attractive to be the strongest

artist in a show, but the context will reflect badly on the work if the other work is not of a professional caliber.

4. *When the exhibition venue is in an organization that does not respect or understand the exhibition process.* I have, for example, booked an exhibition into the exhibiting space of a central London college where I taught. Although I booked this well in advance and the booking was approved by my line manager, it was canceled three days before my last class by the department head who had decided to show work from a different class in that slot. I had the option of leaving my students in the lurch or challenging the decision and, after some difficult negotiation and a great deal of additional work, the exhibition was shown later in the year. It was a tough lesson on the perils of exhibiting for first-time exhibitors.

5. *When the financial burden of showing could be too great.* Exhibiting has become increasingly expensive over the years as standards of presentation rise and rise. Transport, printing, mounting, and framing work, as well as the time involved, can make it uneconomic for the artist if the exhibition is unlikely to sell, be widely seen, or reviewed. For instance, if an exhibition period is very short, it may well not be worth the costs incurred. If the work can go on to be shown elsewhere, using the same mounts and frames, then the investment is more likely to be rewarded.

6. *When the work has already been shown a number of times.* It is possible to show work too often. Although it can be difficult to recognize when your work has been overexposed, and though it may be tempting to accept yet another invitation to show, sometimes the artist is the only person who can see that it is time to disengage with this piece of work and move on.

MAKING AN EXHIBITION PLAN

For most photographers who are just starting out, the most difficult period is usually the few years just after leaving college. This can be when no one seems interested in looking at or showing the work, and the practical, emotional, and technical support systems provided by the college are no longer there to keep the photographer focused on his or her work.

This is the time for the photographer to think about five things:

1. making a short-term exhibiting plan
2. what sort of priority to give to exhibiting in the future
3. ways of promoting work to support and back up exhibiting
4. how to find or create good support systems
5. learning how the exhibition system works

MAKING A SHORT-TERM EXHIBITION PLAN

Over the years it has become harder for photographers who are just starting out to get a foot on the exhibition ladder. However, although chance and opportunity play a part in an

exhibiting career, there is more than one possible route to follow. Why wait until a gallery approaches you? Photographers usually need to be proactive about exhibiting but never more so than when they are first starting out. Many galleries will be booked up, many have more applicants for exhibition than they can deal with, and some will only show exhibitions by invitation. This is the time to look at alternatives and, in the short term, to prioritize getting the work seen as part of a strategy of learning to exhibit professionally and of finding a gallery with which to establish an ongoing, long-term relationship.

Some possible exhibition strategies for a group or individual to consider include:

- hiring a private gallery for a regular exhibition at the same time every year
- holding a regular "open studio" weekend
- looking for smaller, informal commercial spaces (cafes, restaurants, clubs, offices, cinema and theater foyers, for example) that will show photographs and producing a regular exhibition for them
- setting up a small group of photographers with similar concerns to show regularly together and rotate the tasks of finding exhibitions or setting up an exhibiting web site or employing someone to do it for the group
- entering exhibition-based competitions on a regular basis
- keeping in touch with one or more supportive curators who may remember the work when planning a show
- when working on a particular theme (skateboarding, for instance), recognizing that there are interested groups with related magazines, venues, or other outlets who may be interested in showing or promoting the work and researching and approaching those. For example, there are specialist magazines for skateboarding, dance, landscape, music, and so on, all of which may well lead to exhibition opportunities

If a photographer wants to focus on producing new work rather than exhibition, then it is still useful to plan to show the work at some point. Showing once a year is a useful practice that keeps photographers alert to how their work is progressing. A way to achieve this that will suit most photographers is to show "work in progress" on a regular basis. The work can be shown fairly informally in the photographer's studio or work space; the presence of the photographer is an incentive for visitors to talk and to buy work, and the provision of a portfolio can be an invitation to browse. An audience is invited through the photographer's own mailing list of professional contacts, colleagues, friends, and family, and, because seeing work in the artist's own work space is so interesting to most people, attendance is usually

good, and the afternoon or evening can become an important event in the social calendar. If the photographer is not showing elsewhere, this is a particularly good way of making sure that the work does not disappear from the public gaze and that one does not lose the skill of talking about one's work.

MAKING AN INDIVIDUAL EXHIBITION PLAN

If photographers look at what suits their work pattern and their circumstances and think about making an exhibiting program that will suit their individual needs in the long term, they can then work to achieve it. Over a period of time, most artists and photographers develop a work pattern that fits their creative needs and is specific to them. While some are prolific, consistently turning out new ideas and images, others may take years to complete a particular piece of work. Other photographers may combine working on both short- and long-term projects.

Exhibiting has a similar sort of internal dynamic, and it is useful to realize that there is no single model here, no "right" way to make an exhibiting career. Nor is there a standard number of times to exhibit over a particular period. Different photographers have very different exhibiting careers. Photographers exhibit their work in different ways and for different reasons, and they need to be aware of what is right both for them personally and for a particular piece of work. For some photographers, exhibiting regularly and accepting every exhibition opportunity is their main aim, whereas for others an exhibition is an occasional event, a time when they have completed a long-term project or want to exhibit work that has been shown elsewhere such as in a book or magazine. Photographers must be able to identify, by trial and error or by thinking it through carefully, how much and how often they want to exhibit.

For most photographers, a good starting point for assessing the impact that exhibiting will have on their working life and deciding how large a part they want exhibiting to play in their work is to look at the amount of personal input an exhibition requires. Another factor to think about is how they react to feedback. Photographers who find it hard to take unthinking or adverse criticism or to let go of their work might consider waiting until that work is absolutely complete, or until they have a sense of having let go of it, before exhibiting and hearing how the work is received. But sometimes the decision one makes about exhibiting is simply

Handout

OFFERING FEEDBACK

We have probably all been taught to be highly critical of creative projects, but in an independent photography group it is usually a good idea for members to be supportive rather than critical. If you have been to a college where crit sessions are tough, it may take time to adjust to the gentler pace of an independent photography group. But discussions of work should not be a competitive situation where everyone demonstrates how much he or she knows. It is useful to remember how hard it is to show work to other people, how vulnerable one feels when doing it, and how awful it can be to discover that what one is doing is not well received. A group will usually get tougher as it gets established and members get to know one another better.

So when offering feedback to other photographers:

- Don't feel you have to say something just for the sake of it.

- Aim to see what works rather than what doesn't and praise that—or at least start from that point.

- Remember that technical advice and information can be very helpful, but make it accessible and precise.

- Support what works by thinking about how it can be developed, but if the photographer doesn't seem interested in your ideas, don't push it—it's not your work, and the fact you'd take it in another direction isn't helpful to the artist.

- Never say "I had that idea" or "I've done that already" although if it is a technique you do know something about, look for ways you can share the information.

- If the work reminds you of another artist's or photographer's work, say so. It may be difficult (there's nothing worse than hearing someone else is doing the same thing as you), but it'll probably be useful for the photographer to look at that work. Again, don't be surprised if they don't seem interested—some photographers just can't look at what anyone else is doing until they've completed

about whether one enjoys exhibiting and finds it a process that advances the work or not.

Planning an individual exhibition program is about taking some control of the exhibiting process. This means that the photographer can decide to work on the aspects of it he or she can arrange for him- or herself, like deciding to show regularly with a local group of photographers or holding an annual open studio show. At the same time, he or she might be negotiating with a prestigious gallery elsewhere or regularly entering work into competitions. The strategy should be varied, have both long- and short-term projects in it, as well

as challenges and certainties, but above all it should suit the way the photographer works.

PROMOTIONAL TOOLS

A photographer can choose to use a number of promotional tools which have different and complementary uses. These include business cards, postcards, CDs, portfolios, and web sites. All of these have application beyond the gallery system and are useful ways for photographers both to keep a record of their ongoing work and to reach a wider audience.

Business cards

A standard sized ($3^1/_2 \times 2$ inches/9×5 cm) business card can be easily kept in the photographer's wallet or purse and is generally useful when making new contacts. It should be simple and clear and needs no more description than "artist" or "photographer" after the name. Photographers who work from home can use a box number on the card, available at the local post office, if they move frequently or want to keep their address private. The card does not need to have a photograph on it, unless the photographer intends to keep reprinting cards, as the image will quickly date and could be too small to read well. Also, it can be a mistake to select a single image to represent a photographer's body of work, since one image can rarely do this adequately.

Postcards

Postcards are a good way for photographers to promote their work whenever they are in touch with anyone. Postcards have all sorts of uses: as a record of the work, a reminder for potential clients and curators, and as a compliment slip when sending out information.

Most people enjoy postcards, and they are a good way to circulate an image. Think, for example, of how many are picked up if they are provided at opening views and receptions or how visitors buy them as a record of an exhibition they have enjoyed. I can remember the pleasure of walking into the London office of Magnum and seeing a colleague's card pinned prominently above a desk. I also keep a large index file of postcards by contemporary photographers, filed alphabetically, as an aide memoire and as a teaching tool. If a photographer has not been published, this may well be my only visual reminder of his or her work.

However, postcards have a short shelf life. Printers usually print in runs of 500 or more, so the photographer needs to

feel confident that he or she can distribute a large number of postcards over a period of a year, lest he or she end up with a lot of redundant cards. Choosing an image that makes a good postcard needs to be done thoughtfully, since the image must work well as a single, strong, standalone image which will represent the whole of the photographer's work and will not need additional information or date quickly.

CDs

CDs are very useful in that they can be posted or left with a potential client or curator as a reference, record, or reminder. However, in my experience they are not always an adequate substitute for a print, as most curators prefer to see prints when making decisions about an exhibition.

CDs should be simple and easy to access. It is not necessary to add graphics or design elements to enhance the information. The sleeve should include the photographer's name and contact details, the title of the work, the date, and a subtitle or brief description of the project if it needs some explanation. On the CD itself, the images should be sequenced, titled, and captioned. Numbering them will help if the work should be seen in sequence.

This advice may seem obvious, but it is something that photographers frequently get wrong because they are too busy to be meticulous about labeling information or to think through tailoring a CD for a particular situation. If you have made several copies of the same CD for use in a variety of situations, you need to be aware that there is nothing more disheartening for a curator than skimming through what appears to be a random collection of images in search of the one or two that might fit with the theme of the exhibition. The photographer needs to ensure that the CD labeling and/ or file names and arrangement make it clear to the curator (or other recipient) which images are being offered for consideration; a covering letter can also help to clarify the photographer's intention.

Here is an example of how this can go wrong: I recently asked a photographer to send me a specific set of about six images for an exhibition proposal I was making on behalf of four photographers all working on the same theme. I know his work well, explained the proposal to him in some detail, and was clear about which images I wanted. He sent me a CD that included twenty images from about five different projects. Some of the images did not relate to the project I had talked to him about, the captions clearly were for his

reference alone and were a sort of shorthand I did not understand, and there were no contact details on the CD. I spent some time labeling the sleeve and providing backup information related to the exhibition proposal. I knew that without this, the CD would not have been considered by the gallery director I was sending it to—but the photographer should not have let this happen. He could, and should, have taken the time to add a note to the sleeve highlighting the six images that were up for consideration. If the images had been numbered or captioned well originally, this would have taken less than five minutes, but unfortunately they were not, so it took much longer than it need have to make it clear which ones were relevant to the proposed exhibition.

Photographers also must be certain that the image accurately represents the colors that can be replicated in an exhibition print. At the same time, they need to make sure that the image resolution is such that the image can be read from the CD but not reproduced.

Portfolios

One of the most useful things any photographer can do before approaching a gallery is to take their work to a Portfolio Review session at an event like the Huston FotoFest or Rhubarb-Rhubarb. The reviewers have a range of different expertise and their comments will be invaluable in shaping a project and in giving the photographer confidence in their work.

Zelda Cheatle, WMG Photography Fund portfolio manager

Artists who present their work at portfolio sessions for critical comment and advice should recognise that it's their responsibility to prepare in advance and to know what it is they want to gain from the experience.

John Gill, director, Brighton Photo Biennal

A portfolio is still an essential tool for a photographer who wants to exhibit his or her work, even though some of the work done by portfolios can now be done on the Web. A portfolio is essential for meetings with curators and galleries. It should be small and arranged in such a way that it can be used on one occasion for a meeting with a curator and then rearranged as necessary for other meetings. Two good alternatives are a bound book and a smart box of prints; both of these need to use archival-standard materials.

At one time many photographers used large folios and carried exhibition-standard prints in the folio. This is no longer current practice, and a 10×12 or 12×16 inch folio or box is more usual. A book or box this size is easy to handle and show, and it is not always possible or appropriate to take

a very large exhibition print to show in what may be quite a small or cluttered space.

Choosing between a box and a book is largely a personal preference. Both allow the photographer to rearrange the images for different occasions. The advantages of a box of prints over a traditional portfolio are that it looks contemporary and is easier to arrange and rearrange, and it is easy to hand around prints if several people are looking at the work. It can also be used to store a large number of prints between appointments. The boxes should be specialist boxes of acid-free board, and prints should be stored in archival-standard clear envelopes to protect them from careless handling. Such boxes can be bought from specialist photographic or graphic design suppliers. Still, many people prefer a portfolio, particularly when photographs need to be kept in sequence. Portfolios also help ensure that photographs will not go missing, since they are unlikely to be taken out of the folio during a showing.

The purpose of a portfolio is to show a curator a potential show rather than to display all of a photographer's strongest images. So, the first rule of making a portfolio for this purpose is to put together a single set of strong photographs that work together. Most people make the mistake of including too many images in their portfolio. Twenty photographs is usually a good number to show anyone. Photographers should be prepared to edit their work ruthlessly and exclude repetition. It is better to have a set of ten interesting photos than twenty or thirty that include several versions of the same thing and dull or poorly printed images.

It is also always, as in every showing situation, important to put the photographs in a good sequence. The order of the images should be carefully considered so that they flow well from one image to the next. The skills of editing and sequencing work can take time to acquire, and many photographers find it hard to edit their own work (see Chapter 2 for a description of the process). If this is the case for you, it is worth inviting a trusted colleague to help, since other people sometimes see our work more clearly than we do. A second opinion is always useful too, in that it encourages us to question our assumptions about what does and does not work.

Keep the design of the portfolio or box simple and clear. It does not need elaborate graphics. Remember, most people you'll be showing it to will probably give it about fifteen minutes of their time, and you do not want to distract their

attention from the images with flashy graphics or too much information. It may be tempting to try out some very contemporary presentational methods, but unless you are really skilled, you may well end up looking amateurish rather than slick. This is a moment to play it safe.

Everything in a folio or box should be presented in a consistent way so that nothing distracts from the photographs themselves. For ease of viewing, to keep a sense of the flow of the images, and to avoid breaking the viewer's concentration, prints should be consistent in size, color, contrast range, paper type, and finish, as far as is possible. This may well mean reprinting an entire set of images simply because they may not look like a set if they have been printed at different times and are all slightly different sizes or paper types. For the same reason, when you have a mix of landscape (horizontal) and portrait (vertical) photographs, both should be printed so they can be viewed without having to rotate the folio—either all the landscape photographs should be printed across a portrait page if most of the photographs are portraits, or vice versa. All the photographs should be in the same position on each page with the same amount of border all around. If the pictures are almost but not quite the same size, it is possible to make the whole look consistent by making all the borders, either above or below the image, the same depth.

As a general rule, images in a folio or box do not need to be mounted on card. However, if they are to be presented on card, the image should be trimmed to the edge and mounted without a white border on the print. If the image is unmounted, the border can remain. Black or dramatic dark colors of card are often a favorite of photographers but should be avoided, even for black-and-white prints, because dark colors usually overwhelm the photographs and tend to be considered unprofessional. Most neutral grays and beiges are good as background. White card should be carefully considered; it may look dirty or dull with some colors, and contrast with different shades of white in black-and-white photographs. When buying card, it is a good idea to buy slightly more than needed in case pieces are spoiled, as it may be impossible to buy more of the exact same shade at a later date (batches of anything produced at different times may differ marginally). Different colors, weight, or finishes of card will be distracting. Don't mix background colors of card unless you are really convinced that your photos need to be presented in a different way. As a general rule, too

many stylistic changes will distract from the photographs rather than enhance them.

All text and picture captions should also be consistent. Captions are best underneath the photograph, on either side or in the middle. This means deciding where they should be placed before starting the task of mounting images. Captioning is easier to do with computer-generated prints than when a print is to be separately mounted. If images are individually mounted, it may be preferable to number all the images and put captions on a single, separate sheet rather than attaching small slips of paper to each piece of cardboard, since there is always a danger that they will slip or get detached.

Text in a folio should be kept to a minimum. It is useful to include a c.v. and an artist's statement, though the gallery may not look at them. Keep any artist's statement simple, short, and factual. Three paragraphs are usually enough. Do not make elaborate or grandiose claims for the work. Remember that other people may well not know even the basic facts about the work, so a statement that says when and why the photographs were taken is useful.

The photographer may be asked to be present to introduce the portfolio and talk about the work, but this will not always be the case. The portfolio may have to speak for itself, so it has to be strong enough and straightforward enough to be looked at just as it is, with additional written information available as reference. A folio should have the photographer's address on or in it. Portfolios were once designed to be left with prospective galleries or clients. This has always been a risky thing to do, since there is a real danger that the work can be lost or damaged. New technology makes it unnecessary to do this, and a good CD can be left instead of original prints.

It is always a good idea to give people something to keep as a reminder when you have shown them the work: a small print or postcard or a copy of your c.v. or artist's statement which also has your contact details on it. It is also a good idea to follow up a visit/portfolio review with a personal note of thanks.

Web sites

A web site is useful but not a substitute for a portfolio, since most galleries still rely on seeing prints and meeting photographers face to face. However, it is a useful reference and promotional tool, in particular because it can be larger than

a folio and hold a broader range of work. It is also important as a way of reaching a wider or geographically distant audience, or as a quick reference in lieu of a meeting for someone who is already familiar with the work.

The crucial thing here is to make the site accessible and easy to use. In doing this, a careful choice about categorizing the work needs to be made. For a documentary photographer, this is likely to be subject matter. For a photographer whose main aim is exhibition, it is more useful to divide the work into particular projects or exhibitions.

Commercial photographer Paul Carter provides a good example of how a web site can be useful:

> I get work in several different ways now but it's very rare that I'm asked to bring a hard copy portfolio. For me being on the grapevine is crucial. It is still the best way of getting new work because you establish a reputation. Only a very small amount of work comes from people browsing the Internet looking for a photographer. But the difference it does make is that even before I get a phone call the person has checked the web site and knows I might be the right photographer for the job.

> I have had a website for about eight or nine years. It has gone through at least three major permutations and I've been learning each time. I taught myself web design so I can manage the site. Because we manage our own website we have the means of delivery behind it. It is not designed as a very sophisticated site but a fast loading, easily accessible site seems to work well. I think it is really inappropriate to make a site for still photography which jumps around all over the place. I've found over the years that my portfolio was too general because I do such a wide range of work and people have tended to want to see work which is very specific to their area of interest—they don't say, "Oh I like your style. I would like you to apply that to my commission." Over the years I have actually increased my portfolio areas, which is often considered bad practice, and I now have twenty-five portfolios with twenty images in each but they are all very quick to access. People look at their area of interest and then tend to browse through other areas on the site.

> We also have a dedicated server with a forty GB hard drive which is never compromised for speed in loading the site because we are never sharing it with anyone else. (Interview by the author January 2007 for the Oral History of British Photography. All OHBP interviews are part of the National Life Stories Archive and held at the British Library, London. Most of them are available on line to students and academics at www.bl.uk/sounds)

SUPPORT SYSTEMS: NETWORKING, WORKING GROUPS, VOLUNTEERING, AND MENTORING

Photography is often seen as a solitary and competitive practice, but it is a rare photographer who does not need a variety of different sorts of help and advice. It is up to the photog-

rapher to work out what sort of support he or she needs and where to find it.

Four useful ways in which the photographer works with others and keeps in touch with the world of photography is through creating or joining working groups, volunteering, networking, and in finding a mentor.

Working groups

My associates, people like Lee Friedlander, Garry Winogrand, Diane Arbus, we all knew each other. We felt like a secret society that believed in each other. We never criticized each other's work; although we took extremely different kinds of pictures, we would just look at each other's work. I guess we all learnt and borrowed from each other—only with the best intentions of course. It wasn't copying.

William Eggleston, photographer

If artists can pick their own shows, they will reserve for themselves some of the power to determine the way history is written, because exhibitions help define and shape that history; in showing the artists that they feel are important, they will partially deflect the power of critics and curators who have traditionally told artists what is good and not good.

Kay Larson

Politicians are now more prescriptive about gallery and museum exhibition policies than ever before and this limits the artist's options. Now more than ever artists should be setting up their own exhibition spaces and nowadays there are more exhibition options than just the gallery.

John Gill, director, Brighton Photo Biennal

One of the best ways to start an exhibiting career is either to join a group that exhibits regularly or to set one up. Many people find this a good way to deal with the transition between college and a regular exhibiting career. It is also very helpful for any photographer to know other photographers with the same interests or at the same career stage who form a fairly informal support group. In a group of this kind, photographers share information about resources (such as where to buy good, inexpensive materials or who will loan out exhibition-quality frames), exchange information and ideas, loan equipment, and use group members as unpaid helpers in return for similar help when it is needed.

Groups often meet on a regular basis at exhibitions or in someone's home or studio to look at ongoing work or simply to socialize. This may be for the length of a particular shared project or may have a longer life. This sort of group can form the basis for an exhibition project and make it very much easier for an individual to start exhibiting.

Handout

RESOURCES FILE

Having a personal list or file of photographic and exhibition resources is very useful. It should be specific to you rather than general. Most of the resources also need to be fairly local to you. It will take time to build up and should be regularly updated. One of the best ways to find out which are the most reputable and reliable shops and suppliers is to ask other photographers.

A resources file could include:

- general graphic and photographic suppliers
- suppliers of conservation-standard boxes and storage systems
- specialist printers who print to exhibition standard
- printers of catalogs or exhibition brochures (the criterion being that they reproduce images to a high standard)
- invitation or postcard printers
- mount cutters and dry mounters
- framers
- glass-cutting firms
- vinyl letter–cutting firms
- transport—both firms for hire and specialist art movers
- galleries to hire
- a list of galleries with relevant specialist interests or policies (for instance, all the galleries that regularly show young photographers or landscape photography)
- a list of the web sites of international specialist galleries
- a list of sympathetic curators and writers (these could be specialists in the field or people who have shown interest in your work)
- if you show on a regular basis in one particular gallery, a list of nearby bars or restaurants with contact details
- booklist (for instance, reference books, useful d.i.y guides and exhibition catalogues which relate to your area of interest).
- sales and reproduction rates
- possible sponsors
- grants and funding information
- a list of photography festivals and contact addresses or web sites
- a list of annual/regular photography competitions and contact addresses or web sites
- samples of press materials, leaflets, and brochures to use for inspiration or as templates

A group like this works best if it has a clear aim and its members have a great deal in common and less well if it is divided by differences in attitudes and interests. The group should not be very large, unless it is one in which not all members show in every exhibition. The administrative time of dealing with a group of more than about ten photographers can be overwhelming, especially if the group communicates by email and vast amounts of information are passed around.

When a group works well, it supports all its members, shares the workload, includes a range of different skills and experience, and can act as a forum for creative ideas and brainstorming. When a group works badly, it can be taken over by individual egos, can include members who contribute very little, and can get bogged down in battles or minutiae. Russell Miller's book (1997) on the Magnum photo agency, the most famous photographic cooperative now sixty years old, well illustrates both aspects of being part of a group. He points out that Magnum "has reeled from crisis to crisis, usually financial, sometimes emotional, occasionally personal and often potentially terminal." But he also says, "Setting aside the bickering, membership of Magnum provides photographers with a rare opportunity to give and receive frank criticism of their work and sharpen each other's eyes by the constant interchange of superlative images."

So finding a group also means finding the *right* group. Exhibiting as a group means deciding how to organize it right at the start of the process rather than waiting until the last minute. Some tasks are best done collaboratively, and some individually. Group discussion of images is usually insightful and rewarding, whereas group curation can result in an unfocused show. This is because working consensually is slow and often means that the transition from seeing sets of individual images to working them into an exhibition whole is not made. I would advise any group showing together to appoint members to do or oversee specific tasks such as administration, publicity, curation, and hanging, rather than trying to do everything as a group.

Volunteering

Photography students often work in galleries as part of an intern or work experience program and gain useful experience and contacts this way. Continuing to do this on a part-time basis can be a useful way of acquiring exhibition skills and keeping in touch with the photographic world after

college. Many galleries are understaffed and welcome volunteers to help hang shows, serve on committees, and staff the gallery.

However, it is important to find a gallery that is friendly and inclusive. As Nadia Burns points out:

Volunteering is a good way to get a foot in the door and learn how galleries work. When I left college I volunteered at three different places and the best was the one which had a specific programme for interns—a volunteer or intern needs to find a place which gives something back. It's easy to panic when you've just left college and jump at the first opportunity but it's really not fair to land a volunteer with only the dull jobs like photocopying. In the end I got a gallery job by volunteering—it was just good luck really, being there when they needed someone. (In conversation with the author, May 2007. Nadia Burns is Gallery Manager for the Getty Images Gallery, London.)

Networking

One of the ways the art world works is through a system of connecting institutions, organizations, and individuals. Many exhibition opportunities come about fairly informally by word of mouth and through conversation among curators or photographers. If photographers want to exhibit, then it is useful for them to be in touch with people in the world of exhibiting, to attend artists' receptions or private views, to keep in touch with gallery staff they know, and show their work or talk about their work to them. Short educational courses and workshops on different aspects of photography are also a good way of meeting like-minded photographers.

A photographer I know gave me an example of this. At a private view I introduced her to another photographer with whom I thought she shared interests and a similar photographic style. They enjoyed a long conversation about their current work and exchanged cards. Almost a year later she got a call from the photographer, telling her that someone had dropped out of a group exhibition she was in and inviting her to replace the original photographer.

Mentoring

Mentors are quite interesting you know. They're a good thing to have. People don't really have them enough. . . . I haven't had them enough in my life.

Max Wigram, art dealer and curator

Every museum is perforce a political institution, no matter whether it is privately run or maintained and supervised by government agencies. Whether museums contend with governments, power trips of individuals or the corporate steamroller,

they are in the business of molding and challenging consciousness. Even though they may not agree with the system of beliefs dominant at the time, their options not to subscribe to them and instead to promote an alternative consciousness are limited. Survival of the institution, personal careers are at stake.

Hans Haacke, "Museums: Managers of Consciousness," 1984

There are a wide variety of possible mentoring situations. They can be short- or long-term, formal or informal, free or not. In Britain some mentoring schemes are paid for by the funding bodies in order to support and professionalize the practice of younger and mid-career artists.

In essence, a mentor will do some or all of the following:

- talk to the artist about issues of theory and practice around their work
- identify appropriate opportunities for exhibition and commissions
- explore contacts who may help in any way—including buying, selling, helping make, critique, commission, exhibit, or write about the work
- set up meetings that help the artist
- work on specific projects
- help them develop business skills

Gina Glover, who holds regular mentoring sessions for photographers, offers the following comment:

I hold regular mentoring sessions once a month at Photofusion of approximately one hour per photographer, and I usually see three photographers in an evening. Over a year I probably see about 36 photographers, and I may see them only once or they may continue to come back over several years. Each photographer makes an arrangement which suits them.

The mentoring came about because Photofusion holds regular portfolio viewings and I recognised that some people who attend these sessions need a different sort of feedback and to have more than one session if they are to take their work in a direction which is right for them.

What I do is offer a mix of practical and personal advice. It's entirely up to the photographer whether they take it or not. People don't come back again if I'm not being useful to them. My aim is to help them move their work on to the next stage and that varies a great deal with each photographer. It may simply mean suggesting they show their work to a particular gallery or curator. It may mean wrestling with an issue in the work which they can't see or can't deal with. I sometimes spend a whole session working my way towards asking the most poignant question which will allow them to understand their work more clearly. For some people just talking about their work to someone who is a photographer and understands the issues is enough. It's not psychotherapy but it is about giving photographers the confidence and skill to achieve their photographic goals. (In conversation and subsequent email with the author, February 2007. Gina Glover is a photographer and a Director of Photofusion.)

Some curators will provide this sort of support, fairly informally, to a few artists whose work they are interested in. Curators may mentor because they find it personally rewarding and because it keeps them in touch with the day-to-day issues affecting artists and in tune with younger artists as they develop. An important point for the artist is to treat this situation with respect and acknowledge the significance of the mentor's help. If I mentor three people, and one gives my contact details to all her friends who then demand my unpaid help; one only gets in touch when he needs a reference; and one thanks me by giving me a print—then it is obvious which one I will be most disposed toward continuing to help.

Galleries and photographic organizations may also have membership schemes that sometimes host events that provide short-term or one-off mentoring, such as portfolio sessions in which curators look at folios and offer constructive criticism, advice, and suggestions to photographers about their work and about which galleries they might approach for an exhibition. These usually provide useful feedback, although photographers should be aware that they will receive a range of different, and sometimes conflicting, opinion and not all of it will be useful to them.

For most photographers just starting out, finding a community of peers is important and useful. Joining membership organizations that act as centers for information and education, and provide services to members in the form of lectures, portfolio review days, members' juried exhibitions, conferences, bookstores, and libraries provide opportunities for networking and mentoring. The Society for Photographic Education (SPE) and galleries such as the Photographic Resource Center in Boston, the International Center of Photography in New York, San Francisco Camerawork, CEPA Gallery in Buffalo, and the Photographers Gallery in London all have useful events programs.

UNDERSTANDING THE WAY THE GALLERY WORKS

The curator's role

Curators are, above all, the institutionally recognized experts of the artworld establishment, whether they operate inside an institution or independently. More than art critics or gallery dealers, they establish the meanings and status of contemporary art through its acquisition, exhibition, and interpretation.

Mari Carmen Ramirez, curator of Latin American Art

The real problem in curating nowadays is that many curators are making lists of artists rather than working with the artists to make a show.

<div align="right">John Gill, director, Brighton Photo Biennal</div>

My job is to be responsive to contemporary practice, not to make trends.

<div align="right">Camilla Brown, Senior Curator, The Photographers' Gallery, London</div>

90% of the business of putting exhibitions together is in the organization of it. It's not just about selecting work.

<div align="right">John Gill, director, Brighton Photo Biennal</div>

Hoopers Gallery is a commercial gallery and is profit-motivated. However, we have a strong underlying policy of support for our artists—we are there for the long term. Where we recognise real talent and originality but feel an artist needs support and encouragement to develop and focus their work, then we are prepared to work with them for a year or more until we feel they have a body of work that could form an exhibition. We had an example of this recently where a photographer is making the transition from film to stills. This level of support can only be given to a select few but it does highlight that we do not expect every portfolio to present us with an instant exhibition—both sides need to make a contribution.

<div align="right">Helen Esmonde, director, Hoopers Gallery</div>

When I curate an exhibition I have to be fascinated by the subject, it has to grab me and not let me go. With me, it's always a good sign if something actually makes me angry upon first viewing, that the art work has hit a nerve and is making me think.

<div align="right">Dr. Inka Graeve Ingelmann, head of the Department of Photography and New Media, Pinakothek der Moderne, Munich</div>

I work in an organic way. I select one or two artists and then develop the idea of the show in conversation with them and invite further artists to participate.

<div align="right">John Gill, director, Brighton Photo Biennal</div>

The way that exhibitions are always selected: works that we knew; works that were suggested; works that we could find; that were available; that we could afford; works that worked together.

<div align="right">Jeremy Millar, curator</div>

What is curation? The term is a relatively recent one, originating from museum practice. The dictionary defines the *curator* as "the person in charge," and it is useful for the photographer to be aware that it is usually the curator's vision that shapes an exhibition. There are, however, as many different types of curators and different aspects and approaches to the curator's role as there are different types of venues for which to curate.

The task of curation varies from one type of venue to another, so that a museum curator has a different job from the curator of a commercial gallery and both differ from an independent curator. In some galleries the gallery director is

FIGURES 1.2A–1.2E From "21st Century Types: A Photographic Study." All Images © Grace Lau

In 2005 Grace Lau set up a Chinese portrait studio in the seaside town of Hastings and invited passing residents and summer visitors to sit for their picture. The result is about 400 vivid images of "21st century types." Lau's study of archived images of the Chinese, as seen in the West through images made in traditional Victorian studio settings, led to her interest in reversing the process by placing "the British" in an imagined Chinese studio of the late 1800s. From a curatorial viewpoint, a number of very different themes emerge from the work—multiculturalism, youth culture, class, the eccentricity of the British—so making careful selection for an exhibition is crucial if her original idea is to be retained.

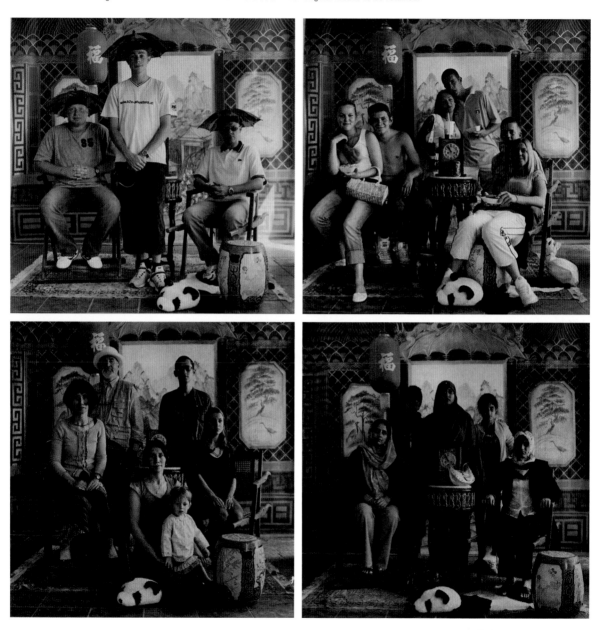

FIGURES 1.2A–1.2E *Continued*

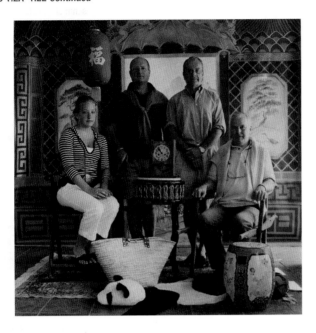

also the curator, whereas in others the roles of director and curator are sharply differentiated. Some galleries employ a different curator for every exhibition or bring in touring exhibitions curated elsewhere, while other galleries have one or more in-house curators. In smaller galleries curators are likely to carry out tasks such as framing and hanging work, which in larger galleries are more likely to be done by a specialist team or contracted out.

As a general rule, the curator's role is narrower in large galleries, where the key tasks may be to develop an exhibition concept, select the artists and the work for the exhibition, and make sure that it is hung to the artists' specification. In smaller galleries the role is likely to be much broader and more hands-on, and curators may oversee or be closely involved in planning an exhibition program, budgeting, producing publicity material, planning exhibition design, arranging framing and text production, planning the private view and educational events, hanging and taking down the work, documenting the show, and updating mailing lists and archives.

The curator's role, however, is usually both creative and administrative, and it is useful to be aware that these two aspects of the work can conflict. The task of developing an understanding of the work in order to shape and present an

exhibition well is about being slow and thoughtful and about giving the work the sort of time and attention it demands—even though it can be difficult to predict how much time that will be. The administrative role, on the other hand, necessitates speed and efficiency and keeping to tight deadlines. Both creative and administrative tasks need to be done well, but under time pressure it is sometimes difficult to prioritize one over the other. An outstanding exhibition that no one sees because the invitations have been sent out too late is as much a disaster as an exhibition that has had a fantastic press campaign but is badly received because the curator had no time to think through how the work should be shown. The experienced curator knows how to balance both aspects of the work, and the photographer who learns to curate his or her own work will develop the same skill over time.

However, no two curators have exactly the same approach to curation or to their understanding of their role, and an important part of the photographer's input to an exhibition is often to negotiate their role with the curator. But although the job descriptions and who does what may vary from venue to venue, the central tasks of curation remain consistent and identifiable whatever the venue. This is to select, edit, and present work to an audience. The curator is first and foremost a mediator or interpreter between photographer and audience, and his or her work starts where the photographer's work has finished. The photographer's finished work is, for the curator, simply the raw material from which he or she will shape an exhibition. Or to extend Ansel Adams's famous metaphor that "the negative is comparable to the composer's score and the print to its performance," if the print is the performance, the curator is the conductor of the orchestra. The curator is creating a conversation not just between artist and audience but among the artist, the audience, the space, the institution, the press, and the art world.

I have heard the curator's role described as being to help artists show their work the way they want to. This may be more true of painting and sculpture than it is of photography, where the curator is likely to have a strong curatorial vision which takes precedence over the photographer's understanding of his or her own work. On this subject, curator John Gill, Director of the Brighton Photo Biennal, says to artists, "It's your work but it's my show"—neatly summing up the relationship of artist and curator.

A good curator can see things in the work the artist may be too close to the work to notice and should be able to make

the work appear stronger and more coherent. In that way the curator may make all sorts of ideas and connections visible. He or she brings to the work knowledge of both the practical aspects of presenting work and of the wider context of the gallery world in which the work will be seen.

A curator is not just an enabler but has to be capable of being ruthless with the artist too. Most photographers get attached to their own view of their work, and it can be difficult for them to accept that what they see as artistic vision may actually be a sentimental attachment to an image. Often the hardest thing for a photographer to understand is that "less is more" and that an exhibition may not include some of their favorite images because the curator knows how much work an audience can look at and how to "pace" an exhibition, whereas the photographer naturally wants to show all his or her work.

Clearly the artist–curator negotiation can be a difficult one, particularly for the artist who has to give up some control over the work. It is helpful for the photographer to ask the curator to be clear about the exhibition concept and how they will be working together right at the start of the process. Again, depending on the gallery and curator, it will vary. In a major gallery the curator may simply ask photographers to submit work and then select from it without any negotiation. In a smaller gallery the process is likely to include more shared discussion of the work.

A curator is usually prepared to give constructive criticism of the work. Photographers have to be able to trust the curator's knowledge not just of their work but of other photographers' work, of the exhibition space, and of the art world. In return, the curator should listen to what the photographer has to say about the work. The photographer has to be ready to put aside his or her attachment to particular images or body of work and listen carefully to what the curator says about it. This can be very useful for the photographer. If the curator, who is usually someone with vast experience of looking at photographs, has missed something the photographer sees as being in the work, it may be that the work is too subtle and a gallery audience would, most probably, miss it too. Something that seems completely obvious to the photographer because he or she has spent many months thinking about little else will not necessarily be obvious to a curator or an audience.

In working with photography students, I have found that they often start to trust my experience when I demonstrate

my ability to put their work into a sequence that makes the work "sing." This is a skill particular to curation (and also to picture editing) which takes time to acquire and one many photographers do not have unless they acquire it through curating their own work on a regular basis.

The curator can also be very helpful to the photographer in a number of other ways. A curator who is interested in a piece of work but unable to show it may well make an introduction to a curator who will show it. Most curators meet regularly with other curators and gallery directors and have a good idea of who is interested in particular themes or types of work and will pass on names and ideas or make a more formal introduction. As a colleague said to me after a recent portfolio review, "I saw loads of things which were great but not for us but it felt very good to be able to pass them on over our lunchtime discussion."

Photographers who are curating their own group or individual show need to think carefully about how to approach it and consider asking a colleague to work with them rather than automatically curating their own work. This is also where a support or working group of photographers can be useful. By sharing these tasks and by discussing the editing and presentation of work on a regular basis, photographers acquire a set of useful skills that will stand them in good stead both in exhibiting and in making the work.

There are, then, two priorities for the photographer in working with a curator. The first is to understand that this is a transitional point—the work you've made as an artist is finished, making an exhibition is another stage in the life of the work, and you have to put the knowledge about the making of it on one side and be prepared to start again, using the finished work as raw material.

The second priority for the photographer is to acquire both an understanding of the curator's role and some curatorial skill. If the photographer is able to suggest appropriate ways of sequencing his or her photographs or has a good idea about how best to show his or her work, it will help them develop a good creative working relationship with a curator. Having practical curatorial skills is essential to photographers curating their own work.

The different agendas of exhibitor, gallery director, and curator

Photographers do need to realise that curators and gallery directors are not just sitting by the telephone waiting to hear from them. We have busy jobs with our

own stresses and strains. In a typical work day I have to think about funding, problems with the building—toilets leaking, junkies, reports for the Arts Council, feedback to staff and all the many other things I have to do, as well as the exhibition programme.

<div align="right">Anne McNeill, director, Impressions Gallery</div>

The curator is subject to numerous pressures, some of them welcome and some of them not recognized perhaps, to keep to safe zones of activity. The pressures include:

1. The desire to get along with the artist or artists.
2. The necessity to keep good relations with the artist's main dealer or dealers.
3. The necessity of maintaining collector contentment.
4. Taste expectations emanating from the trustees and director.
5. Taste expectations of other members of the curator's peer group.

<div align="right">Lawrence Alloway, *Artforum* (May 1975)</div>

Exhibiting should be an enjoyable process, but the relationship between exhibitor and gallery staff can be a delicate one and, for the exhibitor, working with a gallery can be a disappointing experience if the exhibitor does not recognize in good time that everyone involved in putting on an exhibition has a different timetable and set of priorities and that these may well conflict. If the exhibitor's previous experience has been of student exhibitions where everything has been done at the very last minute and the students create a close bond in the process, it may also be disconcerting to discover that gallery staff may keep a professional distance.

Understanding the different agendas of exhibitor and gallery staff makes it considerably easier to avoid problems and potential conflict.

Exhibitors have the priority of showing their photographic work in the best possible light. To do this, they will probably be prepared to drop most of their other work commitments, work very hard on the show, and stay up all night to write captions or hang the show if necessary. The exhibition may well be the highlight of their year; it will probably be the main focus of their life for a short, intense period, and they may well feel emotional and anxious about it. They may also expect a level of emotional support that the gallery staff does not give them. However, the major part of the exhibitor's work ends on the night of the private view or artist's reception, after which they have less to do for the exhibition and may plan to relax for a few days or turn their attention to a new piece of work.

The gallery staff, on the other hand, has a completely different set of concerns. Their job is to keep a rolling program

of exhibitions on track. Even if the current exhibition is a major part of their working week, they still have their daily duties to carry out, a busy telephone, and future exhibitions to prepare for.

Gallery directors will be concerned with the overall financing and running of the gallery. They may spend a great deal of their time away from the gallery and looking after the gallery's interests elsewhere. Once the gallery program is decided, the gallery director's priority is to get the show installed, publicized, and open on time. Making sure that the gallery is cleared up after the private view or artist's reception and open on time the next morning and planning to do the same for several other shows in the year can be as important as the quality of the work on the show. This may well not be the most important show of the year, and they will almost certainly not stay up all night to help hang it. Unfortunately, keeping the cleaner happy may be just as important to them as keeping the artist happy.

The priority of curators is the overall show, but they may be working on other shows at the same time. They have to keep each on schedule and keep everyone working well. If the curator works freelance, keeping on good terms with the gallery, with whom they might expect to work again, could be more important than keeping on good terms with the exhibitor. If they are working freelance, their time is crucial; they cannot spend more hours on something than they have budgeted for or take time from other projects. An exhibitor who starts phoning them at midnight because of an emergency is not going to be popular. They may put up with dramas for the sake of the exhibition, but will think carefully about working with that person again.

These differences should not be a problem but can often become so simply because everyone is working under pressure and there is not enough time to keep channels of communication open. The ideal for the exhibitor is to plan well in advance, to make sure to be clear about deadlines, about what is expected, and about who does what, so that, if misunderstandings do occur, there is time to sort them out.

Curiously, given that the relationship is one of mutual dependence, there is often a struggle for recognition and appreciation between artists and galleries. Artists frequently say, "If it weren't for artists, there wouldn't be any galleries," and gallery directors say, "If it weren't for galleries, there wouldn't be any artists." Both things are true of course, but

in practice the artist who thanks the gallery director for his or her hard work and support is much more likely to be invited to show again than the artist who expects to be thanked by the gallery.

LOOKING AT PRESENTATION AND CURATION

Photographers vary in their attitudes toward looking at other photographers' work; some find it rewarding and even sustaining for their own work, while others feel that it deflects them from their own creative vision. So why is it particularly useful to look at exhibitions by other photographers? It is a practical way to start thinking about exhibiting by looking at and analyzing how photographers exhibit and promote their work. In practice this can be quite a difficult thing to do. It can often take an act of conscious will to go into a gallery and look at the way the work is being shown rather than at the work itself. This is partly because our usual job as viewer is to start by doing the opposite: by being passive and wandering (apparently) aimlessly, postponing critical thought, and letting the work "speak" to us rather than analyzing the presentational methods and curatorial intent of the exhibit. In part, too, it feels like insisting on looking behind the scenes at the theater rather than at the performance itself.

However, an analytical look at a series of exhibitions can help prospective exhibitors approach making exhibiting decisions by themselves or to develop the knowledge and confidence to negotiate with gallery directors and curators over how to show their work to the best advantage.

The aim is for the would-be exhibitor to:

- see and understand what is current in the world of exhibiting photography with the intention of making a place for him- or herself within that world
- learn how an exhibition concept can be shaped to make a body of photographs cohere and communicate with the audience
- learn how other photographers present their work (for instance, in series or as a narrative) in order to acquire the same skill
- look at problem solving by photographers who are dealing with the same issues as the would-be exhibitor (this might include, for example, the use of scale, text, captions, or a light box)
- see which exhibition styles do and do not work and understand the possible pitfalls of exhibiting (for example, when too many images are shown or an installation is too complex)

In analyzing exhibitions it is useful either to take a colleague to discuss these ideas or a notebook in which to make

a record and draw diagrams of the exhibition layout. Gallery staff are sometimes very helpful and pleased to share information and insights about the exhibition. There are three main tasks in this process:

1. *Description.* Essentially this is to look carefully at every detail of the exhibition presentation and record or describe it. The description should be as detailed as possible.

 First look at and—crudely—categorize the types of photographs shown. Are they journalism, documentary, landscapes, portraits, architecture or urban landscapes, abstract or graphic, autobiographical or personal work?

 Then (and I hate to suggest this) *forget the photographs* and look instead at the size of the images, the matting and framing of the images, the size and color of the mat in the frame around each photograph, the amount of wall space between photographs, the sequence and flow of images, and their layout in the gallery. Also look at the lighting, the captions, and text used. What information is provided about the photographer? What information is provided about buying photographs? Are there leaflets or other information to take away? Look at the audience: How have they made the journey into the gallery? Is the door open and welcoming? Is there clear signage outside? Is the audience engaged with the work and following the flow of the exhibition? Make notes if necessary, and write down anything that seems particular to that exhibition or gallery space. For this list, the most crucial thing for the would-be exhibitor to note is the way the work is displayed and whether the audience is looking at it in any particular way (Is their attention held? Do they move around the gallery in a direction clearly dictated by the layout?).

2. *Interpretation.* The task here is to look at the reasons behind the choices the curator made in showing the work in the way it is done. Why are the photographs printed at that particular size? Could they have been shown in a different order? How do they fill the space? Do these particular frames complement the images, and can you imagine them in different frames? Could the exhibition have been lit differently? How do these choices, all of which will have been made by the curator, influence the way you, as audience, look at and understand the exhibition?

3. *Assessment.* The task here is to decide whether the various curatorial choices made help the photographs or not. Are there perhaps alternative or better choices that could have been made?

An example can be taken from "In the Face of History," a major exhibition of twentieth-century European photography shown at the Barbican Gallery in London. As part of two different sections of the exhibition, Ukrainian photographer Boris Mikhailov and the German Wolfgang Tillmans each showed a single wall of photographs. The two installations could not have been more dissimilar, and a comparison gives us a way to understand the curatorial choices made. Mikhailov's sixty-six photographs were shown in a very formal grid which formed a solid block of images that filled

the wall. Inside the block the photographs were subdivided into further blocks of two, three, or four photographs. Looked at from a distance, or seen diagrammatically, the display had a look of military precision, everything lined up precisely, and the grid looked both formal and regimented, almost like a diagram of an army drawn up before one of the great battles of history.

On the other hand, Tillmans's thirty-six photographs appeared to be placed on the wall at random, almost as if a high wind had blown them there by chance (although they were straight rather than at angles) and the placing was accidental. Some of the photographs were almost too high to be seen, others were so low that the viewer had to bend down, some were closely grouped together, while others just seemed to float in solitary space. Many were taped to the wall, apparently haphazardly.

A comparison of the works themselves, and particularly of their historical background, provides us with an explanation for these contrasting methods of display. Mikhailov's work, "Red" (1968–1975), is a satirical response to Soviet power in the Ukraine, so the layout echoes a sense of military discipline and rigid bureaucracy while the content of the images undermines and pokes fun at this formal arrangement. The message for the viewer, given in a way that will usually be perceived unconsciously, thus echoes the subversive view of the photographer.

Tillmans, on the other hand, started the work "Markt" (1989–2005) at the point that the Berlin Wall came down and the Cold War ended. The work as well as the installation, which is characteristic of the way much of his work is displayed, echoes the sense of new-found freedom of that period and, perhaps, of the freedom of his role as photographer.

An entirely different sort of exhibition design decision was made by my colleagues and me at the Tom Blau Gallery where we showed vintage press prints, most of which had been in circulation for many years. Some of the photographs are up to fifty years old and fairly battered. They are journalistic images intended for newspapers and magazines rather than exhibition, but over time they became interesting as artworks in themselves. To make it clear that we were offering these erstwhile press prints for reconsideration as art, despite their sometimes much-used appearance, we displayed them in the most formal and conventional way possible, with wide mats in simple and immaculate large frames.

Thus an interpretation of the work and the context in which each work or piece of work was made helps us see that each installation design is appropriate to the work and, although the audience may not be consciously aware of this, their appreciation will have been assisted and enhanced by the way the installation reinforced the understanding of the photographs.

In his useful book *Criticizing Photographs*, Terry Barrett points out that in looking at photographs and photographic exhibitions from a critical perspective, there are four main activities: describing, interpreting, evaluating, and theorizing. A would-be exhibitor can use the first three activities to develop a sense of what does and does not work in an exhibit. (Barrett's fourth category, theorizing, which he subtitled "Is it Art?" is less relevant here since, by and large, the gallery itself, as an art gallery or a photography gallery, will make that statement on behalf of the work shown.)

It is worth noting that this method will not suit everyone. Some photographers find they need to ignore what everyone else is doing if they are to focus on and develop their own work without either imitating other photographers or becoming intimidated or self-conscious. But for most photographers, looking at how photographs are presented to an audience and carefully examining the decisions behind the presentation are useful exercises which broaden their understanding of how an audience might see their images. So, for photographers who wants to start to exhibit their work the first step is to take a little time to think about the transition from making photographs to showing them, to study the world of exhibiting, to equip themselves for approaching galleries, and to think about what sort of exhibiting career would best suit them and their work. The next chapter will look at how to find that first exhibition.

Photography and Museums

There are large numbers of photographs in museum collections. Many of them are in storage and not on permanent display and hence go largely unseen by the public. It is therefore easy to forget how important museums are as a resource for the collecting, conserving, and displaying of historical and contemporary photography.

Those museums that concern themselves with photography do so in different ways and with different aims. These can be summarised as follows: There are museums (possibly the majority) which collect photographs as an important source

of documentary evidence of the past. This evidence will often serve to inform the rest of the museum's core collections. Other museums might choose to specialise in the historical development of photography as a technical and scientific pursuit. Here the photograph is collected alongside many other artefacts that constitute evidence of this development (e.g., Fox Talbot Museum). Other museums meanwhile value the photograph as Art rather than artefact (V&A), emphasising its historical and contemporary aesthetic role. Finally there are museums that try to cut across these boundaries and present all these aspects of photographs and photography (National Media Museum, Bradford).

Within these broad tendencies, museums each have their own specific collections policy that defines exactly what they collect and why. Firstly this helps to limit what can otherwise become infinite in scope; secondly it focuses a collection within the identity and core mission of the museum. A photographer can certainly donate work to a museum, and the best way is to research a museum's collections policy so as to find the best match for the donation.

However, even within such parameters, collections in some museums can still amount to many thousands of photographs. This clearly limits how much access the public can have through display, and although some museums have made selections of photographs available online (e.g., Museum of London), this is not yet standard practice across the whole sector. Formal appointments are still frequently necessary for anyone wishing to see collections.

So how do museums display photographs? The rationale behind the collection will largely determine the approach to display. Photographs as historical evidence can be used in an infinite number of ways. Most obvious is their function to create a context for objects, or simply prove a fact. More complex is the subtle use of photography to carry forward a narrative, or touch the visitor emotionally. Whatever the intention, photography is used to its best advantage when imaginatively combined with artefacts and multi-media in the staging of an exhibition. Compare the use of photography in the following exhibitions: 1) The Holocaust exhibition (Imperial War Museum, London), where images are blown up to create large life-size backdrops. These serve to surround the visitor with the stark realties of the political context, and also reinforce the terrible human scale of genocide. 2) The touring exhibition "Anne Frank and You" (Anne Frank Trust project) where small photographs of the Frank family are laid out flat in wall recesses. This informal and self-effacing display tells us something of the Frank family story before WWII, but also allows a movingly intimate dialogue between past and present, as the visitor stands so close to these fragments that seem to have just fallen out of an album. Meanwhile other images are exploited in touch screen interactives as a learning device.

Although they deal with similar subject matter, both exhibitions use photographic images in very different ways to very different effect. One similarity however lies in the emphasis on the visual content of the photographs and not their authorship. The authors may not be known, or if known, the fact is secondary to the photograph as documentary evidence. In a similar approach, the selection of photographs on the Museum of London website is grouped thematically according to subject matter, and not according to author, although of course full authorial details are always acknowledged and available.

There is a different emphasis at exhibitions where photography is treated as Art. A case in point might be the Che Guevara exhibition at the Victoria and Albert museum (August 2006), where the portrait of Che by A.D. Korda took centre stage, and its impact and legacy as a significant cultural icon was fully explored.

As authorship can be emphasised to varying degrees depending on the objectives of a particular museum or exhibition, so can the photograph's "authentic" value. Museums have a certain dilemma with photographs, as they have traditionally placed higher value on "original" artefacts and little value on the reproduction or fake. As Walter Benjamin pointed out in his essay "The Work of Art in the Age of Mechanical Reproduction" (1936), photography challenges this notion as there is no original photograph as opposed to a reproduction. Or, to put it another way, every photograph is a reproduction. Where museums can be clear about "original" value is in their collections of "firsts", e.g., first photographic plates or first versions of new processes by early pioneers in the history of photography.

Conservation and documentation are also key to what museums do: all acquisitions have to be stored according to standards that ensure minimum deterioration of materials, and they have to be documented and catalogued in such a way that information is always up to date on what there is in a collection, and where it is. This is particularly important when museums wish to loan objects to other institutions—an activity that is encouraged by the sector to allow maximum public access to collections.

So museums are important to photography, and given the rich and complex resource that it represents, photography remains very important to museums!

Mira Shapur, Exhibition Consultant

Case Study One:
The Degree Show

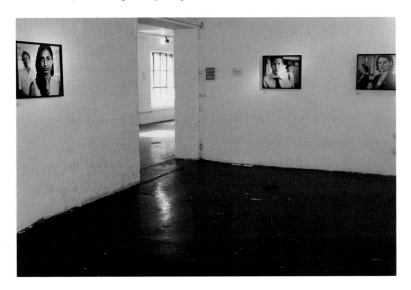

Recently I completed a part-time, two-year M.A. program in Photographic Studies at the University of Westminster. The academic year started in September and ended with a final show in September two years later. Though we had the option to write a thesis, all twenty-four full- and part-time students in my class decided to do a visual project as their final work for exhibition in September. The work would be marked/graded as it was presented in the exhibition space.

As a part-timer doing the course in two years, I had seen the previous year's students organizing their show and

noticed a few issues and difficulties. Since starting late was something they had complained about, I felt it was very important to start at the beginning of the new academic year. So in October I arranged for us to meet each week to discuss organizing the show. As a group we identified all the areas that we needed to work on: web site, finance, venue, sponsorship and press, and curation. But soon it was apparent that our meetings were poorly attended, there was a lack of motivation, and nothing seemed to be getting done. There were many issues I had overlooked that made starting at the beginning of the year difficult.

Looking back, I can see so many things that, had we known and thought about them in advance, would have been very helpful. But I suppose the first time you organize a group show it's always going to be a big learning experience.

There were quite a few factors that affected students in the early part of the year. Because half of the students were full-time and half were part-time, at the beginning of the final year some students had already been in the course for a year and others were just starting. In many cases this meant a big difference in experience, but for all full-timers there was double the workload; and in the early days full-timers were just finding their way around the campus and figuring out what was expected of them in the course. Also, many students not already living in London had to deal with living in a new city. Many were new to the country, and a few had additional struggles with the language. In the early days, if a student was very quiet it might have been because he or she didn't wish to comment—or he or she might have had problems understanding other students and so didn't want to say anything.

Though there were some full-timers who had a lot of relevant experience, in the early days it sometimes felt like the part-time, two-year students had to wait until the full-timers could adjust and catch up and understand all the factors that affect putting on an exhibition. It's a tough choice to decide whether to organize the exhibition anyway and let them catch up, or wait until they have settled in and have more experience and a consensus can be achieved.

In our course the final project is begun in the second year, so one issue that affected almost all students was the stress of deciding what their project should be about. Some students took a long time to decide, and some changed their minds on subject matter and treatment a few times. It can

be difficult to organize an exhibition without knowing what work will be shown in it. I think this affected motivation in the early months, with priority and time being put toward individual projects. However, it should be possible and is good practice to start early even when you don't know the types of images to be included.

It's important to remember that every person involved has had different experiences and will have different ideas and ways of doing things. This is really what you have to cope with when you're organizing a group exhibition. There are times when it can seem frustrating, but there's a lot to learn from it: others have different ways of doing things that you might find useful, and they may have solutions to problems you never even thought of.

Another factor to remember is that each student wants something slightly different from the exhibition and from the process of organizing the exhibition. This affects students' decisions (for example, what kind of venue, in what part of town) and how much time they put into organizing the exhibition and what they are prepared to work on. You're only going to be disappointed if you allocate a task to someone who has no interest in or benefit from doing that task. In the main, people only agreed to work in areas they wanted to gain experience in, such as curating or marketing, so that there remained other jobs that just had to be done by people who hadn't contributed already, such as invigilating or staffing the exhibition. Some students had heavy work and home commitments, which affected how much they could contribute, and some students contributed considerably nonetheless.

I've been told recently that no matter the size of the group, a quarter of the students do the vast majority of the work and about 10 percent turn up on the day of the exhibition just to hang their work, having not contributed at all. If you are someone who wants the exhibition to succeed, you have to get together with other interested students and get on with it.

Initially group discussions revolved around finance. We knew the university gave money toward the final show, which often went toward hiring the exhibition space, but we didn't know how much we could afford. I think we made a big mistake here: we wanted to know what funds we could expect from the university so we could then see what venues we could afford. I have since been told that it is advisable for students to do their research, put together a proposal, and

pitch it to the university. It should outline what the plan is and how much it will cost and should emphasize why it's such a good idea. Universities may have limited resources, but if you put together an inspiring plan, which will be good for the reputation of the university, they may find additional funds to support the plan. This is generally what has to be done in the "real world" after university, when looking for funding for an exhibition. Anyway, it is a good idea to complete this proposal by about three months in, so that there's time for debate and you can make alternative plans if you haven't got the funds for your first choice. In London, gallery spaces get booked six to eight months ahead, which is another factor to remember.

We kept asking for a budget figure and then we waited. Finally we realized that if we didn't book a space we would lose out, so in the new year we started looking at venues and based our budget on what the previous year's students had been allocated. We still had little or no idea of what the photographic work in the exhibition would be.

Finance in general was a contentious subject. In many courses the students have to contribute toward some of the exhibition costs, including venue, invitations, opening night costs, and catalog, but students have different financial situations. In our group the majority wanted the costs for the venue to be entirely met by the university's funds. Many had tight financial situations and couldn't risk footing the bill if sponsorship wasn't forthcoming. Yet it was difficult to promote our exhibition to sponsors when we had no idea of what the show would be like.

Once it was agreed by the students that university funds would cover the venue costs, there were other costs to consider: invitations, web site, catalog, and so on. How much people were able to contribute varied, but we had to find a figure for individual contributions that everyone could agree to. The amounts debated ranged from about £25 to £100 per student; the higher figure was considered unacceptable by many. We agreed that everyone would pay £25 to get us started.

Putting on a show is an expensive business. Besides group costs, students have to find the money to pay for their own production costs, such as printing, mounting, framing, and projector hire, which can be very expensive (from a minimal several hundred pounds to an average thousand pounds and occasionally several thousand pounds) while still paying tuition fees and living costs.

When looking at venues for the exhibition, we decided we wanted a space where everyone could show a reasonable amount of work—say, six or eight in a series rather than just one image each—so people could represent their projects more fully. Eventually we found a really amazing big space with about a dozen separate rooms so work could be shown in groups. It was in central London, which would be good in terms of attracting visitors, but with our budget we could only keep the show up for a week. It was such a good space that getting everyone to agree on it was relatively easy (that is, once everyone got around to going and visiting it). We reserved the venue for the dates we needed. In March the university budget was confirmed, so then we started to organize the contract and paperwork required to book the space (which included a risk assessment for every student's work).

We made decisions by voting, usually online through a Yahoo! group, as we couldn't get everyone together at the same time. We had set deadlines for casting our votes, and decisions were made by majority rule on that date. There were times when we made decisions in meetings, but because this was not the norm, there were sometimes arguments about these decisions later. It's important that it be made clear well beforehand that such-and-such a meeting is when a particular decision will be made (and if you don't turn up you don't have a say). Decision making and debates usually raged on for ages, took up a fair amount of time, and were often quite annoying, but I don't see how this can be avoided.

Encouraged by the course tutor, we picked a title for the exhibition in mid-March. Of course, this had to be fairly all-encompassing, as students' work was far from settled.

With five months to go and only the title and venue chosen, we lacked focus for organizing everything. Eventually some students offered to organize the group. If they hadn't done this, things would have been tricky. At this point several people realized that something had to be done, because if we didn't get started, nothing would happen.

Around April we started work on the invitation. The invitation design caused some arguments because several people said they had friends who would probably design it for free, and then someone else said we could probably find them a bit of money for it, and this was taken to mean that a particular person would be paid. In the end the first design was not popular, and it was redesigned by someone else, for free.

But arguments about whether the first person should be paid went on for months. Ideally we should have had made it clear that no money would be committed unless it was put in writing.

The appearance of the invitation was relatively straightforward; we just had to agree on an image and the design. This took a bit of time but wasn't difficult. The invitations were delivered three weeks before the show opened. They were sent out by the students to the university's list and to whomever the students chose to invite.

We began to organize the web site in late April. It was designed and set up by one of us, so we just had to pay for the address/server. Initially we paid for just one year, but later changed to another company and a much longer period: the web site can continue as a reference point long after the exhibition and course is over.

Getting everyone to submit a statement and an image for the web site was excruciating, partly owing to students not getting around to it, but also because most didn't have final images yet and some hadn't even finalized what their project would be about. In fact, though, the web site worked as a catalyst, focusing everyone: images and text were uploaded as they came in, and a blank web page with their name on it seemed to encourage many to submit material, even if it would be changed later on. From this time until the show opened, students changed their images and text on the web site repeatedly; I thought the people handling the web site were saints to put up with it.

Looking back, the web site could have been set up at the beginning of the year. Although students don't know what their final project will be, they can still have their own page with images from previous projects and a link to their personal web site or blog if they have one. An early web site would be useful for showing to potential sponsors (a kind of proof of existence), good promotion for all the students, and is flexible enough to be updated with new images and text as projects develop.

We started looking for sponsors very late, with less than four months to go many avenues were already closed. A press release on the web site was an efficient way to inform potential sponsors. We started off by contacting a list of banks and similar institutions, but they were only interested in giving to their own designated charities. We then approached companies that were in the vicinity of the exhibition venue, and in a couple of cases we were just a bit too

late and the company had already committed its charity budget for the year. We then concentrated on companies associated with the photographic industry and drinks/alcohol suppliers.

Despite the many protests that students couldn't afford to contribute towards the exhibition costs, very few found sponsorship instead. It's worth noting that sponsorship was only gained through students' own personal contacts or employers, and the only sponsor was a large supplier to the university. Two students found financial sponsorship, one gained sponsorship in kind for projectors for showing digital work, and one arranged for food for the private view.

As we didn't get any sponsorship for drinks at the private view, we paid for them ourselves: around £300. We planned to cover the cost by asking for donations on opening night, and in the end we did cover our costs. We were lucky that the private view was very well attended.

Another feature we had to work on was a catalog to go with the exhibition. From the beginning there had been a lot of debate on whether or not to have one, particularly as it would be costly. Some felt the catalog would be all that remained after the show was finished and it would be a permanent record; others didn't mind having one as long as they didn't have to pay or do anything for it.

There were about six students who really wanted a catalog, and eventually enough others were persuaded and some student contribution was agreed to. Initially we paid £40 each, though after catalog sales at the exhibition, everyone got £12 back. We covered the rest of the costs through the financial sponsorship, in exchange for advertisements in the catalog and on the web site. Without the university supplier's contribution, we would not have been able to do it. Our choices of cover and paper type were entirely dependent on cost. We printed 1000 copies of 60 full-color pages for £1802. However, with printing technologies changing all the time, cheaper deals can now be found.

The production of the catalog was very hard work, and throughout the process students changed their minds about their images and text. One of the students designed and produced the catalog with the assistance of one of the course tutors. The course tutor must have spent about five working days on it, and the student probably spent at least three full weeks on it. It was sent to the printer two weeks before the exhibition opened. The layout had been completed earlier, but printing was delayed while we tried to find more money.

The catalogs were delivered the day before the exhibition opened.

In May it was agreed that three students would oversee the curation of the exhibition. They did an excellent job. We had a massive space with eleven different rooms and twenty-four students with very different kinds of work. Almost everyone was happy with the space he or she got. Exhibition plans were initiated by making floor plans of the space and asking the exhibitors what size they thought their work would be—three 10×8 s or eight 20×24 s or a large screen in a darkened room, and so on. Slight adjustments for technical reasons had to be made on the day the show was put up, so a flexible attitude was important. In the end, the show looked excellent.

About a month before the exhibition opened we organized press for the show, which should have been started at least a month earlier—or three months earlier if we had hoped to get in monthly publications. We were lucky that the gallery had a press list, and we were put in all the major listings guides. We also sent press information to all the London photographic galleries and emailed all the different arts sections of the various newspapers. I emailed press information three weeks beforehand, one week beforehand, and on the private view day, as a reminder. Not surprisingly, there were no reviews, but it was still worth trying.

It's important to remember to invite representatives from your industry. We needed to encourage gallery owners and curators. I hadn't realized that besides emailing them, you need to contact them individually to remind or persuade them to see your show. A tutor suggested this the night of the private view, and as our show was only open Thursday evening, Friday, Saturday, and Sunday, it led to some fairly frantic telephone calls. It was short notice, but in the end we managed to get an extra six or so gallery owners to see the show by delaying the takedown until Monday. This is definitely something to start work on at the beginning of the year. If there are students who are serious about what they're doing, they should make contact with industry representatives much earlier, with the aim of creating a relationship and getting them to attend the show. You'll need these contacts for the future.

The exhibition was due to open on Thursday evening, and we had from Tuesday morning to hang the show. We began by bringing in a large number of flats to create extra surfaces to hang work on, and students worked together to carry them

in. Everyone had an allotted space according to the curators' floor plan, and with the exception of a few particularly helpful people, generally people arrived in their own time, put up their own work, and left. Ideally everyone would have helped each other. We had a huge amount of support from two technicians from the university, who did a fantastic job. They were excellent at carpentry, electrics, hanging work, and much more; without them, we'd have been in real trouble.

We had one major problem in hanging the show, which can be attributed to miscommunication. A student had been assigned a "distressed" wall although he insisted he wanted his work to be on a white wall. So, without checking first, he painted this "distressed" wall with a strip of white. The gallery was furious, and a lot of arguments ensued about how much it would cost to return the wall to its former condition and who should pay for it. It's a good idea to make clear to all students in advance what they can and can't do with their space, and if they do something without checking first, they may well have to pay for it.

There are many things that need to be done just before and during the time of the exhibition. This is hopefully when people who haven't contributed earlier will come forward to help out. In our case, for example, the drinks and food for the show had to be collected, work from the university campus transported, gallery information sheets photocopied, posters put up, and leaflets to be handed out in the local area. The exhibition must be staffed whenever it's open with at least two people at any one time, probably more if you have more than one room or floor. Ideally those on floor duty will hand out information, keep a note of attendance numbers, and be friendly to visitors—you never know when an industry representative might turn up. During our opening night, we had someone at the entrance and three people helping on the bar. We had ex-students and friends doing this to take the pressure off us.

But after all the angst, the show came together and looked good and completely professional. The private view was packed and went very well. It was a great way to celebrate the end of the course and invite friends and family and anyone else who had helped or contributed to the work. When considering numbers to invite, it's sometimes important to bear in mind that overseas students may not have many family and friends visiting.

The next day, one of the students photographed the exhibition so that there would be a record for everyone. This is

definitely worthwhile, as it's the only evidence you have to show how your work was presented.

Throughout Friday and over the weekend, we had a very good walk-in rate. There was a festival in the area of the exhibition; without this it might have been pretty quiet.

After a few gallery owners came around on Monday morning, we all took our work down, which seemed very quick compared with putting it up. Normally you have to make sure the space is returned to its previous condition when you leave, but we had done quite a bit of cleaning, tidying, and painting, so it was in pretty good shape.

It's been about eight months now since the show, and time enough to reflect. For many it was a good experience of producing work and showing it. For others, having their work up meant they got useful feedback from a wider audience, encouraging them to continue their practice. Many of those who helped organize the exhibition got good experience for future events. Some students did get some work and interest from galleries because of the show, but this is unusual. If you want to get noticed in a show, it really is up to you to get to know and invite people who could be important to your future. After the show's over, you'll have some great experience, but you'll have to go straight out and start showing your work on your own.

I think it was an excellent experience of what happens when you organize a large show, with a large number of people in a reasonably democratic way. For an emerging artist who is often in group shows, this was very relevant.

Leila Miller

Finding an Exhibition Space

FIGURE 2.1 Untitled from "inward bound" 2006, 30 × 40 inches c-type. Image © Esther Teichmann

ARCHIVAL CONCERNS

For the working photographer and exhibiting artist, the issues of printing, storing, and presenting archivally sound prints can be a potential minefield. As the market for sales of photographs grows, so too does the demand that prints be produced and presented to high archival standards. Corbis may be able to store analog prints in a deep, secure, environmentally controlled vault, but most people have to make do with

much less costly solutions and with advice that changes as this area of knowledge expands.

Archivally processed and washed prints, properly stored, should last at least thirty years before showing signs of deterioration. Any print that is to be sold should be produced to archival standards. Continuing improvements in the permanence of digitally generated images, such as the use of pigment-based inks and non-plastic archival papers, now make it possible (as was not the case ten or so years ago) to produce prints that can be expected to last. However, since this can't be tested except by the passage of time, it is not yet possible to guarantee permanence, despite the claims of some suppliers.

Having said this, it might be useful to add that I spent some years working in an archive where black-and-white press prints, which were up to fifty-five years old, had been roughly handled and stored, upright, in ordinary cardboard boxes in a large loft where the temperature and humidity were not controlled. It was hot in summer and sometimes damp in winter. As I worked through the storage boxes, the worst deterioration I found was almost always from inadequate fixing or washing of the print when it was made and from rough handling since then. However, color prints are much more vulnerable than black-and-white.

In the Victoria and Albert Museum's Print Room in London, vintage prints are available to the public for study purposes. They are stored in shallow print boxes which hold between ten and twenty mounted prints. Each photograph is mounted in a hinged, window-matted mount with a sheet of acid-free paper held between the two layers of the mount. Although the prints are different sizes, all the mounts are the same size, usually considerably larger than the print, and sized to fit the boxes exactly, in order to limit movement in the boxes. Typed sheets of extended captions and information about the images are stored separately in clear archival envelopes. Students can study these without using gloves (under the very watchful eye of an on-duty staff member) because they are only handling the mounts. To anyone thinking about print storage, I recommend that you visit a museum that offers comparable study facilities and that you study the storage systems as well as the prints.

However, the storage method of the Victoria and Albert Print Room, although good, is a slow way to look at prints because the mounts can be unwieldy and the paper needs to be removed first. A quicker method is used by the Print

Room of the Photographers' Gallery in London which, at an event such as Photo London, shows contemporary prints unmounted in clear, acid-free sleeves stored in boxes. This means that no one has to wear gloves, that anyone looking through the box can handle the prints in the sleeves, and that the prints are immediately visible and can be seen at their best. They use more than one size of box, and a box may contain up to about thirty prints. Each print is on paper that fits the box size exactly, accommodating one set that has no borders and another with borders of varying sizes. Each set is printed and oriented in such a way that the images can all be viewed without turning the box.

STORAGE

Most papers, cardboards, plastics, and woods contain pollutants that can seriously damage or degrade emulsions over time. Fabrics, paints, glues, and all sorts of everyday products can also be damaging, as can damp, salt air, humidity (high or very low, though high is the worse danger), heat, dramatic temperature change, and airborne pollutants.

The perfect storage environment is to be found in museums where controlled air-conditioning keeps temperature and humidity consistent. For most people this is not a viable approach, and so the best option is to take the following precautions:

- Consider investing in a single storage system, buy supplies in bulk to set it up, and stick to that system rather than deal with the issue piecemeal.
- Select a permanent site for storage that is not damp or subject to extreme temperature change. Try to ensure that it is cool, well ventilated, and dry, and keep prints away from direct sunlight.
- If possible, test for humidity with a relative percentage humidity thermometer. If the humidity is higher than 60%, either store your work elsewhere or buy a dehumidifier.
- Make sure that everything you put into storage is clean and dry.
- If necessary, clean dust from images gently with a well-washed, soft, lint-free cloth (old silk scarves or print-handling gloves work well) or, if mold is beginning to appear, use a film cleaner before storing them.
- Store negatives in specialty envelopes which may be made from uncoated polypropylene, polyethylene, or archivally processed paper.
- Store prints in specialized boxes made from archivally processed cardboard, with corners that are either folded or held by metal rather than glue.
- Make sure these prints are not in contact with each other, either by keeping them in archivally sound clear envelopes/sleeves such as Secol or by interleaving them with acid-free paper.

- Don't mix sizes of print or mounted and unmounted prints in a storage box because when the box is moved, a print or mount may shift and so damage another print.
- Ventilate stored materials regularly by opening boxes and files for a few hours a week.
- At the same time, check for insect damage—moths and beetles like to eat emulsions. The best deterrents are cleanliness and good ventilation, which discourage them. Chemical insect repellents should never come into contact with photographic materials but may be used to scent the air. Lavender oil can be used in the same way.
- Wear white cotton gloves when handling prints unless they are already protected in mounts or acid-free envelopes.
- Old metal storage cabinets are better than either wood or modern metal cabinets because modern paints may emit gases. Old cardboard and leather boxes and cases should be avoided. Wood can be sealed with water-based polyurethane varnish, but this needs to be carefully done if plans chests are used.
- Consider making a digital backup copy of both analog and digital material, using memory cards, CDs, and/or hard drive disk storage, just in case.

HANDLING

Prints should be handled as little as possible because of the grease and other contaminants carried on even the cleanest pair of hands. Alternatives are to use white cotton gloves, to store prints in clear conservation envelopes, or to keep prints in window-matted mounts. None of these is perfect. The gloves are usually fairly crudely made, so may make the handler feel uncomfortable and clumsy; conservation envelopes and window-matted mounts look good but are probably too expensive for most photographers to use for all their prints. One answer is to store prints between sheets of acid-free paper and only put them in clear sleeves on a temporary basis when they are being considered for exhibition or publication.

DAMAGE

If you already have damp or damaged prints, put them into a cool, dry, dust-free, and well-ventilated space for several months to dry before risking further damage by handling them. If they are important, then consult a specialist.

CAPTIONS

Including conservation and archiving information in a picture caption is now becoming a norm. At Photo Paris in November 2006, few of the galleries included this information. At Photo London in May–June 2007, all the exhibiting galleries included it.

TO SUM UP

- Prints should be processed to archival standards.
- Prints should be handled as little as possible and with gloves or clean hands.
- Prints should be kept out of contact with other prints, papers, woods, and so on, which means protecting them with acid-free papers or conservation sleeves.
- Prints should be stored in acid-free boxes in a controlled environment.
- Prints should be mounted on acid-free or rag board.

WHERE TO START WITH LOOKING FOR AN EXHIBITION

Where does a photographer start with the complex business of looking for an exhibition? It may seem like a contradiction, but the best way to start thinking about exhibiting is often to stop thinking about it for a time. Many photographers hurtle too quickly from making photographs to trying to exhibit them, which is not always the best way to approach exhibiting. There should be a gap between making work and presenting it to others, during which time the photographer learns to understand the work all over again—from the perspective of an audience—and an exhibition concept takes final shape.

Ori Gersht describes the way many artists make work: "With my photographic work I don't make too many plans, I just have a framework; and then I want my intuition to inspire the work. If you take an overly intellectual approach I feel the work becomes too illustrative and didactic." The same processes shape making an exhibition as making photographs and trying to foresee an outcome, whether in the shape of an exhibition or a finished piece of work, can be inhibiting for most people. Artists have to feel free to trust their instinct and follow where it leads, even if it takes them away from the original idea that motivated the work in the first place. In the same way, they may not see exactly what they have been doing until a project is finished, or nearly so, and they can stand back and look at it with a level of detachment, almost as if someone else made the work.

This is a step that many less experienced photographers neglect, and it is a mistake. Until relatively recently, most photographers had good darkroom skills and simply by spending many hours making prints came to know their work intimately in a way that is not always duplicated by contemporary technology. Photographers need to understand their own work from the inside, rather than rely on how other people see it. The only way to do this is by spending

time with the work, studying it, whether consciously or unconsciously. Diane Arbus did this by covering her walls with photographs by other people as well as her own work: "I like to put things up around my bed all the time, pictures of mine that I like and other things and I change it every month or so. There's some funny subliminal thing that happens. It isn't just looking at it. It's looking at it when you're not looking at it. It really begins to act on you." (From Diane Arbus Revelations, Victoria & Albert Museum, London, October 2005–January 2006. Photographs and other items as they appeared on the wall of Diane Arbus's apartment, circa 1970.)

William Eggleston's approach is to avoid looking at other people's images, probably for exactly the reason that Arbus *did* look at them. Her desire was to absorb them, while his is, most probably, to avoid doing so: "I don't look at other photographs much at all. I don't know why. I study my own a lot. I'm just not drawn to wanting to look at other people's images."

There are very many different ways for photographers to study their own completed projects, and many photographers create a specific method that suits them. I would suggest that the simplest and most efficient method is to devise a hanging system in the home or studio, which means that the photographer lives with the work for as long as it takes. Different ways I have seen this done include stringing lines of prints across the room or attaching battens to the wall from which photographs can be hung using photo-clips or bulldog clips. Some photographers work with small prints in books, like an artist's sketchbook. Others use clear-leaved books, designed for family snapshots, in which small prints can be arranged and then rearranged. I advise always working with actual prints rather than on a computer, as colors and tones on a computer can be misleading and not match final prints. Just living with prints and studying them in whatever way suits the photographer helps to clarify the work again, understand which images are successful, which are the key images and which should be discarded, where there are repetitions, and how different photographs or combinations of images work together.

This next step usually takes time. It is about making the transition that transforms the work from a collection of images into a coherent exhibition. Sometimes it can be a quick and easy process because the photographer has been so close to the work for so long that by the time it is

complete, there is little to do to make it into an exhibition. But it may take longer for the photographer to make the leap of the imagination that will transform the work. Or it may require the intervention of a close colleague or curator who can bring fresh insights to the work. Sometimes it means going back and making additional images. But it is crucial that the photographer does this piece of work to shape an exhibition concept or proposal before approaching a gallery.

EDITING WORK

In terms of young art students, I think they need to develop a point of view and then fully work through that idea. Sometimes we look at work by young artists and they are all over the map, so to speak. It's a disparate body of work. What we're interested in when looking at young work, is that a photographer has taken an idea and really explored it.

> Katherine Hinds, curator of photography, Margulies Collection at the
> Warehouse, Miami

Photographers who can edit their own work well are rare, and they also tend to be the best image-makers. A clear understanding of why images are being included is imperative. Too often photographers include images because of some anecdotal reference.

> Michael Mack, managing director of Steidl and co-publisher of SteidlMACK

Editing is extremely difficult. It's taken me a long time to learn how to edit. Teaching has helped me a lot with editing. One of the ways I teach is to assign my students work and then edit their contact sheets with them every day.

> Mary Ellen Mark, photographer

If someone says they can't edit their images, I normally refuse to see them. I also prefer to see images from a project the artist is actually working on, rather than images from ten different projects.

> Dr. Inka Graeve Ingelmann, head of the Department of Photography and New
> Media, Pinakothek der Moderne, Munich

I do a first choice from contact sheets and then do many, many work prints. From that I then choose an average of six images per film. Then I reduce it down to whatever is needed.

> Sebastiao Salgado, photographer

Before any exhibition idea or portfolio is presented, it is usually necessary to edit the work. This means reducing the number of images to be presented and sequencing them. Many photographers find it difficult to do this or to accept the notion that work will look stronger, rather than weaker, when fewer images are presented. But it is an essential skill

for exhibiting photographers to acquire if they want to retain control of their exhibition work since, if the photographer doesn't edit his or her own work, someone else is likely to do it and that person may not understand the work as well as the photographer.

However, editing work is a skill usually learned over time and through practice. It necessitates developing and trusting one's own visual sense of how images work together. It can also be learned by working with curators or picture editors who have developed these skills over years. For some it is best learned as part of a group discussion of the photographs, of their possible readings, and of what does and does not work. Looking at exhibition and magazine selection may help sharpen this skill, though some people will find doing this no help at all since the exhibition or magazine is evidence of what has been edited in rather than of the whole before-and-after process of editing. An exercise in editing can also be devised by cutting out all the images in a magazine and then editing them into a sequence or story.

Many photographers find it much easier to edit other people's photographs than their own because they have less emotional attachment to them and so can more easily see the way a set of images will work when edited. Most photographers find that they are attached to particular images and are reluctant to lose them from an exhibition selection. Unfortunately, this is often because of the circumstances in which the photographs were taken or the difficulty of taking the image rather than because the image works well. If one image has taken a day of very hard work to produce while another is almost accidental or the product of an inattentive moment, the photographer is likely to prefer the first, regardless of the fact that the second may be more interesting or more relevant to the planned exhibition.

Working with a group of photographers is one of the best ways to edit work because most photographers enjoy the process and are prepared to discuss and analyze photographs in great detail and to persist with an edit until something satisfactory emerges. The photographer can learn through this discussion but will also need to learn to stand up for his or her ideas and preferences since there can be a danger that the edit will be too simplistic or, occasionally, unsympathetic to the photographer's intentions—although most groups are very good at taking their lead from the photographer.

The best starting point is usually to put all the photographs out on a very large table or on the floor or wall, if that offers

more space. If the images have a sequence, either of the order in which they were taken or in which a narrative is intended to develop, then they should be put in that sequence as a starting point.

It can also be useful to number them, simply to be able to keep a record if necessary. Most people can remember sequences and juxtapositions visually for only a short time.

The next step is to look at the images slowly and carefully until you know each quite well. Look first for the things that hold a set of pictures together, which may be a narrative, a chronology, or an aesthetic, technical, or stylistic thread. Then look at how the images might fall into sequence, how images repeat one another, and which, if any, are the weaker images. Effectively you are looking for the qualities that hold a set of pictures together and editing out images that don't fit. This may mean losing individual compelling images that do not work with the rest of the set.

Once you are familiar with all the images, there are different ways to start editing; personal preference will dictate which one you choose. The choices are to start by playing with the images, to start editing images out of the selection, or to start by editing images into the selection.

Just playing with images is a good place to start. Experiment by moving them around and putting images together, making pairs and small sets. This will help determine which images work together and which don't. Gradually, through doing this, a sense of the shape of the overall edit should emerge.

Editing is sometimes best done by taking photographs out of an initial large selection. Images can be removed because they don't hold the attention, repeat other images, are technically weak, or don't quite fit, visually or narratively, with the set that is emerging. Each time an image is removed, the set should be checked to make sure that the right decision has been made and that the set looks stronger by its removal.

The other way to do this is by selecting a small number of key images. These will probably be the strongest images visually and will carry the message or theme of the exhibition. This theme can then be built up slowly with the addition of images to the set of key images. Once again, each time an image is added, the set should be checked to make sure that the right decision has been made.

There are many ways to approach sequencing work. An obvious way is to follow a chronology. This need not be true

to the original order in which the images were shot but simply a device so that, for instance, the set of images starts in the morning and ends in the afternoon. Or a narrative thread may emerge when, for instance, the first image sets the scene or is an establishing shot, the next moves in closer, the story unfolds, and then a final shot seems to sum up or end the narrative. Color, graphics, or composition may suggest a sequence. Or something as simple and obvious as height in a set of portraits or distance in a set of landscapes may mean that the portraits can be placed from small person through to tall and landscapes from distance to close. Often what makes a sequence work is something very simple.

If you are an inexperienced editor, it may be necessary to leave the process and return to it later if it suddenly stops making sense and you become aware that tiredness is affecting your decision making. The crucial thing to do at the end of this process, even if the edit is not finally resolved, is to make a record (using the numbers on the photographs, a photograph, or drawing). When an edit is achieved, it may feel entirely right and as if the photographs can only be in that one sequence. But, unless it is recorded, there is a good chance that you will forget the sequence and you may have to start all over again later.

A curator, who brings an entirely fresh vision to an edit, may later want to re-edit the work and may start again from the beginning of this process. However, the photographer will be in a much stronger position to discuss the work and contribute to the process, having been through an edit already.

PRESENTATION

My advice would be not to follow fashions in presentation but make decisions about scale, framing and so on that best suit the work.

John Gill, director, Brighton Photo Biennal

The big prints—you have a physical reaction. The others you probably study more carefully. You read them. You go close—you look at the details. You step back— you look at the composition. It's a back and forth which the bigger prints probably do not have.

Thomas Weski, chief curator, Haus der Kunst, Munich

So the challenge with photography when you put it on a gallery wall is to get people to spend more time looking at the images. . . . A well-curated exhibition should be thought provoking and ask as many questions as it answers.

Camilla Brown, senior curator, The Photographers' Gallery

FIGURE 2.2 Unspoken Words: Untitled #3, 2006 © Leila Miller.
"I wanted the images to be confrontational so I printed them quite large; with no borders and framed them without glass—there were no barriers between the viewer and the surface of the image. I hung them around the room and at a height so that the viewer would feel they were right in the middle of the situation. I also made an audio installation, with the sound of several people typing in the distance—I wanted the viewer to feel that rather than standing in a gallery looking at artwork they had walked into an office and had found themselves in an uncomfortable situation and had to work out what was going on."

At the end of the day it's all about editing, scale and presentation. And that is as important as taking the photograph in the first place.
Camilla Brown, senior curator, The Photographers' Gallery, London.

Presentation is crucial to the installation of photographs in the gallery. Photographers talk about the presentation of their work all the time, unlike painters and sculptors for whom presentation is usually a secondary consideration. For both curator and photographer, discussion of different options in mounting, framing, sizing, and editing or sequencing work can take priority over discussion of the photograph itself.

There are a number of possible reasons for the fact that this is so important to photography. One is that the gallery has the task of changing or challenging an audience's usual relationship with the photograph. It has become a cliché to observe that we are surrounded and bombarded by photographs and, as Victor Burgin pointed out in the 1970s, "It is almost as unusual to pass a day without seeing a

photograph as it is to miss seeing writing. In one institutional context or another—the press, family snapshots, billboards etc.—photographs permeate the environment, facilitating the formation/reflection/inflection of what we 'take for granted.'"

This everyday quality of photography—the fact that we are so accustomed to seeing photographs that we do take them for granted and assume that they can be read and understood quickly—means that a gallery or curator has to work hard to create a space in which the photographs can be looked at differently—more slowly and thoughtfully. Even if a photograph is from one of the contexts Burgin mentions—if it is a press image, a family snapshot, or taken from an advertising campaign—it will have been taken out of this original context and is being re-presented in the new context of the exhibition. The method of presentation has to invite or entice the audience to slow down and look and think about the image. There are very many ways that the curator can do this, but a good starting point is to make a physical change (in scale, print quality, and framing, for example) from the way the image would originally have been seen.

One of the issues involved here is what writer John Stathatos has called "photography's polymorphous perversity," meaning the way in which the photograph can shift its meaning depending on its context. One of the tasks of the curator is to create a context for an image, set, or series of images. This depends on many things, the most crucial of which is the exhibition concept and text which, as it were, set the scene in which the images will be read and understood.

Another reason why presentation is so central to the curation of photography has to do with photography's long struggle to be accepted fully into the gallery system. In the course of that struggle, photography had to make claims for itself as art. This meant that photography curators have tended to borrow heavily from the conventions of art display and, in particular, used scale and formal framing to present works as if they were paintings, providing critical support and creating an atmosphere of preciousness around the work. This in turn created a convention of presenting photographs in an overly formal way. Many photographers today, such as Wolfgang Tillmans, Fiona Tan, and Joachim Schmid, have actively challenged these conventions of photography display by pinning, taping, and tacking images to the wall and finding

other ways to remind us that the photograph is simply an image on a piece of paper and can be shown in a way that reminds us of these ephemeral qualities.

So scale, context, sequence, method of mounting or framing, the amount of space around an image, and the relationship of the image to the mount or the wall are all key to the way in which the work will be presented and read.

FASHIONS IN EXHIBITION PRESENTATION

It is useful to be aware that there are also changing fashions in exhibition presentation, fashions that change from year to year as new ideas and techniques of showing are developed. Recently, at an exhibition of postgraduate work, the curator pointed out to me that almost every image had a border and was in a frame, whereas two or three years ago the same work would have been presented borderless and frameless on aluminum.

The Victorians borrowed from the fine art conventions of their period and hung photographs close together from floor to ceiling, without greatly considering how each photograph impacted on its neighbor. From 1905 Alfred Stieglitz showed painting, sculpture, and photography in mixed exhibitions at the 291 Gallery in New York, as part of his ideal of getting photography recognized as a fine art. After World War II, design conventions started to shift, as increasing magazine production and popularity influenced exhibition design. In 1955 The Family of Man exhibition drew its design from the conventions of magazine layout. This touring exhibition, curated by Edward Steichen for the Museum of Modern Art in New York, remains the most popular exhibition ever held, seen by more people than any other—with an audience of over nine million worldwide. Since Steichen's intention in the postwar era was to make universal statements about the condition of humankind, the picture magazine layout was a sound choice: a design convention familiar to the audience in the many countries in which it was seen, which made the exhibition much more universally accessible than it might otherwise have been.

By the 1960s and 1970s many photographic exhibitions were routinely hung in regular rows of light aluminum frames. If the presentation seemed dull and conventional, there was good reason for it: photographs were still not regarded as art and therefore the most conventional exhibition design made a statement that this work was to be taken seriously. As Deborah Bright points out, this also "reflected

the dominant aesthetic idea of photography's having an inherent formal language distinct from that of painting and the other graphic media. So having all the prints more or less the same scale and in black and white showed this to advantage."

However, from the late 1970s, as Douglas Crimp describes in *Photographs at the End of Modernism*, the radical reevaluation of photography meant that "photography took up residence in the museum on a par with the visual arts' traditional mediums and according to the very same art-historical tenets." This meant that as exhibiting photography became much more common practice, the styles of showing could become more diverse and experimental. Changes in ideas of photographic presentation reflect the new capabilities of digital technology and, more importantly, the increasing centrality of the fashion and advertising industries to postmodern discourse.

In practice for the curator and photographer, presentation can be a complex issue. While the ideal is simply to use presentational methods to show the work to its best advantage, there are very many different considerations to take into account when showing work, not the least of which is that the presentation is a statement in itself about the contemporaneousness of the work.

MAKING AND BREAKING RULES OF PRESENTATION

There are conventions of exhibiting that most of us are probably not aware of when we visit a gallery. Usually these are designed to habituate visitors to the experience of looking at an exhibition and make it easy for them to concentrate on the work. For example, exhibitions usually start on the left side of the gallery, and the audience is expected to move from left to right or clockwise around the gallery. Another convention is that captions tend to be placed immediately underneath an image on the left-hand side. Both of these standard practices probably derive from the fact that we read from left to right; by duplicating the way we read, these conventions make us feel more at ease and familiar with the process while looking at photographs.

New exhibitors often feel inclined to challenge such conventions by breaking the unwritten rules of exhibiting, thinking that their work will appear fresh and vital as a result. They may also think that doing this will attract publicity. In my view this is a mistake, one that is more likely to result

in the exhibition being ignored or seen as amateur work. It can also undermine the seriousness of the work. My advice to anyone who is new to exhibiting is to follow the conventions of exhibition and work within them until you are able to break the rules with panache and take the audience with you in your rule breaking.

In fact, strategies to break the conventions of showing are difficult and complex to devise and are often risky in that we cannot anticipate how an audience will react. What seems obvious to someone who works with visual images may simply be missed by someone who is not conversant with gallery practice. In the early 1980s, for example, I worked at Camerawork, a gallery on a major shopping street in the East End of London. We showed mainly documentary photographs and had pioneered a practice of laminating photographic exhibition panels under plastic so that they were lightweight and could be toured to other galleries easily and inexpensively. We also believed that the use of rather downmarket laminated panels, as opposed to more formal frames, made the gallery seem a relaxed and informal environment and that shoppers would drop in to look at our exhibitions because of this. In fact the opposite was true, and our attendance figures were sometimes disappointingly low. The gallery was in an area of town that had no other galleries, and it was only when we exhibited conventionally framed photographs that we discovered that our local audience, unaccustomed to having a gallery in a street of shops, understood that the convention of framed photographs meant "exhibition" and felt welcomed into the space. For them the laminated panels were offputting for the very reasons we had thought they would be attractive.

Exhibition invitations are another case in point. People often want to make these as eye catching as possible. In my view this is frequently a misplaced effort. Every year without fail I receive at least one exhibition invitation that is in, or looks like, a film cassette. It is usually from a student group or a young exhibitor and must be fiddly and expensive to make and post. I rarely go to the exhibition the cassette advertises because it signals to me that the exhibitors are desperate to be noticed rather than secure in their work. The thing that does make me decide to go to an exhibition is the image on the invitation. A strong and interesting image gets me to the exhibition every time.

Robert Mapplethorpe is a good example of an artist who was able to use the conventions of photography to good

effect. Although many people found the content of his work offensive, the fact that it was very conventionally and formally photographed as well as beautifully printed and displayed meant that it could be defended as art despite his subject matter. Exhibiting photographers can learn a useful lesson from Mapplethorpe. His potentially difficult subject matter was made more accessible to a much wider audience by the way he handled it.

As a general rule, then, the conventions of exhibiting do make it easier for an audience to focus on the work and understand the photographer's intentions. While there can be good reason to challenge or change these practices, it will often be counterproductive to do so. Ironically, it is often easier for the bigger, more established galleries to experiment with the conventions of exhibiting, simply because they are established and can expect audiences to try harder to understand what they are doing than they might elsewhere. Small galleries or new exhibitors take a bigger risk in challenging exhibition conventions because they may well alienate their audience—something they can ill afford to do. On the other hand, of course, they may see this as an important part of their role and may be uninterested in reaching a wide audience.

APPROACHING A GALLERY

One of the problems we encounter on viewing—particularly graduate and post-graduate photography—is the fact that the work has great relevance within the context of an academic environment. However, outside that environment the imagery, when asked to, as it were, stand on its own, cannot do so convincingly. Usually this is due to an overemphasis on theoretical underpinning and not enough on the technical and aesthetic qualities that go towards making an image.

David Scull, Hoopers Gallery

Unsolicited proposals can be a bit of a bugbear. Most galleries are programmed for two years in advance, as we are. The process of agreeing to a show will take time and when anyone applies for a show their proposal has to be clear and not overcomplicated. Don't send proposals to all and sundry; look at a gallery's website, look at the type of work they exhibit and if it fits in with yours.

Anne McNeill, director, Impressions Gallery

We ask an artist to first send us a selection of his or her work by email so that we can get an idea if the work would be interesting for us and if it fits the programme of the gallery at all. If we then invite an artist to show us his original work we expect him to bring in good quality prints. . . . You have to be able to choose the right image and quality of print in order for a gallery to judge your potential.

Rudolf Kicken, founder and co-owner, Kicken Gallery, Berlin

Museum and gallery programming policies are so constrained by funding criteria, local government policy and sponsorship concerns that it's unlikely that the unsolicited proposal would tick all the boxes.

John Gill, director, Brighton Photo Biennal

I cannot stand pushy photographers. Good manners are crucial. Curators talk to each other all the time, both nationally and internationally, and if you are rude, aggressive and difficult, word will get around. If you are pushy, forget it, you're never going to get a show that way.

Anne McNeill, director, Impressions Gallery

There are three strategies (for looking at new work). Firstly we look at a lot of specialist magazines and go to a lot of exhibitions, art fairs and galleries. Secondly, we have people who come to the gallery to present their work, and thirdly, artists we represent may point out another artist because they have the finger on the pulse all the time.

Rudolf Kicken, founder and co-owner, Kicken Gallery, Berlin

At Impressions we look at people's work informally through our Sounding Board portfolio sessions and give feedback. Photographers who are pro-active and get their work reviewed in this way stand a better chance.

Anne McNeill, director, Impressions Gallery

How does a photographer start looking for a gallery? Many photographers make the mistake of thinking that if they send their folio or details to all the galleries in town, one of them will pick it up. This can be an expensive and time-consuming exercise which, in my experience, rarely works. A better plan is to spend some time shaping an exhibition proposal and researching appropriate galleries before approaching any of them.

If you are just starting out, it makes little sense to apply to the major galleries who only show established figures. Look around for the galleries that interest you because they show work you like or work by colleagues or simply because you can imagine your work in the space, and start there.

Depending on where you live and how much work you have to show, the best place to start is usually locally or in the nearest sizable town. To research possible galleries, look at "what's on" magazines, gallery guides of every type, specialty photographic magazines, and web sites, and talk to other photographers. Your sources of information need to be recent because galleries can be fairly short-lived and most towns have a fluctuating number of photo galleries. If a suitable local gallery does not suggest itself, then start to look farther afield.

If you can concentrate on local galleries, it is reasonably easy to go look at them once you have made a list.

Actually looking at the gallery will tell you much more than any review, publicity, or web site can. You should be able to assess a number of factors, including whether the gallery shows the type of work you make, how your work would fit the gallery, whether you have enough work for a one-person show, and, equally importantly, whether it is a gallery you would be pleased to show in.

Once you have decided that a gallery may be suitable for you, the next step is to find out how it selects shows. Pick up any available brochures and handouts and talk to the staff. The person in the gallery when you visit can usually tell you a great deal and save you from wasting your time. For example, the gallery staff should be able to tell you if the gallery is booked up for the next few years. And, crucially, they should be able to tell you the gallery exhibiting policy, whether the gallery welcomes applications for shows, and how to make that application. They may give you additional written information, tell you of any application deadlines, or introduce you to the staff member who deals with looking at new work.

Some galleries, usually smaller ones, like their staff to spend time in the gallery as a way of observing audience reaction to the exhibitions and making the gallery a friendly place to visit. It is often difficult to tell exactly which staff member is in the gallery, and you need to be aware that you could be talking to the gallery director or to a student who is there for work experience. The role of the person in the gallery is usually both to deal with the public and give out information and also to protect the gallery director or curator from endless interruptions.

One of this person's tasks may be to filter out unnecessary applications, so if you are hearing a "no thanks," it's probably not a good idea to demand to see the gallery director. One of my first gallery jobs included both staffing the gallery and managing a gallery committee, so my role was partly as a gatekeeper for the committee. I was not a committee member but, after a short time working with them, I knew exactly what kind of art they were interested in. As a result, when artists brought their work into the gallery, I could recognize those who were likely to interest the committee, and so I would put appropriate applications at the top of the waiting list. I tried to tell artists when it would be a good idea to defer or represent an application. Not everyone listened, and everyone's time was wasted by this.

It should not need saying, but it is important to be polite. This is not the moment to practice an aggressive sales tech-

nique on gallery staff. As a general rule, heavy self-promotion acts against your work, if only because most curators want to look at work freshly for themselves without the interference of other people's opinions. As gatekeeper I would move rude and unnecessarily persistent artists farther down the list rather than toward the top. I have had artists say to me that they had to see someone right away because they were leaving town the next day and we would regret not seeing their work. My response was to think that, if the artist was so disorganized as not to arrange an appointment in advance, would anyone want to deal with the way he or she might approach an exhibition deadline? No gallery wants to work with aggressive or difficult artists, and staff are often encouraged to pass along comments about the way artists handled themselves when they came in.

Some galleries do not have an open submission system of application. If this is the case, the gallery may offer alternative points of contact, such as portfolio reviews, an annual open submission exhibition or competition, or studio visits. It is worth asking about this and also checking how an invitation to view work will be received. Most galleries spend time looking at new work and for new talent, even when the gallery is booked for the foreseeable future, and this may lead to something at a later date.

Most galleries have an exhibition policy, although it may be expressed in very different ways. It is important to know what this is before approaching the gallery. The exhibiting or showing policy of a gallery reflects the sort of exhibition preference the gallery has. The gallery may concentrate on showing young artists or established artists; be avant-garde or more conventional; have a preference for a particular genre in photography, like landscape or documentary; show themed exhibitions; mostly one-person shows or only group exhibitions. It may show local artists only or artists from one particular country. It may initiate all its exhibitions or take in a large number of touring exhibitions from elsewhere. It may show mostly contemporary work or concentrate on vintage prints or a particular period of twentieth-century photography. A policy could also have several different strands and include, for example, a regular annual exhibition of young artists in a program of major international photographers or one historical show a year in a program of contemporary work. Knowing a gallery policy saves the artist from the unnecessary time and expense of applying to venues that are not even going to consider the work.

Some galleries claim not to have an exhibition policy and say they are open to all exhibition applications, but unless the gallery is one that is hired out, this is unlikely. Although the gallery may not articulate its policy, it probably has one, and this can be detected by looking at what it has shown over the period of a year. Exhibition policies tend to be particular both to the gallery and also to the gallery director or curator, so sometimes a gallery policy will change when a curator or director moves on; this usually occurs fairly slowly over a period of at least a year, since the programs will have been scheduled ahead, before the decision maker left.

Never approach a gallery without first doing your research, to ensure that your proposal is shaped to the gallery's space and showing policy. And keep your research notes for possible future use. Most gallery directors are generous with the time they give to looking at work and to supporting artists. They know what it is like to struggle and are prepared to support and help younger artists while they make their way. However, galleries are usually inundated with inappropriate requests for exhibitions. Some years ago I did some research into training provision for the Arts Council of England. When I talked to gallery directors, most of them commented that what annoyed them most was photographers who brought portfolios that demonstrated they had not looked at either the gallery space or what the gallery showed and were then surprised when they got short shrift. Ten years later I discovered that photographers still have not learned this lesson.

Before you approach a gallery, find out what the procedure is and follow it. Most galleries have a clear procedure about applying for exhibitions. They may also be happy to advise you about what they want to see in terms of exhibition ideas, numbers of photographs, and supporting material.

However, before you approach a gallery, you still have work to do to make your application relevant to that particular gallery. Remember that when you're showing work, the curator is considering not just the work itself but whether it will make an interesting exhibition and how it will fit into both the gallery space and the gallery program. This is something you need to have thought through before meeting gallery staff. Most curators have limited time, so you should expect to do considerable work for them in advance by shaping the work into a proposal for an exhibition that will fit their space. For instance, if the space is large and you do not have enough work to fill it, you should have in mind

other photographers' work that would be relevant to show with yours. Or if the space is small, be ready to say "this is the work I think would work best in your space."

It is not a good idea to show a curator every picture you've ever taken. Show a body of work and show the work you think is most appropriate for that specific gallery and exhibition program. Make it easy for a curator to look at the work by organizing your portfolio well and keeping it to a reasonable size. Bring a c.v. that includes a list of previous exhibitions and (good) reviews from the exhibitions, if you have them. The gallery may not be interested in looking at them while you are there, but they can be left as reference material, along with a CD or postcard and contact details.

It is important to realize that you may get rejected for reasons that have absolutely nothing to do with the quality of your work. The gallery may not like your work, but they are also just as likely to reject you because they are already handling as many photographers as they can deal with, they may be booked so far ahead that it would be unwise to take on more exhibitions, or your work may be too similar to another photographer's. I once promised a photographer who works with pinhole cameras that I would talk to a particular gallery director on his behalf. The day I went to see the gallery director, he had just put his new show up—and it was a pinhole camera show. Although the work was nothing like the pieces I was going to show him, he was not interested in showing pinhole work of any kind again for at least a year, so it was primarily a matter of chance that the work I wanted to show was not even considered.

If a curator turns you down but suggests that you keep in touch or come back in a year or two, do not interpret this as a kind way of rejecting the work and forget what they have said. In most situations the curator will mean it and will take it as a sign that you are not interested in the gallery if you do not return. The curator may well feel you're not ready for a show in his or her gallery now but will be in the future. Most galleries like to keep in touch with younger artists they think they may show in the future. However, they expect the artist to take the initiative in keeping the contact alive. Go back; the curator may say no again but will be keeping up-to-date on your work.

Curators are often motivated by personal preference as well as gallery policy. If a curator seems genuinely to like your work, remember to note that person's name and add it to your mailing list; and if that curator moves away, see him

or her at the new gallery. Every artist needs to have a personal support system of people who are interested in their work. Keep these people up-to-date by inviting them to shows and events rather than just going to see them when you are looking for an exhibition. They will appreciate it.

It can also be worthwhile to show people work just to update them on your current projects. Many photographers forget that curators and gallery directors do not necessarily know all their work. It is easy to miss an exhibition and so not know work that might have taken several years to produce. It is worth saying to curators that you know that your current project is not yet finished or may be something they would not be interested in exhibiting, but you would like them to see it anyway and maybe give you advice. As Camilla Brown of the Photographers' Gallery, London, says, "I don't think there is any problem with showing someone you trust a body of work before it is in its final stages. I personally find it a lot more interesting as a curator." Most curators are generous people who want to see a lot of work and help photographers when they can. But be straight about it and give them the opportunity to say no.

ALTERNATIVES: LOOKING FOR INDEPENDENT EXHIBITION SPACES

Indeed much of the art of the late sixties and the seventies had this theme: How does the artist find another audience or a context in which his or her minority view will not be forced to witness its own co-optation? The answers offered—site specific, temporary, nonpurchasable, outside the museum directed towards a nonart audience, retreating from object to body to idea, even to invisibility—have not proved impervious to the gallery's assimilative appetite.

Brian O'Doherty

One of the most difficult tasks for any photographer just starting out is to find that all-important first show. Most galleries receive many more applications than they can take on. Most will also prefer to take on photographers with some exhibition experience. It can be very disheartening for the photographer to be regularly rejected and to have work which is ready for exhibition and be unable to find a suitable gallery. The answer is usually to look outside the gallery system for an alternative.

FINDING A SPACE

There are several good alternatives to finding a gallery that will show your work. These include hiring a gallery, showing

FIGURE 2.3 "Close to Home" / Image © Alison Marchant
About this work Alison Marchant says: 'This enlarged family photograph was sited in the porch of
the first derelict house in Colville Road, Leyton, London. The house was under compulsory purchase
order for the M11 Link Road. 'Close to Home' inhabited the margin between inside and outside,
and stood at what Michel de Certeau describes as the threshold at which visibility begins. The piece
problematizes the home as stable maternal space protected from the 'public' world of politics and
human rights.' On a practical level photography used as site specific artwork is both attractive
because of our familiarity with hoardings and has to compete with them and with advertising con-
ventions for our attention.

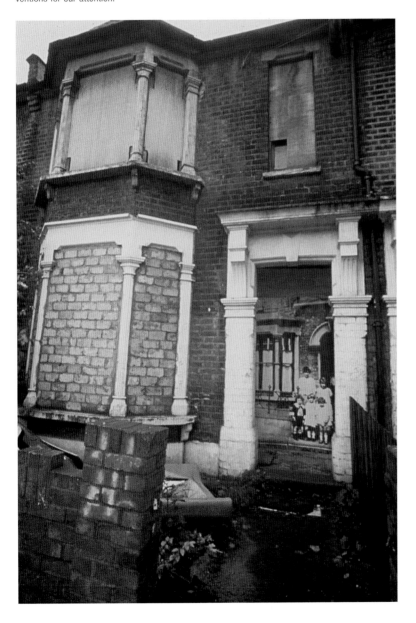

in schools and colleges, showing in places that are not galleries but will show photographs, and converting a space to act as a temporary gallery. There are also all sorts of unusual spaces available to show work. These include cooperative spaces run by artists, people's homes, and galleries in cinemas, theaters, cafes, bars, local libraries, community centers, hospitals, shops, factories, and offices. There are also all kinds of markets, specialist fairs, and festivals where you can hire a space or stall. Some of these will regularly exhibit photographs, while others will be available only in the short term, for a single exhibition or one-off event.

This option can bring a new audience to your work and be an enjoyable experience. It is often a good opportunity for a photographer to be experimental and innovative in his or her presentation. It may also be a challenge and can be stressful, but it is the fastest way for any photographer to learn exhibiting skills. Equally importantly, these sorts of venues are usually carefully watched by most curators and galleries looking for exciting new work and may be a faster route to exhibiting than the more traditional one of presenting a folio to a gallery.

The potential downside is that most of these spaces will lack the system supports that exist in the regular gallery. Many will have no permanent staff or regular audience, no publicity system, inadequate hanging, lighting, and security systems, and little money or experience in dealing with exhibiting. These sorts of opportunities are probably best explored as a group or by an individual who already has a good support system, as they are generally more labor intensive and require a wider range of skills than showing in a conventional space.

There are several ways to find such a space. As a starting point, try your local council or government, particularly if they have an arts office. Once again, it means looking at "what's on" or "around town" magazines, gallery guides of every type, specialist photography magazines, and web sites and, of course, talking to other photographers. However, the simplest solution may be simply to walk around an area of town and look for possibilities. Several cafes and restaurants in my locality either show work or could perhaps be persuaded to do so. In the main shopping street near where I live, a computer shop had recently closed down. There were about six months left on the lease, and the leaseholder loaned the premises to a young curator. She held a series of interesting temporary exhibitions in the vacated premises before the

lease expired and the premises were handed back. She relied on her own mailing list and on attracting an audience of passersby in a street with no other galleries; she had no costs to set up the gallery and very low running costs. Opportunities like this are there if you look for them.

HIRING A GALLERY

Hiring a gallery brings with it all the advantages of having a space specifically designed for showing artwork. The gallery should also have systems in place for promoting the work and attracting visitors. It may also be a gallery that can be hired on a regular basis so, for example, it could be hired every year for a summer show. However, many such galleries are expensive propositions, since they rely on hiring out their space to support their regular exhibition budget over the rest of the year and charge a high rate to cover possible damage and disruption.

In this situation, a great deal depends on the suitability of the space itself and on the attitude of the gallery owner or staff. If they are enthusiastic and supportive, hiring a gallery could be worthwhile, and it might even be worth considering hiring the same gallery on a regular basis. On the other hand, some galleries are available to hire only because the owner doesn't quite know what to do with the space, and so the place gets gradually shabbier over time and has a dispirited atmosphere. Such spaces should be avoided.

One of the key things to remember when you do hire a gallery is that, as far as the gallery is concerned, taking down the show is as important as putting it up. If you leave the gallery in a mess, that particular gallery won't hire it to you again and may bill you for cleaning, damage, and redecoration.

CAFES, WINE BARS, AND RESTAURANTS

These are often good places to show and sell work. Any environment where people relax and enjoy themselves can provide a good selling opportunity. People who have spent a pleasant evening looking at a photograph they like may well feel that the image will work just as well in a particular corner of their home.

However, owners and managers can vary a lot in their attitudes to displaying artworks, so an opportunity like this needs to be carefully explored. Some cafe owners like showing work because, as one of them said, "I could have bought the

art I wanted but we'd still be looking at the same stuff two years later, and when you're serving food one hundred hours a week, it's great to have a changing environment. We generally use local artists and I take 10% of sales revenue." However, other cafe owners take the opposite view, fearing that arranging a program of changing shows will be too time consuming and that they will lose regular customers if they close for a private view or artist's reception.

It is important to find out what is actually being offered before arranging such a show. Some years ago a student of mine arranged to show his work in a wine bar in a fashionable area of Chelsea. We were all impressed until we arrived for the evening opening and found a dark bar with a poorly hung display. He had been so pleased to have persuaded the bar owner to show his work that he had not asked any questions of him. When he arrived to install his exhibition, he was told that he could only use the existing hanging system, which had been designed for large paintings. His small, irregularly spaced photographs almost disappeared on the dark walls of the bar.

This type of venue is likely to want to keep their walls undamaged and so will limit the possible places for installing photographs. This can be awkward and may make the venue unsuitable if, for example, the photographer wants to show small works and hanging spaces are only behind tables. No viewer wants to lean across other people's food or drink to examine a photograph! The downside of cafes, wine bars, and restaurants is that the work might be difficult to hang and even more difficult to light. Work might get damaged or stolen and be uninsured. The upside is that the work may well be shown for several months rather than several weeks, and the chances of selling work are usually good.

USING A NON-GALLERY SPACE

Another alternative is to use a space that is not usually a gallery. Spaces I have seen used as a temporary gallery include disused factories and empty shops and offices.

This can be exciting and challenging. Most audiences like the sense of discovery that a different sort of space promises. However, it does pose a different set of curatorial issues. Few people are likely to invest in the space itself if it is going to have only a single use as a gallery, and painting the space or installing special lighting may be too costly to consider. Security of the premises, if not of the work, may necessitate hiring a security guard at night, particularly if computer or

video equipment is part of the exhibition. Some of the most interesting uses of this sort of space are those that emphasize and utilize the temporary nature of the place or its abandoned condition. Fragile works on paper, or work with a subject matter like urban landscapes, may be well suited to this type of space, whereas traditionally framed photographs may sit uncomfortably on crumbling walls.

FAIRS, MARKETS, AND FESTIVALS

These can be enjoyable and rewarding occasions. Hiring a stall, either as an individual or as a group, may or may not bring sales, but it is usually informal enough to bring feedback, informed and uninformed comment, and networking opportunities.

In art fairs and festivals, conventional subjects and styles with wide popular appeal are the norm and the most likely to find favor. Even major international events such as Paris Photo or Photo London are often not the venues for experimental or socially critical work.

WEB SITE GALLERIES

For most photographers, running one's own web site is primarily a useful tool for reaching a wider audience. Most galleries now use a web site to promote their exhibitions and to bring in new clients. Some see them as an educational tool. For galleries, however, there is also the possibility of selling online. This is a relatively new way to market work and one that is developing quickly.

In the early days of these new technologies, a number of companies, including Sotheby's and Eyestorm, set up web sites for selling photographs. The two had different approaches. Sotheby's brought together existing U.S. and U.K. galleries that were interested in marketing internationally and sold both contemporary and vintage prints. The galleries guaranteed the authenticity of the work they were offering for sale. Eyestorm commissioned editions of contemporary photographs from artists and stored them to sell.

Neither site was very successful, for a number of reasons: start-up costs were high and buyers were slow to start buying. In part this was because it took time for buyers to trust the new systems. In particular, it was difficult to convey the quality and feel of an image online and to guarantee provenance. Trust in the attributed provenance often depends on a close examination of the actual photograph. Experienced

collectors know what they are handling and can rely on their own senses, so it took time for people to start buying without actually handling the work themselves. In 2002 Sotheby's linked their site with popular Internet auctioneer eBay (www.eBay.com).

Established galleries see web sites as a means to reach clients who are searching for specific works. This is particularly useful for opening up the international market for photography. Howard Greenberg Gallery gives an example of a client from Los Angeles who had been searching for a 1990 set of Roy DeCarava photogravures; another example cited is of Catherine Edelman of Chicago selling a Joel Peter Witkin work to a London dealer via their web site ("Photography Online" by Jennie D'Amato in *Photography in New York International*. January/February 2002, page 82).

In general, the problem of setting up a selling web site remains one of guaranteeing provenance. Only a reputable dealer or gallery can provide this. If web sites are to be successful as art venues they have to be easy to find, fast to upload, and regularly updated.

WHAT AN EXHIBITION SPACE DOES OR DOES NOT OFFER

So, what are the advantages and disadvantages of showing with an established gallery rather than in a gallery that can be hired? Or in a place like a cinema foyer or cafe? Or of turning a non-gallery space into a temporary gallery? How does the potential exhibitor decide whether to show in a particular venue or not?

Every exhibition is a balancing act in terms of the time, cost, and effort put into it by the exhibitor. Each option needs to be considered in terms of the specifics of that situation. Each one will be different. No two galleries are likely to offer the exhibitor the same amount or kind of practical or financial support. Where one gallery may not involve the photographer in anything more than providing prints, another will expect them to be hands-on in every aspect of the exhibition, from framing to writing text and publicity material.

Using a space outside the gallery system usually means that the photographer has to put more time and effort into exhibiting than he or she would in a more conventional gallery situation. However, this should not be a disincentive to putting on an exhibition in a temporary space. On the contrary. Working in a non-gallery space can be an enormously enriching experience that will give the photographer

a much deeper understanding of his or her audience and how to show his or her work and a confidence in his or her own exhibition skills which will stand him or her in good stead in every future exhibiting situation. Because it often means working with a group, it can forge strong friendships and working relationships that will continue to support the photographer over time. Most important of all, it can be fun.

Exhibiting in difficult or unusual circumstances can be richly rewarding if the photographer can be creative about the process and ignore the conventions of the traditional gallery space when necessary. I have never forgotten an exhibition I saw in an unused shop where the electricity had failed shortly before the exhibition was due to open. The audience was met at the door by someone who solemnly handed each of us a torch and ushered us into the space two at a time. We had, literally, to find the works in the dark. The visual impact was stunning. The black-and-white photographs loomed up out of the darkness like treasures being discovered. We were forced to explore each image individually as we came across it in the dark because the torches were not powerful enough to illuminate the entire photograph at once. I felt as if I were discovering photography for the first time. Afterward we were escorted down the street to another empty shop illuminated only by candles for an opening party, which was enlivened by our shared experience of near-disaster.

No exhibition opportunity is likely to be perfect—each space will probably have some advantages and disadvantages. Postponing a decision to book a gallery until the perfect space can be found is usually a mistake, one that may leave the exhibitor with reduced options and deadlines that are too short. To be successful in selecting any of the different available options, a photographer must consider carefully what sort of financial, practical, and time commitments are involved in each, *before* choosing one. None of the factors listed below should pose insurmountable problems, but the exhibitor needs to recognize in advance what the particular costs and workload are likely to be and to adjust to the particular situation as required.

This means considering some, or all, of the following:

1. the space itself and how it can be used
2. control over the work and the availability of curatorial help
3. what practical help is available
4. the possibilities for publicity and a regular audience
5. possible unforeseen or additional costs

6. keeping the space staffed and the possible need for additional security

7. the possibility of follow-through

(1) In an established gallery, a great deal of work has already been invested in making the space work as a gallery. It will probably be smart, well lit, and secure. The gallery staff will have long experience of using the space to show the work to its best advantage. And the gallery will most probably have a regular audience accustomed to the way that particular gallery works.

At first sight other spaces may look just as appealing, but careful consideration needs to be given to how the space will work both for the photographs and for an audience. The size and condition of the space need to be checked. The space may need painting, decorating, and signage. Heating and lighting might be a problem and the electrical circuit inadequate for the necessary additional lighting. Access may be poor and staircases a safety hazard. It will take time to make sure that the exhibition works in the available space.

Timing is also an issue here. It takes time to put a show up and take it down again. This time needs to be built into the schedule. Some spaces hire out with very little change-over time, and this needs to be carefully assessed.

(2) Most galleries show work the way they want it shown. This can be frustrating for the photographer who has his or her own vision and ideas about how the work should be shown. Hiring a space or putting work in a non-gallery space usually gives the photographer much more freedom to experiment or to show the work as he or she has dreamed it should be seen. However, for the inexperienced photographer it may mean either hiring in some curatorial help or allowing him- or herself enough time to learn by trial and error what will best suit the work.

(3) Most galleries have staff with expertise in every aspect of exhibiting, from framing and hanging work to producing exhibition texts and publicity material. They will either take responsibility for doing these things or help the exhibitor to do them. An exhibitor who hires a gallery space or uses a non-gallery space will probably have to hire help or rely on friends, family, and colleagues to work jointly on the exhibition. Once again, this is only a problem if an exhibitor fails to allow enough time to experiment or acquire the necessary skills.

(4) Most galleries also have a regular audience and a good publicity machine. Many galleries have an audience who visit

regularly, even without knowing in advance what is being shown. It is often considerably harder to attract an audience to a space that has never been used as a gallery. Publicity needs to be sent out early and, since many exhibitions achieve success through word of mouth or late reviews, it is worth extending the exhibition period because audiences may build up slowly. On the other hand, the real advantage of showing in spaces such as a cinema or cafe is that there will be a captive audience of moviegoers or lunchtime regulars and the exhibitor should be able to attract them.

(5) Costs are the most important item that every exhibitor must check carefully before entering into any agreement, as this is the most likely source of misunderstanding. Most galleries will meet certain costs but not necessarily all of them. This varies from gallery to gallery. Galleries available for hire may, for example, have their own mailing list and produce publicity material but expect the exhibitor to pay a portion of the costs and help with the mailing. An exhibitor should make sure all aspects of the financial arrangements, particularly who pays for which expenses, are discussed before an agreement to exhibit is reached. If this is not done, the exhibitor runs the risk of incurring entirely unexpected bills at a stage in the exhibition process when it is too late to do anything but pay the bills or cancel the exhibition.

(6) Staffing the exhibition and keeping the work secure can be the biggest problem in using a non-gallery space. Most galleries make sure that a member of the staff is in the gallery at all times. Some will welcome the presence of the exhibitor or ask him or her to spend time in the gallery, but this is usually an informal arrangement made to suit the exhibitor. However, one of the real problems of the non-gallery space is arranging for it to be secure and staffed. Sometimes, if the gallery is in an isolated place, two people need to be present. Overnight security can be a particular problem in this kind of space, depending on where it is, and exhibitors should consider either hiring a guard or removing equipment or artwork at night. Opening up and staffing the gallery can be a big commitment in terms of time, and first-time exhibitors are notoriously bad at turning up on time (or at all!) and at keeping the gallery clean, quiet, and tidy and answering visitors' queries adequately. I have been at an exhibition staffed by students who could not tell me anything about a fellow student's work, how to contact the student, or when she would be in the gallery. I was considering including the work in an exhibition I was curating, but the complete indifference

of the students to questions by a member of their audience put me off. I decided I was not interested enough in the work to persist and left.

(7) It is in a gallery's best interests to continue to promote "their" artists and program. They may take on handling sales for the photographer. They will keep visual and other records for many years, and the exhibition may well be on a web site. All of this is very useful. If the exhibitor uses a temporary gallery space, this follow-up will not be done, and since the space no longer exists, there is no site to act as a reference point in the same way as a gallery does.

Showing work means getting started, choosing a gallery situation that may well not be perfect but will allow the photographer to get the work out and into the world. Exhibiting gets easier with practice.

Exhibiting in a Cinema

The Metro was an art house repertory cinema in Rupert Street, Soho. I found out about the space by seeing others' work up when I went to see films there.

Like many places with free exhibition space in London, it had a booking system—where different work was generally up for one month at a time. When I finally asked the manager how it worked, he said there was a nine-month waiting list. I had to show some work in an initial meeting but I then had plenty of time to get the main body of work done.

Hanging work sounded easy, but in a cool, Brutalist, concrete-walled corridor, it actually involved buying specialist diamond-tipped drill bits to make more than a scratch on the walls to put the rawl plugs in. Visually, I had to ignore the scattering of red, yellow and brown plugs in the wall that hadn't been removed by previous exhibitors. Unpainted concrete can't be easily filled with Polyfiller and repainted.

The hardest thing with showing your work is the high expectations leading up to the private view. You hope that something miraculous will happen where someone famous or rich turns up and buys every piece on the wall. What tends to happen is your friends turn up because they like and support you, but mainly come for the free booze. They don't, necessarily, wish to live with your artistic efforts. In this case, some friends of mine arrived early from Paris and did actually buy 3 out of the 15 one-off photos and a couple of editioned prints. It did make for amusing Chinese whispers when I heard later in the evening, from another guest, that someone important had bought lots of work. They were, however, the only pieces I did sell there, except for one sold to an agony aunt who lived in Soho and obviously felt sorry for me.

Five years later, the venue had changed name (to the Other Cinema) and now had lovely clean, white boards covering the concrete. Unfortunately, you couldn't screw into them. When I realised that you had to use their very ugly and obtrusive

metal hanging devices or find an ingenious invisible hanging method from the top bars, it was the day of hanging and a Sunday morning. It limited the possibilities of where to find heavy-duty fishing line to support the heavy framed prints I had. Worse was to come, though. The private view was a great success (although nothing sold) but then five days later, at a private screening party at the cinema, a piece of work was stolen. Of course, their insurance didn't cover it and I had not taken out my own. The party was for a major bank, which did, finally, pay for the work, but not for a long while and after a lot of insistence.

The Other Cinema, like many art repertory cinemas in London, is now closed. A few years later, I toured a solo show in some well-known photography exhibition spaces in the U.K. The process of submission and exhibiting was very similar although the notice period is normally much longer and they always fill in the holes.

Dominic Harris
www.dominicharris.co.uk

Exhibiting in a Library

A local library is a good venue for the individual photographer who wishes to display his or her own work. One great advantage that libraries have over other venues is that many devote a lot of space to information panels, equally suitable for print display.

Most libraries charge for the use of display panels though, in my experience, these charges are fairly reasonable. For exhibitions connected with charities, you may be able to exhibit for free. In my local branch I am able to rent hessian-covered wall boards measuring 8 feet × 8 feet for £10 each per week. I recently put up an exhibition of forty-five 12 × 16-inch prints using three display boards, and for three weeks the total cost amounted to £90.

Try to work out in advance your themes, juxtapositions, and so on, but accept that you may need to do some tweaking on the day to ensure the series of display panels works as a whole, as well as individually. You may have to book space many months in advance to get exactly the panels you want, which gives you time to try out specimen prints to test for attachment methods and decide on foamboard or card mounts, print size in relation to viewing distances, spacing between prints, and so on. Avoid a mish-mash of mount colours and sizes and overcrowding the prints.

Assuming you have set up a web site, all enquiries and potential sales can be dealt with through that, which is probably a better solution than involving the library staff. A4 or A3 flyers can be easily produced on an inkjet printer and put up in likely locations some two weeks before the start of your exhibition. It is also common sense to produce an information sheet giving details on your photographic background and philosophy, as well as notes concerning the images themselves and your contact details. A pile of these should be close to your display, as also should

a Comments Book, preferably with a ballpoint pen attached to a chain! Quite apart from the glow of satisfaction you will (hopefully) feel reading other peoples' views, you will be better able to judge the success or otherwise of your venture from an aesthetic point of view. You may also find you sell more prints than you expect, and receive a good many follow-up enquiries. Compared with a prestigious private gallery where an established photographer may be attempting to sell signed limited edition prints for considerable sums, in a library situation you have to be more realistic. Your potential customer is unlikely to be a committed buyer of fine photographs and will have a much smaller budget.

Security is an issue that has to be considered. Library books may be tagged, but your beloved, expensively mounted photos are not, and the staff cannot be expected to oversee your display. There is no simple solution to this, and whether your prints are attached by Velcro or by my preferred method of pushpins, the risk is always present. I can only say that after several exhibitions in different locations, I have yet to lose anything through theft. However, it perhaps adds weight to the view that to show expensive signed prints could be a mistake.

As with any exhibition, the more free publicity you can gather the better, and local newspapers are the obvious choice here. If your photographs concern local issues, so much the better. Unfortunately I have yet to come across a public library that will allow a private view outside normal library hours. You will, however, be guaranteed a wide cross section of visitors in a large central library, but remember that many regulars visit only once every three weeks, the usual book-borrowing period, and I suggest that this be regarded as the minimum length of time to show your work.

Jim Thorp
www.jimthorpimages.co.uk

Exhibiting in a Hospital

I've had three hospital-based exhibitions, all of them commissioned by the hospital. As venues, hospitals are very different from most galleries. The audience for your images will not be self-selecting; most will just be passing by on their way to somewhere else. The exhibition space will generally not be at all secure. It will probably be in a corridor close to the main entrance, will be accessible twenty-four hours a day, seven days a week, and many hundreds of people may pass it in the course of the day. So your images need protection from theft and from vandalism and from over-enthusiastic attention. If they are framed, they need to be fixed to the walls. If they are large panels of photos, people may be less likely to walk off with them, but they will still need to have a heat-sealed protective covering to protect them from handling. I had been warned of these dangers, but in fact it wasn't a problem.

It's difficult to get much direct feedback from the public passing through, as a visitors' book is likely to disappear. The best way is probably to be there at busy

times and to talk to anyone who stops to look at your work. To collect feedback from hospital staff, it's useful if your exhibition provides a hospital contact name as well as your own. They may well receive a lot of informal feedback from other staff members.

You may have to negotiate to move some of the hospital clutter that tends to end up in corridors and will certainly need to revisit your exhibition regularly to check that is not obscured or damaged in any way. Your work can also be vulnerable because people in very large organisations don't necessarily communicate with each other, nor have much respect for the exhibition itself. One of my exhibitions consisted of ten very large exhibition panels displayed continuously across a large atrium area in a new children's hospital. It had been up for several weeks and was due to remain for several more. Imagine my shock and horror when I took a friend to see it one day and as we rose up in the glass-fronted lift to the atrium area, it was all too clear that the whole exhibition had disappeared! No one seemed to have any idea who had taken it down or where it had gone, and it took some considerable detective work to finally reveal that the contractors had decided to give the wall the exhibition was on another coat of paint, so they just took it down, locked it in an empty office, and didn't tell anybody!

Nonetheless, exhibiting in hospitals can be a very rewarding experience. If your work is well received and particularly if it's of direct relevance to the hospital itself or its local community, your exhibition may well open up other opportunities. Your work might be used in hospital publicity material, in more permanent displays, or might even be published in book form.

Carole Rawlinson
www.carolerawlinson.co.uk

Photobook Exhibitions

My first photobook was created one dull Saturday in mid-February following a day shoot on the set of a new live television production for ITV1. The story of the launch of the TV show seemed a natural topic for the creation of a photobook.

The launch shoot produced some sixty to seventy images worthy of reproduction but few that really stood out as individual images. This was one reason I chose to design the book as a photo diary. Some images illustrated the movements of an impressive TV set design which, presented in sequence, were like animation. Other images needed to be grouped together: behind the scenes shots, production office shots, informal portraits, studio and gallery rehearsal shots, images of mounting tension, and photographs of the presenters performing live on air. However, I believed that the images would benefit from being exhibited together as a whole in order to convey the unfolding story and excitement of the launch of the new live TV show.

Needless to say, curating your own photobook exhibition comes with its own problems. For this exhibition I selected, adjusted, and "hung" all the images

electronically without seeing any printed images. I made this decision in the knowledge that the photobook would be printed on different paper from the paper I use, so I made no attempt to test print the images. The service I used only makes photobooks with one type of non-archival paper (silk 170 gsm), and only one paper size (U.S. letter 8.5 × 11 inches). This is one of the frustrations with the commoditized photobook production process.

It is possible to share albums over the Internet, giving others the chance to view the album electronically, and sell albums online.

The slowest part of the process was the uploading of around 70 JPEGs to the hosting site. My JPEGs are 4 to 5 MB each and, even with a hardwired fast broadband connection, FTPing around 300 MB of data required a long break from the curating process. I uploaded more pictures than the 58 finally used, as several were rejected by me during the page creation process. Standard photobooks are 20 pages in length and can display between 20 and 88 pictures. Although it is possible to add additional pages, I think this is a good number of images, and the best approach often a more ruthless edit.

The next part of my photobook exhibition was the traditional hanging and walking through: here, page formatting and electronic page turning. It is probably best to separate this process from the initial selection of the images. Naturally, it is essential to review the images in their proposed page formats and in sequence, but this can only be done electronically. The software I used had several standard page templates: from a full bleed single image per page, to four images of differing sizes arranged with plenty of white space plus titles and captions per page. The page templates can crop the individual photographs, so care is needed to retain the images exactly as the photographer intended. The use of titles and captions for each photograph is optional, but there is no choice of font or text size. The finishing touches included selecting the colour of the hardback cover, the inside cover page photo, which is seen through a window in the cover, and the book title and caption.

My first photobook arrived by mail three working days after electronic submission. The resolution and colours were excellent, and the silk finish paper worked well with the high impact TV set photographs. The tactile hardbound photobook proved a winner as a memento for those individuals involved in the TV launch. Plus, the television production company ordered copies as coffee table PR in addition to electronic copies of the JPEGs.

Photographic diaries, family compilations, commemorative events, and holiday snaps all have a history in hardcopy photobooks and photo albums. The new online photobook services provided by *www.photobox.co.uk* and *www.myphotobook.co.uk* off hardback publishing with exceptional turnaround speeds, tactile appeal, ability to customize, and availability to all with broadband access. Other suppliers, including Kodak, provide similar book-making programmes, but I have not as yet compared them.

Until a few weeks ago I was an online photobook virgin; now a week is incomplete without the anticipation of the postman's knock.

Caroline A. Brown

Case Study Two: Photodebut: The Collective as a Site for Independent Collaborative Exhibiting

FIGURE CS 2.1 "Stop Moving," a light-box show held over three nights using a forty-ton truck. Image © Esther Teichmann

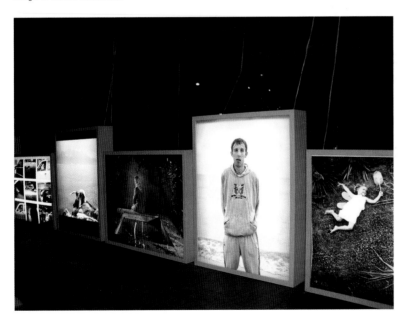

Dialogue needs community and creativity thrives upon dialogue. This triangular relationship between creativity, dialogue, and community, which is the foundation of all fine art education, often gets forgotten outside the framework of the

academy. Photodebut's founders, Jan von Holleben and myself, Esther Teichmann, did not forget the inspiration a group environment has the potential to create. Upon leaving the academy we, along with that year's generation of photography graduates, entered the highly competitive and initially confusing whirl of the fine art and commercial photography market.

At that point, von Holleben was already involved in the expansion of a Web-based international photographic collective, and it was via their activities that we first met. Jan was managing the London branch, which I had applied to join. Frustrated with the impersonal and distanced aspect of working purely via the Internet, Jan instigated meetings for the London-based photographers. And within this informal environment, over portfolios and drinks, we both realized a form of dialogue was taking place which, if channeled, could create an exciting collaboration.

Following this initial glimpse of energy and enthusiasm, which was to become Photodebut, Jan was given the opportunity to use a gallery space in Shoreditch to coincide with PhotoMonth in Autumn 2003. Rather than curating an exhibition, he invited a large selection of like-minded emerging artists to participate in a salon-style show. Over four hundred people jostled their way through the space, images cluttering every wall. And suddenly a dialogue was taking place, which was self-propelling and exhilarating. A possible form of collaboration among artists made itself apparent, and we decided to structure and shape it into a collective of photographers.

The initial members were selected photographers from the Shoreditch exhibition, who had expressly voiced their desire and need for such collaboration. Beginning with our initial mission statement "to promote, support, and connect emerging photographers," we would draft and redraft our aims and ideas as a united group. These conversations took place within monthly crit meetings and while looking at and critiquing each other's work. It soon became evident that one of Photodebut's strengths was the variety of backgrounds and experience among its members; alongside developing and working on our own practice, most of us were also working within another aspect of the industry, as picture editors, agents, art buyers, critics, lecturers, producers, photographic assistants, and within galleries (to name but a few areas). By pooling and sharing this knowledge and these resources, Photodebut soon developed into a professional network while maintaining its founding principle of collab-

orative project and educational work. On a purely practical level, this expertise allowed for a professional management of projects such as the exhibitions held. We were also able to get extensive media coverage from leading journals and papers such as the *Independent, Hotshoe, Creative Review, BJP, AN,* and *DayFour* and to raise sponsorship for private views. An independent collective combining elements such as self-promotion, exhibiting, and publishing with a wider-reaching educational and support ethos was met with encouragement and generosity. A list of impressive trustees who wholeheartedly embraced the concept added credibility to a group tentatively maneuvering their way through new terrain.

Now, in 2007, Photodebut consists of a group of twenty-seven members, having expanded in numbers only minimally since its inception four years ago. The close personal relationships among members have been key in securing and perpetuating the level of activity within the group.

By choosing fewer than a handful of new photographers from the stacks of applications every year, Photodebut opens itself to continually taking on new members, while becoming more and more selective, thus assuring the quality of work being produced within the group and maintaining the intimate atmosphere. Within such a relatively small group, each individual has his or her unique place, hereby ensuring that all members become more acutely aware of their potential input.

Each new member to the group is asked to propose and oversee a project, which varies from exhibitions to humanitarian charity projects. The most recent exhibition project was "Stop Moving," a light-box show held over three nights in three different locations from within a forty-ton truck, and the current charity project is running workshops for unaccompanied asylum seeker children. These projects are always optional; thus smaller groups within the collective are formed who work together intensely for the span of the given project. In this manner Photodebut is constantly shifting organically within itself. With no given hierarchy, each project is approached anew, involving those to whom the particular concept speaks, while still including all within the group within the continuing dialogue, which makes a potentially isolating pursuit that much richer and more rewarding.

Esther Teichmann

Planning and Research

So you have your gallery booked and the work selected. The exhibition is several months away. Time to relax, right? Wrong. All exhibitions need good planning, the earlier and more thorough the better. The very early months of an exhibition schedule are the best time to sort out the administration and production of the exhibition. This is the work which, done very thoroughly and done early, leaves the curator and exhibitor free to concentrate on the creative side of exhibiting. Good forward planning cuts the stress load of an exhibition immeasurably.

The tasks to plan as far in advance as possible are:

- timetabling
- budgeting
- fundraising
- organizing publicity and invitations
- talking to press
- planning exhibition design and presentation
- arranging transport (if necessary)
- planning accompanying events, educational programs, or artists' talks
- preparing the venue
- planning the private view
- organizing gallery attendants, security personnel, or invigilators during opening times
- preparing to hang the work and clean up afterward
- writing all the exhibition texts including captions and titles
- pricing and insuring work

PITFALLS

When I was director of the Tom Blau Gallery, I worked on an exhibition by the leading celebrity photographer Jason Bell. The exhibition was being used to raise

<div style="border:1px solid black; padding:1em;">

Handout

THE TIMETABLE

This list is a guideline only. You need to adapt it to your own specific circumstances and add items to it as necessary. There may be all sorts of additional tasks, and your time scale may be over a year or less than two months! Publicity, in particular, will have its own set of deadlines but will also have to be dealt with as an ongoing task since magazines will have a wide range of deadlines.

When drawing up a timetable, work backward from the date of the opening view. This is the absolute deadline. Remember to allow time for emergencies and for unexpected delays.

Task	Timing
Set up web site	When you start
Phone publications to find out copy deadlines	When you start
Look for sponsorship if necessary	When you start
Book in tasks such as printing, framing, mounting, or anything that relies on an external supplier	When you start
Draw up budget	When you start
Draw up timetable and circulate to everyone	When you start
Prepare listings information and press release	When you start
Select press prints	When you start
Send listings information to magazines	Approx. 3–4 months in advance and as necessary to meet ongoing publication deadlines
Book equipment hire if necessary (e.g., projectors)	2–3 months in advance
Book/confirm speaker for private view if necessary	2 months in advance
Prepare artwork for invitation cards and other printed material (include time to proofread)	Allow 2 weeks and do 2 months in advance
Send artwork to printers	2 months in advance
Arrange insurance if necessary	2 months in advance
Do initial exhibition plan, decide number of images and text and approximate placings	1–2 months in advance
Start mounting, matting, framing	1 month in advance
Send out press and media invites	3–4 weeks in advance
Organize transport of work to and from gallery	Approx. 1 month in advance
Organize all texts in exhibition (e.g., captions)	1 month in advance
Draw up price list	As soon as captions are complete
Organize opening, book staff	At least 1 month in advance
Post invitations (2nd class)	Between 2 and 3 weeks in advance
Plan staffing rotation (if necessary)	At least 3 weeks in advance
Do local publicity by word of mouth	1 week in advance
Phone/email press reminder	1 week in advance
Phone/email reminder to speakers, key guests	1 week in advance
Clean and paint gallery	Before starting the hang
Check and replenish toolkit	Before starting the hang
Hanging	As long before it opens as possible
Preparation for private view (tables, glasses, flowers, etc.)	1–2 days before opening
Private view	The day before it opens to the public
Document the exhibition	Just before or after it opens
Take down exhibition	The day after it closes

</div>

awareness for a cancer relief charity, and it was decided to hold a pre-exhibition event in a fashionable Notting Hill venue, at which many of the celebrities would be present. This was to occur a few days before the exhibition opening at Tom Blau Gallery. The show consisted of some 40 images, digitally printed by Epson UK, with a book produced by Dewi Lewis Publishers. The Notting Hill event was going well when I arrived, with many famous faces in attendance and a well-stocked cocktail bar proving hugely popular.

After a few hours I left to return home but sensed something was amiss when I received a telephone call from the PR agency the following morning. "There might be a few images requiring reprinting. . . ." It transpired that most of the prints had been removed from the walls by the partygoers. A panicked call to Guy Martin at Epson followed. Could he reprint the entire exhibition in time? Over that weekend Epson delivered batches of 10 prints at a time. Meanwhile I was hanging empty frames in the hope that the prints would all arrive in time for the opening. Thanks to Epson's generous support the exhibition opening was a great success, and only a very few of us knew how close a call the whole thing was.

<div align="right">Keith Cavanagh, gallery director</div>

This is also the moment to recognize that exhibiting is stressful and to prepare oneself for the unexpected things that can go wrong. The pressure of exhibiting can be intense. It is stressful for many reasons. An irrevocably fixed deadline makes most people nervous. Most peoples' expectations are unrealistically high, and most exhibitions are one-off situations, short on funds and time. Often the people involved are working together for the first time. There is not enough time to get to know each other slowly, and the result is frequently communication problems with people working to different timetables and priorities, sometimes on different sites. Exhibitions also inevitably bring with them small emergencies and unexpected problems, and it is impossible to anticipate them all. A broken pane of glass can become a disaster if there is insufficient time to replace it.

No two people react to pressure in the same way. A group of students, when asked about how they reacted to exhibition stress, came up with the following list of the things they found they did with a deadline looming: panic disproportionately over small setbacks; suddenly become indecisive; lose things; forget things; break things; get irritable; get muddled; get argumentative; lose their tempers over nothing; walk out; get a stomachache; feel ill in other ways; stop eating; eat too much; stop sleeping; sleep too much; start drinking too much; experience endless equipment and transport failures; start working on something minor and forget tomorrow's deadline; lose all sense of their normal routine; become very untidy.

There are a number of ways to prepare for the stress that an exhibition will inevitably cause:

- look after yourself very well indeed
- get support from friends and/or family
- forward plan very thoroughly
- get as much done as early in the process as is possible
- build extra time and some flexibility into the schedule
- expect at least one small thing to go wrong for no apparent reason
- be ready for other people to be stressed and behave uncharacteristically or unpredictably

Looking after yourself means eating and sleeping well, keeping to a normal routine as far as possible, and not putting your whole life on hold while you work on an exhibition. It means seeing friends and talking about things other than your exhibition. It means arranging treats if you know that will help.

Support can be anything you can arrange that will help you through difficult moments. It will probably be temporary and short term. It may mean just having good friends to email or talk to about the exhibition process. Artists know the sorts of stresses that come up when working on exhibitions and can share experiences, so an informal arrangement to see one another through can sometimes help. It may mean hiring someone to help you frame your work or hang the show. It might mean joining a creative writing group to help you sort out the tangles in writing an artist's statement.

Good forward planning is the key to exhibiting success. If an exhibition is well planned, the exhibitor will know that he or she is on track and can work through the many tasks without feeling overwhelmed by them.

Small tasks have a way of turning into problems if left until the end of the exhibition process. Artists who fail to think about titles for their work or who should be invited to the opening are likely to find that they no longer have time or energy to do these things well when the time comes. Getting them done early on so that they're out of the way helps and may well ease the sense of overwhelming pressure an exhibition deadline can generate.

Allowing some flexibility in the timetable means that tasks that take longer than expected need not hold up the entire exhibition production. If the framed work arrives two days late but the gallery has built in an extra day or more into the

hanging time, then it is not going to be a problem. If it arrives two days late and this has not been done, it may spell disaster.

Almost every exhibition I have worked on has had what I call my "deliberate error." This is a mistake so inexplicably stupid that it can only have been caused by a moment's inattention and is probably the result of stress. This has included miscaptioning images, misspelling names, and leaving key information in the wrong place. For the same reason, every gallery I have worked in has at some point printed an invitation without one key piece of information—the gallery name, the title of the show, or the date of the private view—despite having a template that they use for every invitation. If you expect the unexpected and expect people to do something out of character, then hopefully it will not be an impossible problem when it happens. Systems of double-checking and making certain, for instance, that all text is proofread by someone who has not seen the text before will do a great deal to ensure that one person's moment of inattention is caught by someone else.

It is also worth being aware, right from the start, that curators, gallery directors and assistants, and artists and photographers can all behave in ways that are completely out of character during the process of exhibiting. Everyone is under pressure and everyone will have different priorities and deadlines. Personal clashes can be the most difficult part of an exhibition. One of the ways to prevent this from happening is to make sure that everyone's role is clear and timetabled in advance.

CONTRACTS

Artists should not be so grateful to be represented that they lose sight of the fact that art dealing is a business, not a philanthropy, and they should protect their interests when working with a gallery. Many artists get quite nervous when the word *contract* is mentioned in conjunction with the word *exhibition*. It may seem bureaucratic and something of a burden to add a layer of legal language to what is intended to be a creative and pleasurable event. However, the purpose of a contract is not to open a gateway to litigation but to establish a shared understanding of what has been agreed, what the timetable is, and who is responsible for which aspect of the exhibition.

Artists frequently fail to recognize that when they agree to show in a gallery, they are making a verbal contract. The

artist and the gallery director talk about the proposed exhibition in some detail, and then each goes away with a slightly different recollection of the agreement. Misunderstandings proliferate and later take time to sort out. The result can be a damaged relationship between the artist and gallery director and could mean that the artist will not be invited to show in that gallery again, or would not want to.

A written contract is a safeguard against things going wrong. The most common problem in exhibiting is that misunderstandings occur around who is expected to do what and when deadlines are. A very basic contract negotiated carefully by the artist and gallery together should mean that this situation is avoided. Keeping a contract simple is important. If changes to the contract are to be made later in the process, they can be added in the form of a letter or document signed by both parties.

A standard exhibition contract between a gallery and exhibitor should include the following information and be signed by both:

- the name and address of the gallery, and the name and address of the artist
- the date of the agreement
- the date of the exhibition
- the works to be exhibited
- the prices of the work and whether the price includes or excludes tax
- the amount of commission to be retained by the gallery
- who is responsible for arranging the publicity, sending out private view invitations, and bearing printing, postage, and other incidental costs
- the arrangements regarding delivery and collection of the artworks
- who is responsible for insuring the artworks during transit and during the exhibition
- who is responsible for hanging the show
- the gallery opening hours and arrangements for invigilation or attendance of security personnel at the exhibition
- the date of the private view
- the arrangement for when and how the artist is to receive the proceeds of sale of his/her artworks and how the gallery will account to the artist
- that the artist retains copyright in all their work
- any additional special terms and conditions as discussed and agreed to by the artist and gallery

Many galleries have a standard contract that they issue for each exhibition. It can take the form of a letter to the exhibi-

tor. However, it should be read carefully rather than signed automatically. Exhibitors should feel free to ask for changes before signing the contract. It is quite easy for the administrator of an organization to send out a contract without thinking through every aspect of it and for it to include inappropriate detail. I have, for example, received a contract that stated that my fee would be paid once "evidence of entitlement to work in the U.K. had been seen." I had been working part-time for this organization for seven years, and they had seen my eligibility to work at the beginning of the process, so I included this fact on the contract before returning it.

At this stage it may not be possible to specify exactly which works have been selected for the exhibition, or the selection may change later. It is essential that both artist and gallery have a complete list of works held by the gallery at all times. If the list has not been agreed by the time the contract has been drawn up, it can be written when a final selection is made and delivered to the gallery and can take the form of a delivery note. This has to be signed by a responsible member of the gallery staff (rather than a student intern, for example) and can then be attached to the contract.

It is very important indeed that artists always have a signed record of what work of theirs is being held by the gallery at any one time. They must keep this up-to-date, which means making a new list every time the gallery sells, takes on, or gives back a work. It is not unusual for a gallery to suddenly close and, when this happens, the artists are often the last to find out. If the artists have an up-to-date record of the works the gallery have in hand, they are less likely to have to file a lawsuit to get their works returned.

Galleries sometimes hold works on consignment, whether or not they exhibit them. Sometimes they do this as a way of assessing the possible reception of an artist's work before committing to an exhibition. In this situation, or in any situation where a work is left with a gallery, a complete list of the works needs to be made and signed by both artist and gallerist.

TIMETABLE

Every exhibition has its own timetable, which needs to be drawn up as early as possible and to be both realistic and slightly flexible. One of the main aims of a timetable is to make sure that all the many tasks, usually involving a number of different people or services, are scheduled and in the calendar. Part of the process of timetabling is to allocate responsibility for each task in the timetable. It should be possible

to use the timetable as a checklist to ensure that everything is moving along, everyone involved is on target, and nothing has been forgotten.

The main difficulty inherent in timetabling is that it usually does not flow either particularly logically or chronologically. The order in which things need to be done is often dictated by fixed external factors, like venue booking or publication deadlines, which mean that decisions have to be made regardless of the fact that the exhibitor may not be ready to make them, for all sorts of practical reasons. For instance, press prints may have to be chosen before the final selection of images for the exhibition is complete, or an exhibition venue may have to be booked before all the exhibitors have been confirmed. This can be stressful and it can be infuriating but, unfortunately, most exhibition timetables work in this way, and it is crucial to keep to the timetable or the whole process may come to a halt.

In approximate chronological order, the tasks that need to be scheduled include:

- production of final copy for printed and press materials—that is, press release, advertisements and listings information, press prints, and invitations
- dates for copy to go to printer, with turnaround time for proofreading and delivery (invitation, catalog, printed brochure)
- printing of photographs
- planning and booking of talks and educational programs
- arranging insurance
- arranging transport
- text production (artist's statement, captions, price lists, supplementary texts)
- matting and framing photographs
- private view preparation, including arranging additional or specialist staff if necessary
- mail out
- arranging security personnel, gallery attendants, or invigilators
- reminder to press and colleagues of the opening date
- preparing the gallery for the new show and decorating if necessary
- hanging the work
- overseeing the private view or artist's reception and clearing up afterward
- documenting the work
- taking down the exhibition and cleaning or decorating the gallery

A timetable, if it is to work well, must be detailed. There is an art to drawing up a good and useful timetable. Most

galleries do this well because they do it all the time, their systems become routine, and they work with the same suppliers for each exhibition. It is much harder for a small organization or individual to draw up an accurate timetable, and it is worth putting a lot of time, effort, and research into doing it and liaising well in advance with all the other people and organizations involved (press, printers, framers, transporters, and so on) to make sure that it is going to be accurate. This means, for example, not simply asking framers how long it will take to frame a certain number of prints, but also when they can fit it into their schedule, how busy they are, and whether they can still complete the framing if it comes in late or, perhaps, if just one or two prints arrive at the last minute. Every eventuality needs to be thought through.

Some aspects of a timetable, like press deadlines, will be absolutely inflexible, whereas others, like writing exhibition captions, can usually be allowed to slip slightly. However, most items in a timetable depend on other tasks so if one deadline slips, others follow. For example, writing captions may sound relatively trivial in the grand scheme of the exhibition, but if the captions are not ready quite early on when press prints are sent out, it can cause major delays and missed opportunities for publicity. Or if the final selection of work is not done on time, then press prints cannot be sent out, frames cannot be made, or price lists drawn up. If a press print is sent out despite this, it may turn out to be an image that is not in the final exhibition; this will undoubtedly result in complaints from people who have come to the exhibition because they saw and liked that particular image in their listings magazine.

It is a good idea to build a little extra time into the timetable for emergencies and missed deadlines. However, it is a mistake to think that deadlines can be set unrealistically early. If too much time is built into the timetable, what tends to happen is that everyone involved recognizes that this has been done and they start to ignore the timetable and to work instead to a set of personal "real" deadlines. Usually the result is chaos.

Although a timetable can be amended during the process of organizing an exhibition, this should not keep happening. When it does happen, it is crucial that the revised schedule be clearly dated or numbered so that everyone involved continues to work to the same timetable rather than various different, earlier versions, as may happen if timetables are undated or unnumbered and get muddled.

Drawing up a timetable means working backward from the date of the exhibition opening. It's important to include at least one free, unscheduled day before the opening so that staff and artist can relax before the opening party and be ready to promote the work—rather than surreptitiously trying to make sure the captions are in the right place or being too tired to enjoy the event. Large public galleries often have the exhibition hung a week before it opens to the public; smaller galleries are usually closed for a much shorter period between shows.

Drawing up a timetable involves making an estimate of how long each task will take. Specialist providers, such as framers and printers, are usually precise about such things because their profits depend on it. Artists, colleagues, and gallery staff tend not to be precise and to underestimate how long each task takes, so it is worth making generous estimates. Most people, for example, when asked how long it takes to produce a press release, might say an hour or two. In fact a day is probably a much more realistic estimate, and it can only be done when all the decisions about dates, opening hours, titles, and so on have been finalized. Estimating time also involves building in time for delays, deliveries, and reviewing and redoing work as necessary. Anything printed or computer generated has to be checked for errors and reworked if needed. Printers may accidentally lose a crucial logo on the invitation and need to reprint the entire run in order to include it. Framers have been known to produce matted prints using the wrong color card. Staff time cannot be double booked to simultaneously proofread text and oversee framing.

Estimating times can also be difficult when the creative work involved in an exhibition is concerned. Most creative processes defy rigid timetabling yet have to be scheduled for an exhibition. It may take one artist an hour to make a final selection of his or her work and another artist several days. Some people can produce good text at speed and under pressure, and many more cannot. Many people postpone some of the apparently simple tasks, like providing captions, until the last minute. In fact, it is a very good idea to schedule these sorts of tasks early, either so that they are done and can be forgotten about or so that they can be considered, reconsidered, and rethought as many times as it takes without affecting either tempers or the schedule.

Actually hanging the exhibition is the task that most people tend to underestimate by a factor of about three. It is a

process that is almost impossible to hurry, so it is worth allowing an extra day for it so that, for example, if an exhibition is due to open on a Thursday evening, the work is hung by the Tuesday evening. This allows Wednesday and Thursday for the staff to relax, catch up on other work, and make any last-minute adjustments.

Publicity work must be done in stages, and publication deadlines have to be established as part of the process of timetabling. Glossy magazines have deadlines of anywhere between three and six months ahead of their publication date. Specialist photographic magazines may only be published a few times a year; their deadlines will also be well in advance of the publication date. Crucially, the publication date for a photographic magazine may not coincide with your exhibition, so it is important to check precise dates and make sure that the deadline is relevant to the exhibition date or information may be published after the exhibition has closed. If a magazine comes out rarely but is interested in a particular exhibitor or exhibition, it is well worth inviting the magazine to preview the work. Listings and "what's on" magazines usually work to deadlines of about a month.

A press release should be written and sent out as early as possible, but invitations should not be sent out early or people will forget—between two and three weeks in advance is usual. Telephone calls or emails to press or colleagues are important reminders in the last week before the exhibition opens.

Framing should not be scheduled in too tightly. A little flexibility is needed here. When the gallery frames its own exhibitions, time should be allowed for the inevitable breakages and discovery of missing clips and mirror plates as well as for cleaning glass and frames.

Both the show and the private view should be photographed as a record. The documentation of the exhibition should be made as soon as the exhibition is hung, just in case work gets damaged later.

BUDGET

It is essential to keep a budget for even the smallest exhibition. Even if the budget is tiny, keeping a record of income and expenditure is good practice. The experience and the information gathered can be used to cost future exhibitions and for fundraising. A budget can be kept very simply in an account book or computer program. All receipts should be

kept, numbered, and related to income and expenditure columns.

Keeping a budget is a two-stage process. The first stage is to draw up an estimated income and expenditure budget before the exhibition starts. This means asking for estimated prices for each contracted item, from framing to transport. It also means costing in time, materials, publicity, and administrative tasks in advance of the work being done. The ability to draw up accurate estimates is a skill that can be learned over time with experience of particular venues or types of exhibitions. The second stage is to draw up an actual accounting of costs when the final bills have been received. Comparison of the estimated and actual budgets is the basis on which anyone can learn to make more accurate estimates for future exhibitions.

Successful fundraising depends on being able to present a detailed and realistic estimated budget to a potential funder. For most funders, an important priority will be to ensure that their money will be wisely spent, and they are likely to ask sharp and detailed questions about a budget. This should not be difficult to respond to if each figure has been arrived at by a demonstrably realistic method, either with written quotes from suppliers or by estimates drawn from previous exhibition budgets. For example, if the exhibition organizers need help to install the exhibition, an estimate of the number of hours it will take can be derived from looking at how many people installed a previous exhibition, how long it took, and how the previous exhibition compares with the current project in scale.

It is important to include in-kind help—for instance, when someone donates the use of a gallery or curatorial assistance instead of charging for them. It is important to include this help for two reasons. First, it would give a false picture of the budget if an obvious item like a hire fee is left out. Second, it makes a donation very visible. Potential funders are always encouraged to give money when they see that another individual or organization has thought this project worthy of support.

In-kind help should appear as an equal amount in both columns of the accounts—as income donated and as expenditure—and the two amounts must balance out. For example, in 1998 the Royal College of Art in London supported a weekend conference I organized by lending us their lecture hall and adjacent spaces. The hire fee for this would have been £3500, and it appeared in the accounts both as an

expenditure of £3500 on venue hire and under income as a donation of £3500.

As part of budgeting it is also essential to keep a record of the time spent working on an exhibition, especially when no one is being paid, on the basis that time is money. This can also be entered as in-kind help in both columns of the budget. Having realistic and accurate figures from previous exhibitions is particularly useful when estimating curation costs.

It is also good practice to include a contingency amount of 5% or 10% of the total budget to cover unexpected costs and emergencies. Emergencies are likely to happen—no one can predict costs absolutely precisely, even if every item was carefully estimated in advance.

For photographers who need to keep their costs down, drawing up a budget can be painful because standards need to be professional but professional exhibition production can be expensive. So where can you save money without compromising on quality? Consider these possibilities:

- If you use one printing or framing firm regularly, they may well offer a discount for a bulk order in return for a credit (in the exhibition or on publicity material) for the exhibition prints or frames.
- The Internet has become a good source for economical frames and supplies.
- You can learn to cut your own mats for smaller works.
- Prices to mount and frame work vary more than almost any other item, so thoroughly researching what is available well in advance may result in reasonably priced options.
- If you have a good home printer, captions can be printed, mounted, and cut by hand.
- Visitors can be asked (politely, by leaving a bowl marked "donations" rather than by bar staff) to contribute to the cost of drinks at the opening or private view, and you need not produce food or nibbles.
- An exchange of an amount of time (for tasks such as hanging, working at the bar, and being present at or invigilating the exhibition) can keep down staff costs.

FUNDRAISING AND SPONSORSHIP

Finding funds and sponsorship for exhibitions is time consuming and is the sort of task many artists dislike intensely. It is also a slow process that needs to start well in advance of an exhibition. And, of course, it is not always possible to find financial support. Or sometimes people who offer support want too much in return—for example, the regular use of the gallery space to entertain their clients in return for a

Handout
THE BUDGET

Expenses could include:

1. Staff/personnel costs and fees and additional costs for
 - additional staff such as a curator or publicist
 - temporary help—e.g., with mailing, hanging, painting the gallery, staff for opening party
 - fees for designer of artwork and/or the exhibition
 - fee for speaker at opening event
 - costs for gallery attendant(s)

2. Gallery costs: Could be any or all of
 - hire fee/rent
 - electricity, lighting, and heating
 - insurance

3. Administration and miscellaneous general costs
 - phone calls; photocopying and stationery; travel; petty cash, etc.

4. Publicity: Could be any or all of
 - press release
 - invitation
 - poster
 - catalog
 - press prints and CDs
 - paying for listings or advertisements in magazines and newspapers
 - postage

5. Producing and presenting the work: framing/mounting to exhibition standard

6. Hanging and presentation of work
 - captions and text production and mounting
 - large vinyl letters to go on the entrance or similar
 - miscellaneous materials or tools (e.g., velcro strips, screws, plugs, blue-tack, mirror plates, paint, brushes, cleaning materials, etc.)

7. Transport and packaging of work, including van hire, insurance, and material such as crates or roll bubble wrap

8. Opening event or private view
 - wine/beer/spirits
 - juice and water
 - food or small snacks
 - glasses hire/breakage

9. Documentation of the show

10. Contingency at 5% or 10% (always allow for contingency on principal)

Income could include:

1. Sales of work

2. Sales of anything else: catalogs, postcards, picture frames, etc.

3. Sales of drinks at the opening event

4. Funds raised through sponsorship, grants, fundraising events, support in kind

contribution to the private view budget. This can cost the gallery a great deal in time spent attending these events and clearing up afterward and may put fragile work at unnecessary risk.

However, it is well worth exploring options in this area because one of the ways in which this sort of support is invaluable is in creating a firm base of support for a gallery and introducing new audiences to the work.

The sorts of financial support you may achieve include:

- drinks for the opening night (supplied by firms who want to advertise their product)
- photographic printing (by printers who will give a discount in return for advertising)
- printing, of invitations and catalogs (by printers who are using down-time on their equipment and hope to gain a market in specialty printing for artists)
- support for exhibitions on particular subjects such as poverty or homelessness (from related organizations and charities who will support a project which raises the profile of their charity)
- support in kind (by local firms such as caterers, florists, or decorators in return for advertising by word of mouth or in a gallery leaflet)

In return, the firms usually want the name of their product prominently displayed and their logo on all publicity material. A thank-you can be included in text in the gallery itself.

Just as important is a real thank-you made in person by phone or by letter. Sponsors should always be invited to the opening party. If they do not come, it is well worth phoning them the next day to give them an informal report back. This is a way of ensuring their continuous support. Many commercial organizations enjoy supporting the arts because they find them glamorous, and inviting the directors or other personnel to occasional events or an informal lunch, keeping them informed and in touch with ongoing developments, is a way of keeping their involvement and interest.

Many artists hope to avoid having to learn how to get sponsorship, but it is a skill that can be learned and gets easier over time. Good fundraising is done when everyone in an organization is aware of the need for it and what funds are being sought rather than when it becomes the remit of one person alone. This is because the initial fundraising contact or opportunity is likely to come through chance, word of mouth, or casual conversation rather than by cold calling. A gallery that is well thought of in its local community is likely to find more financial help through this sort of connection than is one that keeps itself apart from that community.

Cold calling to ask for sponsorship takes nerve. If you don't know who to speak to, phone first and get the name of the person who handles charitable applications. Before you phone, write out your blurb or pitch. Be direct, precise, and brief. Have amounts, dates, and numbers ready. For example, if you are looking for drinks sponsorship for the opening night, you need to be able to give the date, the approximate number of people who will attend (based on previous figures or knowledge of who has been mailed), and how much you are looking for. With cold calling like this you have about thirty seconds to make your pitch. If this makes you nervous, then practice on friends first!

TRANSPORT AND INSURANCE

Transport needs to be planned well in advance, particularly if distance is involved or if the work is too large for the use of the exhibitor's own vehicle.

If the works are small and can be framed in the gallery rather than the studio, it is worth considering transporting the work unframed rather than risking damaging both frames and images in transit.

Specialty transport firms for the arts are much more reliable and experienced than firms that specialize in domestic or commercial moves, although they also tend to be more expensive. However, it is often worthwhile to use a firm that understands the careful handling of artwork.

Works can be packed using bubble wrap. Corners should be additionally protected by padded or solid corners. These can be bought from framers or be homemade by using corrugated cardboard or large padded envelopes. Mirror plates should be removed before packing the images because the plates may snag against the work, prevent the frame from resting flush on the floor of the van, or tear packaging materials. The plates and screws can be put in an envelope and taped to the back of the frame.

If a set of framed images is to be moved, they should be packed in pairs face to face. A large number of works in frames should not be packed flat on top of each other, as the weight can damage the work at the bottom. Framed images should be stacked upright. Old blankets or heavy-duty cardboard should be used to cover the floor of the van or car. This will absorb vibration and protect the frames against scratches caused by metal projections.

You must make sure you have a detailed list of what is being moved and that it is checked both when it leaves your space and when it arrives in the gallery.

INSURANCE

Insurance in the arts can be a problem because insurers, and in particular domestic insurers, are unaccustomed to insuring or valuing artworks. Reputable arts insurers should be used wherever possible.

Most galleries have their own insurance that will cover artwork while on the premises. However, while theft is relatively straightforward to prove, artwork that has been damaged while in the gallery is often more problematic. It is worth drawing up a delivery note, which the gallery signs when receiving work, to make sure that the work is seen to have been delivered in its entirety and in good condition. This should be checked by both artist and gallery together. This may seem unnecessarily bureaucratic, but it safeguards both artist and gallery.

A gallery's insurance will not necessarily cover work being transported to or from the gallery. Specialty art movers will insure the work while it is in transit and make sure that they pack and handle the work appropriately. Commercial firms, however, may well take on moving work and not treat the work with appropriate care because they are not used to moving artwork. They may then refuse to pay for damage on the grounds, for example, that the work was inadequately packed. It is difficult to prove that work has been properly packed and difficult to put pressure on the insurers if the insurance was taken out to cover a single journey.

Exhibiting work in non-gallery spaces is a riskier proposition than showing in a gallery, so the costs for insuring a building for a one-off exhibition may be prohibitively high. The work is likely to be more at risk from vandalism and opportunistic burglars than from art thieves. In fact, artworks are sometimes stolen by burglars who really only wanted to steal equipment but the art gets lifted too because it is *in* the equipment—for example, an irreplaceable CD that is in a CD player. Artists showing in a gallery that seems at risk would do well to recognize that equipment can be replaced but work lost is often irreplaceable—and so they should take appropriate steps. For instance, work can be removed from computers and projectors when the gallery is locked up at night. Then if the equipment is stolen, at least the art is safe.

It is probably also worth removing price lists at night if this is possible. A colleague of mine packed up all her framed work after an exhibition in which she sold nothing, only to find that the space was burgled over a holiday weekend. Every piece of artwork was taken. At first she was surprised but then remembered that the back of every frame had the price marked on it and assumed that the burglars (who were undoubtedly opportunistic rather than art thieves) thought they could sell either the frames or the work. In fact, it is unlikely that they could have sold the signed work publicly and the frames were worth only a fraction of the value marked on the back. Nonetheless she lost a year's work simply because of the prices marked on the back of the work.

It can be difficult to reclaim the full value of an artwork that is damaged or stolen while in a gallery. Insurers are unlikely to be sympathetic to a claim of rarity for a photograph that can, hypothetically, be reproduced an infinite number of times.

USING THE EXHIBITION SPACE: PREPLANNING

Photography is, then, always a doubled or paradoxical form: the image is a transcription of a bit of the world and, at the same time, a picture shaped by the determinants of the apparatus and the choices made by the photographer. Maintaining this double focus requires effort and attention; failing to do so gets the viewer caught up in all sorts of problems.

Steve Edwards, *Photography, a Very Short Introduction* (2006)

Having an exhibiting career is a long-term commitment. A gallery will want to build a long-term relationship with its photographers/artists over the years and be actively involved in nurturing the artist and developing the work with them.

Zelda Cheatle, WMG Photography Fund portfolio manager

Galleries have a duty to represent their artists/photographers and work on an international basis, involving museum and institutional exhibitions and participating in art fairs such as the Photography Show (AIPAD) in New York.

Zelda Cheatle, WMG Photography Fund portfolio manager

It is scary how much it costs to bring work across the Atlantic.

John Gill, director, Brighton Photo Biennal

A gallery is constructed along laws as rigorous as those for building a medieval church. The outside world must not come in, so windows are usually sealed off. Walls are painted white. The ceiling becomes the source of light. The wooden floor is polished so that you click along clinically, or carpeted so you pad soundlessly, resting the feet while the eyes have at the wall. The art is free, as the saying used to go, "to take on its own life." The discrete desk may be the only

piece of furniture. In this context a standing ashtray becomes almost a sacred object, just as the firehose in a modern museum looks not like a firehose but an esthetic conundrum.

<div align="right">

Brian O'Doherty, "Inside the White Cube: Notes on the Gallery Space,"
Artforum (March 1976)

</div>

The sequence of hanging an exhibition is as follows:

- look at the space
- look at the work
- group the images
- decide on frames, picture sizes, and presentation methods
- plan a hypothetical hang on paper
- reconsider the plan once the mounted work is in the gallery and do the actual hang

A "good hang" is one of the most important aspects of an exhibition. A good hang will work at a fairly subtle and unconscious level and show the work in a way that seems natural or inevitable, as if each image is in its proper place and this is the only way that the work can be shown. An audience is much more likely to recognize when a show has been hung badly because they will feel uncomfortable with the sequence of images or feel that they have somehow missed the point of the exhibition.

Positioning depends as much on such superficial elements as choice of title, presentation, and method of hanging as it does on weightier factors such as the critical language adopted by the catalogue; exhibited in one venue, a particular body of work will attract the attention of photography critics, while precisely the same work shown in a different venue may be discussed by art critics whose knowledge of photography might be quite superficial, but who will attempt to place it within the context of the contemporary visual arts.

<div align="right">

John Stathatos, exposed 02 January–April 1998

</div>

I could never bear unnecessarily elaborate installations—designers who impose their "look" on an exhibition instead of letting the work speak. It's very much a museum thing to do with a perverse notion of increasing accessibility. It says to me that the museum doesn't have confidence in the work.

<div align="right">

John Gill, director, Brighton Photo Biennal

</div>

A good hang takes time and careful thought and combines awareness of the work and of the space it is placed in. A space can, and should, dictate the way work is shown, and every aspect of the presentation of the work has to be sympathetic to the size and atmosphere of the space as well as to the work.

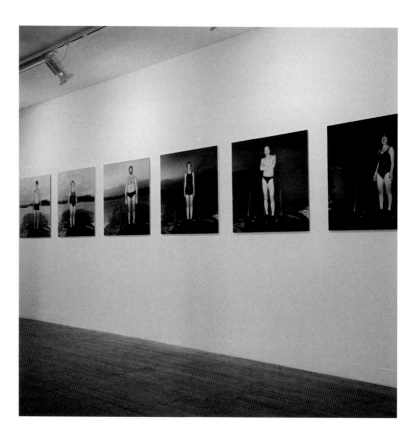

FIGURE 3.1A Image © Valentine Schmidt "Minus 7" from "Minus 7/plus 18" at Lounge, 2005. This series of images of Finnish swimmers was made just after they emerged from the ice-covered sea as dusk became darkness. Because of the extreme cold they all presented themselves to the camera in a particular way and it became important to present them as a phalanx of people and hang the images quite close together. The gallery floor plan made it clear that there was only one wall which would allow this hang—both because of the amount of wall space needed and because we wanted the audience to view the images from a distance in order to enhance the impact of the swimmer's stance.

The person who makes these decisions varies from gallery to gallery. Large institutional galleries may employ exhibition designers who select frames and organize the sequencing, size, and placement of photographs as well as the placement and style of accompanying texts. However, in some large galleries the hang is entirely decided by the curator, supported by in-house exhibition technicians rather than designers. In most galleries it is a negotiation between curator and artist, and in small galleries the artist may be expected to order and hang the work by him- or herself.

Planning an exhibition installation is usually a two-stage process. The first stage takes place early on when the gallery and artist decide:

- how the photographs will be presented
- what size the photographs will be
- how many photographs will be shown
- approximately which photographs go where and/or how the images will be sequenced

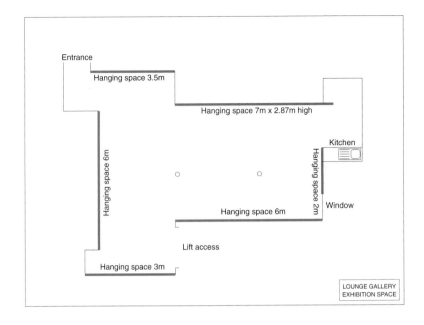

FIGURE 3.1B Floor plan from Lounge gallery, *www.lounge-gallery.com*

For some exhibitions a final hang can be decided at this stage, although for others this will wait until the actual installation of the work. Initial ideas about placing photographs may change during the actual hang, and sometimes the decision to leave certain photographs out of the exhibition is made at this later stage. This is because, in essence, a hang is dependent on seeing the actual photographs at full size in the real space. No amount of previsualization or preplanning can accurately duplicate this experience. Most curators will make an initial plan but leave enough time to rethink a hanging plan during the hang so that the final version shows the work to full advantage and makes the best possible use of the space.

STEP ONE IN EXHIBITION DESIGN

When starting to design an exhibition, the curator needs to spend time familiarizing him- or herself with the space and to take account of several things:

1. the size of the space

2. the space itself and its feel or atmosphere

3. the flow of the space or how a potential audience will move through the gallery

4. information points

5. practical issues particular to that space, such as the condition of the walls or floor

(1) Gallery size is estimated on running wall space. This is the amount of wall space available to hang work on, so it excludes windows, doors, "dead" or unusable space (small areas between windows or behind doors, for example) and pillars. It is measured horizontally rather than by square footage. Knowing the amount of running wall space allows the curator or exhibitor to estimate how many photographs can be shown.

Most galleries have a floor plan, which usually includes wall measurements with windows, doors, pillars, and electrical outlets and lists any additional freestanding panels or flexible wall systems that can be rearranged.

If you are curating your own exhibition, you will probably be doing most of the planning when you are not actually in the gallery space, so it is important to have a floor plan to work from. Photographs are also useful, though they can be misleading when it comes to size. I have also known people who worked with scale models. It is surprisingly difficult to remember a space accurately when you are not in it and very easy to miscalculate the number of photographs that will fit on a particular wall, so a floor plan is crucial and you should draw up your own if necessary.

It is also crucial to know where the electrical outlets are, particularly if projectors or light boxes will be needed in the exhibition, since they will probably have to be installed near those outlets. No gallery can risk the danger of trailing wires which could trip the unwary visitor. The lighting situation needs to be checked in case the lighting is uneven and there are places where it would be inadvisable to hang very dark images. Both things can be entered on a floor plan.

(2) Just as important is the "feel" of the space, its atmosphere, and the way it works visually. A great deal of thought has to go into getting the best use out of the space. To a certain extent most spaces dictate the way exhibitions are hung. For instance, a formal space—such as a perfectly proportioned, purpose-built gallery—may suggest the work should be hung formally in straight lines or a grid pattern. An informal space, such as a corridor or an unusually shaped room, may suggest that the work could be hung more experimentally. Alternatively, the curator may decide that a formal hang in a formal space will overwhelm the work and so hang the work in a deliberately informal or apparently random pattern. The curator might also decide that the informal space needs a formal hang in order to overcome a haphazard layout and so hang the work in a straight, evenly spaced line which

takes no account of uneven floors, unexpected steps, or turns in the corridor but keeps the audience's attention on following the line set by the photographs. Whichever decision is made, the final installation will be a negotiation between what the space and the work each suggests. The important point is to take the space itself into account when looking at exhibition design.

On a practical level, spaces that are built to show art or that include large, uncluttered rooms are easy to work in. Obviously it is more challenging to work with spaces that were not originally designed as galleries but have been adapted. Such spaces can have awkward areas with quirky corners, curving walls, large or unevenly spaced windows, and pillars impeding sight lines. Sometimes, though, an awkward space can be an advantage rather than a problem and can add to the interest of an exhibition if used imaginatively. Where a large space can intimidate visitors, a series of smaller spaces can be intriguing and give visitors a sense of privacy in which to respond to the work. This may mean that they feel more able to pause, meander, and take their own time to view the art rather than succumb to the relentless few seconds in front of each image that large galleries sometimes impose.

An experienced curator gets to know and understand the way the space works by spending time in it and looking at it from every angle, walking around it, and seeing what the space itself dictates. Where does the light fall? Where does an audience coming into the space tend to look first? Where are the sight lines? Do certain walls need to be used in particular ways? Will a straight line of photographs work on a curving wall? Is there a danger that the audience could miss parts of the exhibition because of the layout? Might a low ceiling, uneven lighting, or a dark floor create a slightly oppressive atmosphere that will not suit particular photographs? A curator of the Photographers' Gallery once told me that one of his achievements was to lay a temporary floor over the gallery floor when he recognized that a particular exhibition of light and delicate imagery would be visually dominated by the dark gallery floor.

Again, when planning to design your own exhibition, you will need to note strategic places to hang key works, places where a pillar, alcove, or doorway could get in the way of the sequencing of the work, odd spaces that will need to be used in a different way to the rest of the hang, and where you can't hang the work into the corners.

(3) The "flow" of the exhibition is how your audience will move around the space and how you keep them interested in seeing the whole show and in moving from one piece of work to the next. This is particularly important in non-gallery venues like old factories or shops that have odd spaces or several floors and you have to make sure people get from one space to the next. In most galleries the flow is dictated by the space itself and by the placement of items like the reception desk, office doors, and internal staircases.

I experienced how this can go wrong when I went on a bus tour at the opening of a photography festival in a city I didn't know with a group of critics and curators. The first exhibition we visited was in a converted shop. The shop was long and narrow, and I followed the people in front of me as they moved around the exhibition. I found myself back at the bus quite quickly, so I returned to look for more work but could find nothing. There was no list of exhibitors so I had no way of checking whether I'd missed something. Later I found out that there had been more work on a different floor, but the door was unmarked and had been accidentally closed behind one of the visitors. As a result, more than half our group on the whistle-stop tour had missed a sizable part of the exhibition, and there was no time to return to see the rest of it. This situation could easily have been avoided if the exhibition curator had thought to continue the work up the staircase, fix the door open, or attach a sign saying "exhibition continues upstairs" by the door.

In addition to making sure the audience moves easily from one space to the next, the curator thinks about how the audience will move from one image or set of images to the next. To make the flow work, the images should connect visually or by subject. This need not be subtle at this stage of the plan and is simply about juxtaposing different bodies of work that will be sympathetic.

The curator should also be thinking about the overall look of the whole space. Standing by the entrance and imagining how the audience will be drawn into the space is a good way to do this. Often this means putting a large and striking image at the back of the space. At a recent Photo London, a whole vista opened up through doors which led through room after room with only the end wall visible from the main doorway. Hooper's Gallery placed a single, large, predominantly red image in that space so the audience, who were too far away from the image to see it in detail, found themselves drawn

through all the other exhibitors' spaces to look at that one dramatic image.

(4) Thinking about the flow also includes planning the placement of text and information panels. It is essential that this is taken into account at this early stage, even though the text may not yet have been written, because space has to be allocated to these panels. An approximate calculation of what text will be necessary can be made and the panels placed within the overall design.

The number of text panels designed into the exhibition at this stage will then dictate the amount of text that will be written, and it is important to get it right. Few galleries have the sort of flexibility to allow extra text panels to be inserted at the last minute.

Text usually includes a panel at the beginning of the exhibition which acts as an introduction and context. There may also be a panel at the end with thank-you's to sponsors, logos, and credits for work done on the exhibition. Text panels can utilize a gallery's dead spaces; these are spaces that are too small or too awkwardly placed to show photographs. Text can also be a way of dividing different sections of an exhibition and marking the introduction of a new exhibitor, a new concept, or a new period of time.

(5) This early planning stage is when the exhibitor or curator should ask practical questions of whoever is responsible for the hang. This may mean talking to a gallery manager rather than the director or curator. The aim is to find out what systems are in place, who does what, what they expect of the artist, what technical help and equipment are available (does the gallery have a toolkit or long ladders, for example) and to check timings (for example, what hours do the technical staff work or is the gallery open for work to be delivered or installed on the weekend).

It is also essential to check if there are fire, health and safety, or other regulations about what you can and cannot do in the space. This might mean knowing what notices can and cannot be removed, which exits have to be left completely clear, and so on. One of the biggest mistakes I nearly made was many years ago when I took an exhibition to the Royal Festival Hall on London's South Bank. We had drawn up our hang fairly precisely. The largest piece was a single image approximately 16 × 12 feet and there was only one wall where it could be installed. Unfortunately no one had thought to discuss this in advance. We discovered on the day

FIGURE 3.2A Image © Arno Denis. Not hanging images right into the corners of the gallery makes the flow of the exhibition work better.

of the hang that the Royal Festival Hall is a Grade 2–listed building which means that no one is allowed to drill into the original structure, but there was no other way to secure the piece to the wall. In the end, after a long day of discussion, the gallery director took the drill and made two tiny, invisible holes himself and the work went up.

Many of these design issues are only meaningful to the curator or exhibitor—an audience will barely notice the space or exhibition design if the space is used well. It is usually only when it has not been thought about or handled successfully that the audience becomes aware of the space itself or the layout of the exhibition because it distracts them from looking at the work itself.

FIGURE 3.2B Image © Arno Denis. Hanging images right into the corners of the gallery creates audience traffic jams.

STEP TWO IN EXHIBITION DESIGN

Having taken these five things into account, the curator then starts to work on the overall look of the exhibition, planning how the photographs will be presented, what size they will be, how many photographs to show, and approximately which photographs go where or how the images will be sequenced. All of these decisions are interdependent and relate to the space itself so that, for example, a decision made about the number of images affects their possible size and vice versa.

So, for example, in a large, high-ceilinged space the curator might decide to show four images by an artist, all of which are presented at their maximum size in order that the space should not overwhelm the images. In a smaller space the curator might use more images from the same set of images at a smaller size. One way to test the proportion of the images to the available wall space is to make rough prints of various sizes or use sheets of colored cardboard and attach them to the wall in order to make a visual assessment of the best size of print to show in that particular space.

The curator will probably consider each wall as a separate hanging area rather than as one continuous hanging line. The exception to this is when the work has a clear narrative thread, which means that it has to be shown in a particular sequence with a beginning at the start of the gallery and an ending at the exit.

The curator will usually start the process of exhibition design by looking at what practical issues dictate certain choices in placing the work. There are all sorts of possible practicalities to be taken into account. In a group exhibition, for example, this could mean that one person's work can only fit on a particular wall because there are either too many or too few images for other walls. Or that a large image can only go on a particular wall because it needs a good viewing distance (that is, the audience needs to be able to stand well back from the photograph to take it all in) which can only be found at that one place in the gallery. When dealing with projectors or light boxes, the positioning of electrical outlets may mean that these can only go in specific places. Or the curator may know that certain images are fragile and want to place them where they are least at risk from casual damage or will be directly under the eye of the gallery staff. Once decided, other choices can be made around these initial decisions.

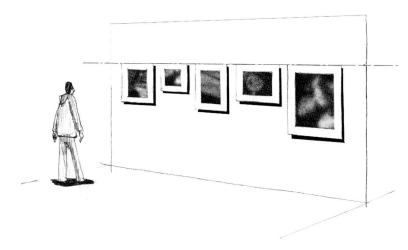

FIGURE 3.3A Image © Arno Denis. Hanging from a top line.

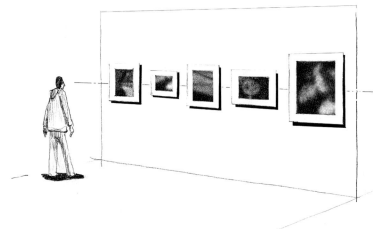

FIGURE 3.3B Image © Arno Denis. Hanging from an imagined middle line.

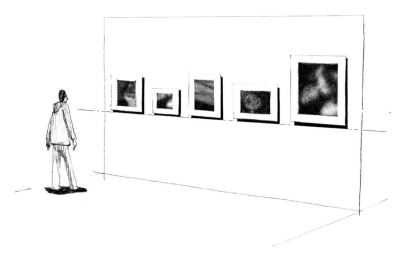

FIGURE 3.3C Image © Arno Denis. Hanging from a bottom line.

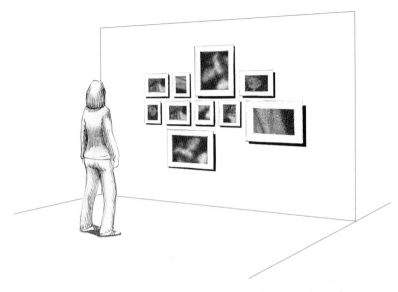

FIGURE 3.4A Image © Arno Denis. Creating the same amount of space between each image can hold a disparate group of images together.

Once choices have been made out of necessity, there are choices made because of the overall look and feel of the exhibition or images. Size, impact, and flow are all thought about here. It could mean that certain images are best hung separately because they are busy or disquieting and need space around them. It could mean that particular images are chosen to hang at the start or close of the exhibition because of either their dramatic or their contemplative quality. In a fairly bland gallery space, the curator may well want to place a dramatic image or grouping of images where the visitor's eye alights from the entrance, to draw them across the space.

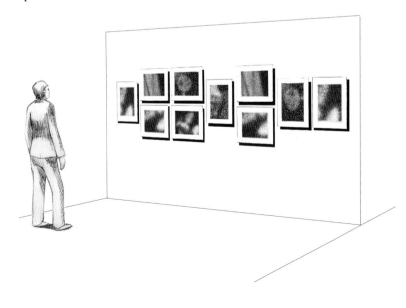

FIGURE 3.4B Image © Arno Denis. Making a grid often works well though is sometimes too formal.

Choices made about the size and framing of images depend both on the images themselves and on the space they will be shown in. Not all photographs can be resized to suit the scale of the gallery space. Some images may have to be a particular size or are already be printed at that size. In an installation of Fiona Tan's work "Vox Populi (Sydney)" at the Photographers' Gallery, for example, she showed images from family albums. The images were small and represented a genre of photography that is most usually read as small images. She therefore retained the size but showed over ninety photographs which filled the wall space in the same way that family photographs fill a family album.

The scale of the gallery and the print should be related where possible. In a large gallery, small photographs tend to disappear in the space unless they are hung in groups. In a small gallery, it may not be possible to stand back far enough to take in a very large print. A large print will appear smaller in a large space but move it, for example, to a smaller space between two windows and it can become overwhelming and appear cramped in the space. As a rule, the larger the image, the more space it will need around it.

In a mixed exhibition the curator will want to consider how to group work and how each group of works leads on to the next. Color, composition, subject matter, and style all play a part here.

An example of this is an exhibition of student work in a gallery in which the gallery space was divided into five discrete areas. There was no overall theme to the exhibition, and the students had produced eighteen sets of very diverse personal work. It was exactly the right amount of work for the space available, so fitting it into the space was not an issue. The issue, however, was how to group the eighteen sets of images to fit into the five spaces while ensuring that the juxtaposition between each set of images would enhance, rather than distract from, each set.

After much discussion we grouped the work in this way:

- three sets of images on the landscape of the human body (these included close-ups of hands, of heads, and a set of back views of women with exceptionally long hair)
- two sets of images where the subject matter appeared out of darkness (one of trees at night and one of joints of meat hanging in the dark interior of a meat store)
- four sets that shared a cool objective look at their subject matter, all devoid of people and slightly desolate or melancholy (interiors of rooms to let, shop fronts, decaying industrial scenes, and empty corridors)

- six sets that had a more subjective, gentle, and personal feel to them, some in soft focus or showing movement (they included light reflecting on an old mirror, a beach in the rain, sun through a car window, odd moments of London light, and the edge of a palm leaf)
- three sets in which the print size and style held the sets together because they were all panoramas (of skating, water, and street scenes)

So, within one exhibition, it is possible to group work using a variety of completely different types of links—in this case, the subject matter (the body landscapes); the mood of the photographs (the objective and subjective approaches); the contrast of light and darkness of the images and the shapes or format used (the panoramas). None of these links was subtle, nor did they need to be. The division of the space into five discrete areas meant that the audience unconsciously expected work to be presented in five discrete sections. Each section was held together visually. The groupings meant that the transition from one image to the next was made easier for the audience. If we had put the exhibition up more randomly—for example, putting a set of images of the human body next to bleak industrial images—we would have undermined the impact of each set and perhaps encouraged the viewer to make connections between the works that were not intended.

Once the work is grouped, it is a great deal easier to decide which sets of images to place on which walls. This will be determined by the relative size of the walls and of the groupings of work as well as by the overall flow of images. The curator then decides how the work should be placed on the wall. All sorts of options are possible here. It is no longer the case that photographs must be hung in neat single or double rows of identical frames. We do not expect images to be presented at the same size, in matching frames, or even in frames. There are many alternatives to traditional frames, including mounting on aluminum or board; attaching directly to the wall with pins, tape, or behind acrylic glass (Perspex or Plexiglas); light boxes; hanging work clear of the wall; and using display boxes.

The wall itself can be designed to be viewed as if it were a page in a magazine or book, or like a theater set in which the photographs are used to make a shape on the wall. Groups of photographs in the shape of a circle, triangle, or cross all work, as does a more amorphous shape. Photographs can also be placed on the wall in an apparently random way, stacked tightly to fill the wall or placed at uneven intervals. The wall itself can be painted, written on, or stenciled on.

In planning an exhibition, the juxtaposition of photographs should help to open up the meaning of each image. By putting these two photographs together—one shot in the open air in Iceland and the other inside a women's prison in Britain—the audience is encouraged to think about the sense of freedom that swimming can bring and what place might mean to the swimmer.

FIGURE 3.5A Image © Astrid Kruse Jensen. From "Hypernatural."

Text can be placed on panels but can also be attached directly to the wall by using precut vinyl lettering.

While each wall can be designed separately, the look of the whole space is kept in mind along with the way that each wall leads into the next set of images.

ESTIMATING HANGING TIMES

Hanging a show, if it is to be done well, always takes more time than anyone imagines. Look at the space, look at the work, estimate how long it could take to hang your photographs, and then multiply that number of hours by three and you may get somewhere near a realistic estimate.

Always allow at least one extra day to hang. The task can't be hurried. If possible, get additional help from people with practical skills and people who will be happy to run errands.

However much prepreparation has been done, there will always be delays caused by small tasks that have to be done precisely and therefore take time.

Besides the slow process of actually hanging the work, two things usually take the most time during a hang:

FIGURE 3.5B Image © Valentine Schmidt.
First length in Bullwood Hall Prison.

1. Checking and rechecking the original plan for placing the images in the space to
 see whether it works in practice. This means moving the images around and testing
 different layouts until everyone is satisfied that the work looks its best in the space.

2. Working out exact measurements for the hang. Very few people can hang a show
 by eye and get it right.

Below are a few examples of the time it takes to hang an
exhibition. In all these situations, the people hanging were
fairly experienced, all the work was already mounted, the
hanging systems were already in place, and the basic design
of the hang decided.

- In an exhibition in display cases in a college corridor, a colleague with fifty-four 16
 × 20 inch photos, already window matted and mounted on card, took between five
 and six hours to organize the images into groups of two, three, and four and attach
 the images to the soft board interiors of purpose-built large frames, using long-
 shanked pins.

- In a conventional gallery space, it took ten hours for two people to put up a wall of
 twenty-two images. This included seven photographs under acrylic glass (Perspex),
 thirteen mirror-plated small frames, and one large box frame. The Perspex was
 predrilled, and most of the frames were mirror-plated before the start. Some work
 had to be completed on the large box frame, one image had to be remounted in its
 mat, and four additional mirror plates had to be attached.

- In a studio gallery in a factory, it took six people a full day to hang an exhibition of twelve large images by two photographers in a gallery space with six walls. The images were 30 × 40 inches and 32 × 32 inches and had two different but simple fixing systems. The day included a lunch break, one person arriving late because he'd gone to collect catalogs, and a fairly early end to the day. All six people were experienced, the layout had been worked out in advance (although not in mathematical detail), and it included putting up a text panel and large vinyl lettering. We had all the equipment we needed and nothing was broken or needed replacing on the day. We did it a week before the show was due to open, something that is not always possible, and returned to put the captions and price list up and light the show on the evening before the opening.

- In a student exhibition, it took one of the students four hours to hang six photographs. I don't know what happened, but he was the most experienced of the students and I think he not only took a great deal of time experimenting with different layouts but stopped hanging his own work in order to help other, less experienced students. Both these things frequently happen during any hang (and are often part of the pleasure of hanging a show)!

The forward planning of an exhibition is, in itself, time consuming and finicky. And at times it will feel like wasted effort as the timetable or the budget may well have to change during the months of exhibition preparation. But once the planning is done, the exhibitor should feel much more in control of the whole process of exhibiting and that will be liberating. Sorting out the detail well in advance, even if it does necessitate making hard decisions, should allow the exhibitor the time and the freedom to focus on showing the work to best advantage.

Case Study Three: TRACE: An Initiative by and for Artists

We moved as a family to Dorset from London in 1991. The experience of living in such a rural environment had quite an effect on us. We felt quite cut off culturally; there seemed to be no venues showing the kind of work we wanted to see; most of the exhibitions were fairly routine and unchallenging. We did feel as if we were in the middle of a (very beautiful) cultural desert. In 1998 we moved from the small rural village where we had been living, to Weymouth. Weymouth is a seaside town with a lively tourist industry. It is very much a working community and has a lively edge to it. Our

new home is close to the beach and shopping center and had been a shop. It still had the large Edwardian shop-front window, and once the interior had been opened up, displayed a wonderful north light. It seemed a perfect space for showing work.

TRACE was established in 1999. The thinking behind the choice of name was to suggest the idea of something left behind, an after-experience, which hopefully might stimulate further thought or activity. Our aims were, and are, to develop projects and events that promote new visual and literary work. The first shows took place in 2000, and we held only two exhibitions that year. Work was selected over the first two years, from artists whose work I admired and knew already and who were finding it difficult to get their work exhibited. Exhibition, postage, printing, and private view costs were all shared equally by the artists and TRACE. Since then, an average of four exhibitions a year of primarily photographic work have been held in the house, by artists of international standing as well as newer emerging names. More recently, TRACE has begun publishing books under the imprint TRACE Editions.

Our priority is to support and promote artists. As artists ourselves we know how important it is for TRACE to offer artists the space and freedom to develop new ideas, away from other constraints and pressures in the marketplace, by directly addressing their needs and concerns, giving them the time and space to develop projects that they might otherwise not have had the opportunity to develop. It is an experimental and research-based initiative, where concentration is on the work, in new forms and in new formats.

One way TRACE helps artists is by offering them an opportunity to show work that might be at an experimental stage— to test it, see if it works. The overall intention is that everyone who attends a TRACE event will undergo some form of transformation from the experience, not least the artist. We developed a package that we offer to every artist showing with us: private view with accompanying talk event, documentation in the form of a CD with installation photographs of the exhibition, a copy of the talk event on video, a set of postcards ordered at the time that the invitation postcard was printed for promoting their work, and a small fee.

It is important to us that the exhibition itself is presented in the best way possible. This does not mean that we spend vast amounts on production; often the work is pinned or clipped to the wall unframed. Each show is very tightly

edited, and maximum space is allowed around each exhibit. For many photographers this is quite challenging, as they are always very keen to display their complete life's work, but we are very firm about retaining a concept for each show and veer always toward less rather than more. For instance, we never label the works in our exhibitions; instead we have a plan of the exhibit space with the work titles on the plan which the audience can carry with them while viewing.

For the last four years TRACE has been mentoring photographers; in addition, we regularly look at portfolios and offer guidance on editing, presentation, and new directions. We are also currently working on setting up a network for artists and photographers so that they can exchange ideas, have dialogue, and support each other through our web site. The goal is for the photographers, in time, to take ownership of the network for themselves, with TRACE acting as catalyst and the web site a conduit.

When we started out, we made a conscious decision not to apply for funding. Our thinking was that, if we could prove initially what could be achieved without funding, then later, with a good track record in hand, we would have a much better chance of obtaining funds. It was also important to remain autonomous; we really did not want to be coerced into running workshops for children or jumping through any of the other hoops one is expected to do when in receipt of public funds. One solution was a brilliant idea by two of the artists we showed in 2001: Siebe Hansma and Mirjam Veldhuis. Siebe and Mirjam are sculptors from Holland; they suggested that we sell art multiples at a low price and take some commission on sales, the revenue from which should help cover exhibition costs. This turned into the TRACE Edition, more of which later.

In 2002 we received a small production grant from the Arts Council. This was meant to pay TRACE for four exhibitions over a twelve-month period. We were able to make these funds last for thirty months, with the help of the growing TRACE Edition (and by not paying ourselves). This meant that all the funds were used to cover TRACE project costs. In April 2006 TRACE was awarded three-year funding by the Arts Council. This has been revolutionary for us in that, for the first time, we have funds in place for a small salary for the director. Having managed without proper funding for eight years, my main learning curve has been to sit down and work out exactly what TRACE's strengths and weaknesses are and to put systems in place that allow for growth

but not to the detriment of my own art practice. This has forced us to get organized and to make plans. The aim now is to make sure that in 2009, when the three-year funding comes to an end, the systems we have put in place will allow us to continue without having to rely on public funds but knowing we can access them when required for projects.

It took us quite a lot of time over the first couple of years to get the opening times right. The first exhibition happened in July. We were convinced we would get a large audience, being summertime by the sea. We had not counted on the fact that in good weather (and Dorset weather is very good) everyone would rather be on the beach. We also discovered that if we were open on weekends over a four-week period (which we were for the first two exhibitions), then someone had to stay in all weekend, every weekend for four weeks. This was not a great move when it was warm and sunny and there were two stir-crazy small boys in the house. We held the second show in October; this proved better for attendance, although the four-weekend situation was not helpful, as people tended to come for the first weekend or the last, not the two in the middle. Another problem was timing the openings and private views. In the end we decided to make exhibitions last for just two weekends, with the Thursday and Friday between them, and the rest of the week we'd be open by appointment only. This is the formula we have stuck to ever since, and it seems to work well for us. We also decided to have closings rather than openings; everyone is welcome, and this guarantees that more people will turn up to see the exhibitions than if they missed the start. We have experienced a number of problems since TRACE began. Most of them have been through lack of experience in running a project of this kind.

Now we face larger problems in attracting audiences, brought about by a slow collapse in infrastructure of the railway system and the growing creep of apathy in this part of the world. We used to have closings on a Sunday afternoon, which guaranteed a pleasant day out by the sea for our audience, many of whom would come from London, as well as an afternoon at TRACE, there being a reasonably fast train service back to London at the end of the day. Gradually over the last two years, the rail system has been affected by weekend repair work and much extended journey times of up to four hours each way with an interrupted service. We moved the closing events to Saturdays but now the rail repairs are happening on Saturdays as well. This is causing

a huge problem in scheduling exhibitions, forcing us to question whether we can continue with exhibitions in the house. At present we are seeking partners with larger venues and guaranteed audiences whom we can work with in promoting TRACE exhibitions. The plan is to place group shows in the outside partner venues, with a one-day symposium added in, and to continue to hold smaller solo shows in the house with a smaller talk event.

TRACE tends to show mostly photographic work, but we do not want to limit the sort of work that interests us. We promote all kinds of fine artwork, from lens based through to performance. It is hard to give a list of criteria used for selection; a lot of it comes down to instinct and intuition, although it goes without saying that work that is selected has to be of the highest quality. Much of it has been selected in quite informal ways, through recommendation, through teaching, through having exhibited alongside them, and through being familiar with the work in any case. Work is also selected at formal portfolio reviews such as Fotofest, USA, and Rhubarb-Rhubarb, Birmingham. TRACE has reached an exciting point now, in that we are not just selecting work for in-house exhibitions. Our expanded web site means that we now select for the online gallery, the TRACE Edition, and for publishing. The criteria for selection for all of these outlets are broader, and we are able to promote more people in newer and different ways, to suit what their work requires at any given time.

TRACE has achieved a lot since it began. We are proud that an involvement with TRACE has enhanced many artists' careers. At a time when public funding is being cut and many galleries and artist-run projects are folding, TRACE has kept going despite some hard setbacks. It is worth mentioning here that TRACE is still the only project dedicated to promoting photography in the entire South West region. Here is an outline of some of our main achievements:

The Edition exists largely on the web site, where it has currently expanded to over 100 artists. TRACE regularly sells to museum collections from the Edition; curators tell me that TRACE has the newest emerging names at affordable prices. In purchasing from TRACE they are not only acquiring good new work for their collection, but they are also supporting us. For many years the Edition was the main source of funds for our projects. The best illustration of this is the TRACE Edition Sale, the first of which was held in May 2004 at Hirschl Contemporary Art gallery on Cork Street. Over 150

works were exhibited, all for sale at the same price of £250 each. It was a benefit event for TRACE, and we took 50% in commission on sales. This profit covered costs and expenses for our projects for the next eighteen months. It had another advantage too, in that it offered support to over seventy-five artists; for some of them it was their first exhibition in a London gallery and it gave them their first ever sale of work. It was extremely well attended. Work is now available for sale directly via Paypal on our secure site. We plan to hold more Edition sales in the future and are currently researching partnerships with art fairs.

Publishing is now a key TRACE activity. In logical terms, the costs of production for an exhibition are similar to the printing and production costs for a publication, but a publication is potentially more rewarding. An exhibition, especially outside London, will—if a lot of time and expense are devoted to marketing it properly—guarantee a maximum audience of possibly 250 for an exhibition lifetime of four to six weeks. A book, on the other hand, can reach an audience of say 500 to 1000 and decidedly more if it is placed in libraries for an indefinite lifetime. It can be disseminated not only all over the U.K., but internationally too. It is well known that a book is frequently the perfect medium for viewing photographs; it provides repeated viewings of an artist's work and an intimate engagement with it. As a curator, I consider editing a book equivalent to putting an exhibition together, one that has a much longer life and can open many more doors for the artist.

TRACE asks the artists whose work we publish to raise the basic funds for printing and design of the book. Many of the authors have academic research requirements and are able to access these funds through their institutions as well as their regional arts boards, which TRACE acknowledges in the publication. Everyone we have worked with in this way has been happy with this arrangement.

The first book published under the imprint of TRACE Editions was *Wild Track*, poems by Mark Haworth-Booth (recently retired as curator of photographs at the Victoria and Albert Museum). It is a book of poems and images and perfectly illustrates the TRACE philosophy. Two further monographs were published in 2006: *Imagine Finding Me* by Chino Otsuka, and *Villa Mona, A Perfect Kind of House* by Marjolaine Ryley. Both books were supported by the Arts Council, and *Villa Mona* received additional support from the University of Sunderland. Both have been very well

received and have been reviewed widely in photographic journals. We are currently working on a word and image book, *Dark City/Light City,* a collaboration between writer Michele Roberts and painter Carol Robertson. This book is being supported by the University of Wales Institute, Cardiff, and Fivearts.

Every talk event TRACE has held has been recorded on video. This provides an excellent research resource for curators, writers, and students. We are updating our web site and are in the process of creating an archive of all the talks and events we will offer on the web site as downloadable podcasts. This means that the archive will be available worldwide.

TRACE has its own collection of work which has been growing over the last six years. We acquired the complete series of "Afghanistan Chronotopia" at the time of Simon Norfolk's exhibition with us, and one of the aims of TRACE is to offer the collection to university galleries for hire to enhance student learning and research, particularly in universities outside London where access to exhibitions is limited.

In 2006 TRACE hosted its first artist residency. This was a collaboration between TRACE and independent curator Kim Dhillon, supported by the Arts Council and Visiting Arts. Titled "Transylvania-on-Sea," we placed a young Romanian painter, Adrian Ghenie, in a studio on Chesil Beach on Portland. This came about after Kim and I, as Visiting Arts curators, visited Romania in 2005, where we discovered that studio space for artists in that country is almost nonexistent. The work made by Adrian during his residency is scheduled for exhibition during 2007 in the house. TRACE is now planning to sponsor at least one residency a year for lens-based artists, along with an exhibition and small publication, made possible this first year by the generosity of Neeta Madahar who has given us five unique Ilfochrome prints to raise funds for TRACE. The proceeds of the sales of these prints will totally fund at least one artist residency.

To be honest, the pleasure of running TRACE far outweighs the pain. The main pain is the worry about funding and the time that TRACE takes away from making my own work. I can cope with this though, if I think of TRACE as an artwork in itself; I can believe then that I am still working creatively and making something happen. It has been a major surprise to me that the experiment that began eight years ago has simply grown like Topsy and turned into a force that

drives me along, rather than the other way around. I have been constantly surprised by artists and their commitment to the project, the enormous amount of goodwill that surrounds it, how it has captured their imaginations as a small piece of freedom where artists are given room and space to try things out and to be allowed to fail (no one ever has, by the way). All of this I call the TRACE Effect—it just brings out the very best in people. So many artists have offered suggestions to keep it going: Mirjam Veldhuis and Siebe Hansma with their idea for the edition, the artists who have donated work for the edition, the many who refused their exhibition fees, Neeta Madahar who by her generosity has helped bring about the new residencies. There are times when I feel tired and wonder what it is all for, but all I have to do is to think of the Effect and everything is brought back into perspective.

Sian Bonnell
www.traceisnotaplace.com

Text, Printed, and Publicity Materials

FIGURE 4.1 "Highgate." "I print everything myself and each print will be slightly different. My images are often printed for the first time some twenty years after they were originally taken, so I have serious problems with the way photographs are described as being 'printed later'!" Gary Woods. Image © Gary Woods

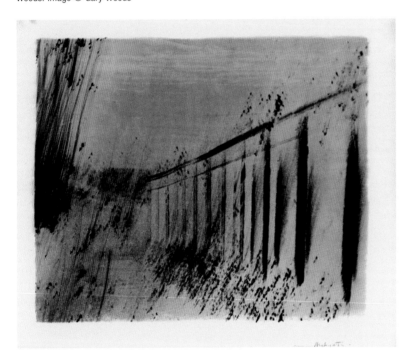

One of the most neglected areas of exhibition preparation is generally the text. This is often because photographers see themselves as visual rather than verbal people and either dislike writing or ignore its importance in showing the work. But exhibitions almost always entail a certain amount of textual material and it is well worth learning to produce good

text or the text can let down the rest of the show. Learning to write well about your work often goes hand in hand with learning to speak well about it and is a very useful skill to develop. The texts for an exhibition can include:

- an introduction to the exhibition and texts that accompany the images or different sections of the exhibition
- artist's statement(s)
- titles
- captions

There are many books on the market about how to write well; it's a big topic. But some basic guidelines about writing text for an exhibition are as follows:

- Keep text short. Too many words will be seen as privileging the text over the images and will distract the audience from the artwork.
- Keep text as straightforward and jargon free as possible.
- Make sure that basic and essential information is covered—places, dates, and names are usually important to the audience (even if they are unnecessary to an understanding of the images).
- Do not try to influence the reading of the work, critique it, interpret it, or describe what is in the images. All these things get between the audience and their experience of the work.
- Avoid emotive words and keep an objective tone. If the work is emotional, it will be undermined by the use of an emotional text.
- Avoid intimate personal statements. It is possible to present very personal work and still keep your privacy if the text is impersonal.

Think for a moment about your reaction to the text in an exhibition. Do you read text first or last? Do you feel unable to look at the exhibition until you have read all the accompanying texts? Do you look at an image and then at the caption, or vice versa? How different would the exhibition experience be if no text were provided?

Even when photographs are not provided with accompanying text (sometimes on the gallery wall or the odd advertisement), the viewer brings experiences and beliefs with them; we fit the images into narrative contexts.
Steve Edwards, From *Photography, A Very Short Introduction*

In the 1980s, photo exhibitions were text-intensive as a reaction against the formalist aesthetics of the previous era where any contextualization or captioning was excoriated. But the pendulum swung again, and today text is usually shunned in the gallery space and banished to the artist's statement available at the gallery desk or as a handout for visitors. Photographers can be creative at supplementing

their images by using sound, narrative forms, or producing their own gallery guide, or brochure. But it's not seen as acceptable at the present time to "force" visitors to read texts if they do not wish to.

<div align="right">Deborah Bright, artist, academic and writer on photography</div>

One way to envisage the difference between "art" and "documentary" in photography turns on this relation to language and narrative. In the main, documentary is a closed form, designed to produce preferred interpretations. As such, images are usually combined with some form of anchoring text that steers the viewer/reader in a particular direction. Photographic art, in contrast, typically abjures words, or employs elliptical text, in order to leave the image open to associations and interpretations. For art, vagueness or ambiguity are often the preferred modes.

<div align="right">Steve Edwards</div>

Seating also disappeared from museum galleries but has reappeared in the nineties. It is arranged so that its focus is not the art. A catalogue and other, varied reading materials are placed beside, on or in front of the usually hard chairs or benches. The pleasure of sitting and looking at art has been replaced by the task of reading about it. The work ethic prevails.

<div align="right">Reesa Greenberg, art historian, from *Thinking about Exhibitions*</div>

In his essay "Rhetoric of the Image," Roland Barthes (1977) asked us to look at the interdependence of text and image and the way that the "linguistic message is indeed present in every image: as title, caption, accompanying press article, film dialogue, comic strip balloon."

In the gallery, the danger is that the text will become more important than the image. There are many possible reasons for this. We live, we are told, in a visual world. Surrounded by images, we have a sophisticated understanding of them. While this may be true of images from television, advertising, and journalism, it is less true in the gallery context. In fact, many of us experience an uneasy shift from our daily experience of being bombarded by photographs that carry a common message ("buy this" or "try this") to the more complex experience of standing in front of a photograph in a gallery where we are being asked to look, to feel, and to contemplate possible meanings or perhaps ask questions of the image. In a gallery, an audience can be tense and wary and very uncertain of their reading of the images. For some people, the gallery experience also makes them nervous that they will be at the receiving end of heavy sales pressure, others that too much will be asked of them and they will demonstrate their ignorance of the finer points of art. As a result, an audience can rely too heavily on the explanation provided by the exhibition text.

FIGURE 4.2 Sea Change: Solway Firth Low Water 5.20 pm 27 March 2006. Image © Michael Marten

" 'Sea Change' compares identical views at high and low tide around the coast of Britain. The whole work is made up of pairs of photographs so, in thinking about how to present them, I considered printing two images on a single piece of paper or keeping them separate. In the end I decided that the best way to present them would be separately, probably without borders, and hung in pairs fairly close together." Michael Marten

For both curators and photographers, an important objective is to get the viewer to spend time with the image and to look thoroughly. As Simon Norfolk says (in an interview with the author for the Oral History of British Photography, 2003) "I aim to get people to look at my images for more than the usual four seconds." To achieve this, it helps if the text is short, unobtrusive, and as clear and straightforward as possible. It's important that the text not compete with the photographs for the attention of the audience.

In the past, many photographers insisted that their work "spoke for itself" and so provided too little explanation. Today we frequently have the opposite problem: the work may have been interpreted for us before we see it. The purpose of any text should be to give information and provide a way into understanding the work.

The use of text is one of the most important and least understood areas of exhibition production. On a practical level, writing text for an exhibition is one of the tasks that is worth doing early in the exhibition process rather than, as often happens, leaving it until the last possible moment and producing it under pressure. Writing about an exhibi-

FIGURE 4.3 Sea Change: Solway Firth High Water 12 noon 28 March 2006. Image © Michael Marten

tion before the exhibition has been designed is a useful exercise, which should clarify issues and ideas about the work for both artist and gallery; and doing this can make it easier to find the best way to present the work. A good text acts to support an exhibition, and a text produced in the early stages of an exhibition helps ensure that everyone involved can talk about the exhibition in a coherent and informed way.

Exhibition texts should always be as short as possible. As critic Lucy R. Lippard famously said, "I'd rather not read standing up!" Most people can comfortably stand and read a panel of text of between 50 and 100 words. Three or four simple paragraphs are usually sufficient for an introduction to an exhibition, an artist's statement, or a press release.

An exhibition introduction and additional texts may not be necessary. They are there to provide the audience, who could have wandered into the gallery without knowing the exhibition title or theme, with background information. If the exhibition is divided thematically or chronologically, each new section may need an introduction.

ARTIST'S STATEMENT

An artist's statement is sometimes used as an exhibition introduction, although it is useful in a number of other ways.

It is usually a very good starting point and reference for anyone writing a press release about the work and a way of making sure that he or she represents the work accurately. It is also appropriate text for any short leaflet, handout, or catalog and can be used as an introduction for an artist's talk.

Another, surprising use is as a record for the artist. Making work can be such an intense and all-absorbing process that many artists forget that, in a few years' time, there is a real possibility that they will not remember how the work came about. A statement serves as a way into the work for the artist as well as for the public. For any artist, writing a statement about his or her work can be very difficult but, whether it is used in the exhibition or not, it is a beneficial exercise to write one and a good way of clarifying ideas about the work.

This statement on "Maps from Nowhere" by Roma Tearne gives an idea of how to approach writing something that can be both personal and distanced. It was written before she undertook the work as a way of making clear for a gallery director, and for herself, a starting point for the work:

In 1991, soon after my youngest child was born, I moved from the house where I had lived for many years. Having moved the furniture I left a large rosewood box with my most personal belongings standing in the middle of my studio. The box was one that had travelled with my mother and myself across seven thousand miles from Colombo to London. It had once held all the belongings we brought with us from the tropics. Now I filled it with the photographs, the diaries and the mementos from the intervening years. I intended to collect it in the morning. So, having packed the box up, I placed a large "Do Not Touch" notice on top of it and went away for the night. The following day I was due to vacate the house. But on my return I found to my horror that the rosewood box had vanished along with the other debris. It had been removed by the house clearance men. Everything I owned, all the memories of generations of my family had been dumped somewhere in the North Sea. Discarded.

I have been looking for those stories, those diaries, those maps of my past for sixteen years now. Every photograph album in every junk shop I pass is a source of ardent curiosity. Who knows, I tell myself, they might still appear.

"Maps from Nowhere" is a project about this loss. It is an investigation on what might or might not be found after time. It is about a journey I may or may not undertake back to my home in Colombo, a journey that has been more than forty years overdue. It will not be easy to go back. My family is dead, my relatives untraceable, there is a war on in Sri Lanka, dengue fever is rife, as is malaria. And, even if I do go back, what can I hope to discover? The white house on the hill beside the coconut grove cannot possibly exist any longer. The school I attended—will it have withstood the war? Even the sea might have changed. I have heard that the tsunami has swept some of the rocks away from Mount Lavinia

Bay. I had carved my name on one of those rocks. Roma Chrysostom, age 10, Colombo, Ceylon, The World, The Universe.

"Maps from Nowhere" will take the form of a photographic project. It will be part of a journey into the interior, of a place, constructed by me over a lifetime. Nowhere was the place where my parents longed to return to when life became hard. It was a place that has existed for so long in the collective imagination of my family that finding it will not be easy, but by the writing of this proposal the journey itself has already begun.

This is an artist's statement that stands as a piece of writing in its own right and works whether or not we see the images. While it is intensely personal, it is both thoughtful and accessible and explains the photographer's intent clearly.

TITLES

Titles, both of the exhibition and of each work, are crucially important. They can be:

- descriptive
- locating
- allusive
- metaphoric
- contextualizing
- subverting

A title should be short, precise, and, if possible, both resonant and memorable. Titles can also be borrowed from books, poems, film, or music.

Alternatively, they can simply be a date, place, or name. Candida Hofer or Andreas Gursky will locate an apparently entirely anonymous modern institution by giving us its name: "Beinecke Rare Book and Manuscript Library New Haven CT IV" and "Prada 1" are both title and comment. Equally, a title can point out an absence of locating information: "Untitled," "Set 1," "First Series," and "Monochrome" are titles used to prompt the viewer to look at the image rather than seek information from a title.

However, a title can also be personal and inexplicable; it does not need to be explanatory or even very accessible. Rut Blees Luxemburg, for example, called one of her works "Cauchemar." This means "nightmare" in French, but the word itself is resonant enough for it not to matter if it is not immediately understood.

Titles to avoid are the sorts of generalizing and slightly sentimental "poetic" captions used by many magazines, such as "Light and Shade," "Sudden Smile," and "Time and Tide."

Titles can also point to the important element in the work but you should avoid describing something that can be seen in the image. Again, this is about *not* using text to do the job best left to the audience. Consider, for example, a photograph taken in China of an old woman's feet. This would be well described as "Feet"; as "Bound Feet" the title is overly descriptive. The audience will be aware that the photograph is interesting precisely because it is a photograph of bound feet and of a custom that has all but disappeared. "Boy, Serbia" is also overly descriptive if the child in the photograph is clearly a boy.

Appropriate titles can be surprisingly difficult to arrive at, and the task should not be left until the last moment. Word games, brainstorming sessions, and dipping into favorite books and poems are useful ways of finding titles. Sometimes they simply come about over time. If you start thinking of possible titles at the beginning of the exhibition process, write down every possibility and spend a few minutes each day mulling over words, you may end up with a useless list, but at some point the right word or words are likely to emerge from the subconscious mind.

CAPTIONS

The interaction between image and caption, ever-present in magazines, advertising—and textbooks—had been shunned in art photography, which expected the image to carry the full burden of meaning.

Mary Warner Marien, from *Photography, a Cultural History*

The convention for producing caption information is as follows, and in this order:

• the photographer's name

• the title and date of the work

• any necessary additional information like "from the Series . . ."

• the print type and size and mount information

If this is a selling exhibition or fair, the caption will usually include further detail such as:

• archival information (such as "archivally processed, mounted on rag board")

• the edition information or number (for example, edition of 5)

• a price or a number related to a price list

This information should be kept simple and unobtrusive, the text aligned left, and each data item on its own separate line. Use as little punctuation as possible; commas or full stops at the ends of lines are unnecessary and make the caption appear fussy. Emphasis can be added by putting one item in bold and one in italic typeface (usually the name of the artist and title of the work). Otherwise, using several different typefaces on different lines should be avoided.

If the photographer is not known, the caption should say either "photographer unknown" or "anonymous." If the print is vintage or taken from an old negative, then this information should be included with the print type—for example, "vintage silver gelatin print" or "printed later" if it is a contemporary print from an old negative. If the print has been loaned, then this information is included as the last line—for example, "courtesy of . . ." or "gift of"

Captions are usually approximately $3^1/_2 \times 1^1/_2$ inches (the size of a sticky label) and mounted on card or foam board or printed in black on clear sticky-backed acetate which can be stuck directly to the wall. Print size may be 12 or 14 point.

It is worth printing two sets in advance so that if a caption goes missing or needs to be replaced for any other reason, it can be done with the minimum delay. It is also absolutely crucial that the gallery staff have another way of relating image, caption, and price list that does not depend on the memory of staff members or the caption on the wall—just in case a caption goes missing. A missing caption can cause chaos if the gallery staff does not know the work well and is asked for further information, titles, or prices. Two ways of avoiding confusion are to make sure that there is a copy of the caption label on the back of the frame and that there is a full list of captions with thumbnail images held by gallery staff.

PUBLICITY

An exhibition is a great shop window for a photo-journalist as long as the exhibitor makes as much effort doing publicity as putting the work up. Newspapers will often use images from exhibitions, especially if they cost nothing, and having an exhibition can be an occasion to email picture desks or make contact with editors. Working with an appropriate organisation can also be useful as they often have press departments and access to radio and TV. Actionaid did the publicity for my exhibition at the Oxo Gallery and that brought in an audience and media contacts I wouldn't have had the time to approach. Timing is crucial though, and forward

planning helps a great deal, particularly if the exhibition coincides with an anniversary or seasonal event—this can really help get a picture story published.
Jenny Matthews, www.jennymphoto.com

As new gallery spaces emerged in the sixties, two forms of experiment emerged with them: the making of new and complex works of art and new forms of interaction with an audience.
Sandy Nairne, *Thinking about Exhibitions* (Greenberg et al., 1996)

There are five basic tools to publicize an exhibition, and a sixth—the publicist—who can make them work to maximum effect:

- the press release
- the press prints
- the invitation or private view card
- the press pack
- the catalog

Publicizing an exhibition is one of the tasks that a gallery will routinely organize. Most galleries do this well because their reputation depends on their exhibitions being well received, they have built up a good publicity machine over time and, crucially, because they know their audience.

It is usually harder for an artist or group of artists to organize their own publicity. This may be because they are inexperienced and feel awkward promoting their own work, or because it is hard to write about profoundly serious work with the right distance, or because they are unsure who their audience is and how to reach them. It may be easier for artists to hire a publicist to promote an exhibition than to do it themselves.

However, it is important for artists to understand how the publicity machine works in order to make it work for them. Whether or not the artist is very actively involved in producing the publicity material, it is important to keep some control over this process and to be involved in it. The danger for artists is that if they hand over publicity to others, they or their work may be misunderstood or misrepresented, even minimally. This may seem not to matter a great deal, but the photographer does need to find direct and honest ways to talk about the work and for any publicity to reflect this. Although trying to publicize one's own show for the first time can be daunting, it is a very good way to begin learning marketing skills, which can be developed over time as the artist learns how to talk to his or her particular audience.

One way to start the process is to collect publicity material from galleries showing similar work or the work of an artist at the same career point and use it as a template for both writing and design styles.

Publicity material has a number of different functions. This can be explained as "AIDA," which means it should:

- **A**ttract (so the exhibition will get noticed)
- **I**nform (so the audience knows what the exhibition is about)
- **D**esire (so it creates a desire to see the exhibition and is persuasive)
- **A**ction (so it induces action—that is, it tells an audience what to do next, like how to get in touch or get to the gallery)

While these categories are essentially accurate and useful, they do tend to suggest that art can be sold in the same way as soap powder. Indeed it can, and the art market is right up there with gold and coffee in the world commodity markets. But there is often a difficult negotiation for the artist over the professionalization of art marketing. The temptation, especially for new artists, is to try to attract an audience through dramatic publicity (the "attract" and "create desire" aspects of the AIDA mnemonic). While sensation and scandal in the art world, from Mapplethorpe and Jeff Koons onward, have been a part of bringing new audiences into galleries, most artists would prefer to have their work understood and valued for its own sake. "Talking up" work can be counterproductive: it may mislead an audience, who start to expect art to have entertainment or shock value or may simply experience a disheartening gap between what is being said about the work and what they experience when they visit an exhibition. For artists whose work has been over-promoted, the danger is also that they will start to believe the promotion and may find it hard to recover their sense of direction once the exhibition is over.

It is also a mistake to believe that marketing will, in itself, sell artwork. Eminent financial advisor and art buyer Alvin Hall was speaking for many collectors when, in conversation with critic Sarah Kent on BBC Radio4 (April 25, 2007), he commented, "I buy art totally on gut reaction." He explained that if he tries to buy art for any other reason, including investment value, he often fails to make good decisions. He is not alone in thinking in this way and, although a percentage of buyers are entirely concerned with buying for investment, most people buy work because they love a photograph and can imagine living with it. No amount of marketing can

shape individual taste to the degree needed to sell work to people who are not interested in it.

So, in my view, it is much more useful to focus on producing informative and insightful press materials than using more aggressive marketing techniques. If press material is written by someone who understands the work and can highlight some of the issues or concerns of the artist, it will do a great deal to engage an audience. Many people who lack training in the arts are unsure of how to start when looking at an exhibition, and a good press release is invaluable in helping them find ways into understanding and enjoying the work as well as ensuring that all the listings and press mentions will have something concrete to say rather than being empty "puff."

THE PUBLICIST

A combination of charm and persistence, as well as a good understanding of the way the media works and a knowledge of artists and the art world, are the most useful qualities for the job of publicist. Larger galleries usually have a publicity department or someone for whom publicity is a full-time job. Small galleries may have one person in charge of publicity for whom this is only one aspect of his or her job. A gallery director will often write publicity material for his or her gallery.

The most important task for someone trying to get an exhibition reviewed or noticed is to make sure that the press material is thorough, interesting, and produced on time. Publicity for the show opening is key. Once a press release has been distributed, the task is to follow up with phone calls or emails. There are two aspects to this. One is to ensure that the exhibition is in all the listings magazines and remains there for the full run of the exhibition, as some listings magazines will drop a listing after a week or two if they are not reminded to keep publishing it. The other is to target publicity to reach the magazines and reviewers who will be interested in covering the show in more detail. Such coverage may vary from the use of an image with an accompanying paragraph of information to a detailed review. An experienced publicist should be able to predict what sort of coverage a particular magazine will be interested in using and shape publicity specifically for that magazine when approaching them by phone.

It is also just as important to target the appropriate critic. Many critics have clearly defined areas of special interest, and it is well worth making sure that these critics are

approached personally. One in-depth and well-informed review is more rewarding for a gallery and artist than a splatter of short newsy pieces.

Targeting publicity is not difficult, but it can be very time consuming. For the artist publicizing his or her own show, it is usually well worth studying reviews and publicity pieces carefully to see what the magazines are looking for. Reading photography reviews regularly will develop an awareness of which critic might be interested in reviewing a particular kind of work. The artist's role in working with a publicist is both to impart useful information that can be incorporated into press materials and also to suggest appropriate reviewers, since the artist's knowledge of his or her particular area

Handout

PRESS RELEASE

The press release for an exhibition should always include the following:

- the artist's or artists' name(s)
- the exhibition title
- the curator's credit
- the date and time of the opening view (unless this is for invited guests only)
- the start and end dates of the exhibition and opening hours of the gallery
- information about the content, theme, or idea of the exhibition
- specific data about the work being shown, such as the number of images, when the work was made, whether it has been seen before or collected, whether or not it will be for sale, and whether there will be an accompanying tour or publication
- some biographical information on the artist, including previous exhibitions, background, prizes, and the like
- a quote, if desired and appropriate
- information about the gallery if useful or necessary (for instance, that it is a new gallery, or has a particular exhibiting policy)
- a web site address
- travel or access information as necessary
- the gallery address
- a contact email or phone number
- any logos and credits
- information about any accompanying educational program of talks and workshops

of work may be much more developed than that of the publicist.

PRESS RELEASE

A press release is crucial to publicizing any exhibition and, if possible, should be written when the original contract is drawn up between gallery and artist. This is both because it will then probably be true to the thinking that originated the exhibition and because it will provide invaluable publicity and reference in the months before the exhibition opens, and can be used time and again without anyone having to do a great deal more work to promote the upcoming show.

It can be sent out months in advance of the exhibition and then again nearer the exhibition opening. It should be printed in bulk and widely distributed through a regular mailing; it should also be enclosed in every letter sent out from the gallery as well as visibly present on a reception desk and so available to all visitors over a period of time.

The two people best placed to produce copy for a press release are the curator and the artist. They should have the most detailed understanding of the work and the proposed exhibition. If they don't write the press release themselves, they should at the very least produce a draft or extensive notes for the person who will write it.

A press release should be fairly short and cover no more than one side of A4 or letter size paper. Three or four fairly condensed paragraphs will suffice. These should describe the work, the exhibition, and the particular interests, methods, or subject matter of the artist as well as a brief biography or exhibiting history. It can include a quote by the artist if a personal description of his or her ideas or method of work brings it to life very vividly.

A press release need not include an image, although some galleries like to do so. There are probably more reasons not to use an image than there are to use one. It is often hard to find a single image that can adequately sum up the entire exhibition; the image will necessarily be small and may be too complex to be read easily. Since the press release is likely to be photocopied and copies possibly recopied, the reproduction may deteriorate to the degree that it becomes a smutty black image that does a disservice to the original photograph.

The press release should be on letterhead paper (including company or charity registration) and include a contact number or email for the person who handles gallery and/or press

information as well as the address, dates of the exhibition, and opening times of the gallery. It should also include information about any talks or educational events. Most crucially, it should also include the logos or names of any sponsors of the gallery or exhibition. Arranging for these to be included and checking the appropriate wording can be a tedious task and delay the production of a press release if it is left until last, so arranging for the use of the appropriate logos should always be a starting point when compiling a press release.

The language used for the press release should be accessible and, as far as possible, free of academic or art-world jargon. It can, however, contain complex and difficult ideas as long as they are presented with the minimum of pretension. One reason for keeping the language jargon free is that the press may well use a paragraph or more of text taken directly from the press release or rewrite it very slightly before publication, and they will only do this if the meaning of the original copy is direct and clear.

A press release should also aim to "show and not tell," by which I mean it should avoid telling the reader what to think about the photographs and should steer clear of providing a judgment. Consider this example of a poor press release issued by the communications and marketing department of a London college: the photographs, it says, are "powerful, graphic and lyrical images." This is a fairly meaningless statement. No reviewer is going to use this as a quote. By putting a judgment of the work between viewers and the work itself, such a press release makes it hard for viewers to look at the work freshly and come to their own conclusion and is more likely to alienate than attract an audience for the work.

A more useful approach is simply to describe the work in the exhibition in enough detail to give a potential reviewer what he or she needs to produce a short review or a piece for a listings magazine without necessarily having to see the exhibition. There should also be sufficient information to be used in a longer review.

Generally the first paragraph of a press release is about the exhibition itself. For example:

This will be Juan Cruz's second exhibition at Matt's Gallery. "Portrait of a Sculptor" takes as its starting point a painting by Velazquez in the Prado, Madrid: "The Sculptor Juan Martinez Montanes," catalogue number: Prado 1194, painted in Seville ca 1648. Using the spaces of Gallery 2 and the bookshop/reading area, Cruz has employed text, photography, video, and architectural interventions to

make an exhibition that both comments upon and adopts the reflexive nature of the painting. (Juan Cruz at Matt's Gallery, London)

and

Grouped loosely into three areas, the exhibition will open with images of sleep, of dreamers, and of nightmares. Secondly come the dream messengers and their vehicles, horses, birds, ecstatic flight, sheep as night visitors, spaceship travel. Thirdly will be the "man of my dreams," images of archetypal, heroic male figures. (Arthur Tress at Zelda Cheatle Gallery, London)

The second paragraph gives more detail about the artist and his or her work. For example:

Rickett's subjects are exclusively photographed at night and are located in primarily peripheral and mundane environments such as deserted parking lots, motorway bridges, the grassy island of an arterial motorway with light provided by street lamps or car headlights. (Sophy Rickett at Emily Tsingou Gallery, London)

and

Davis generally works in series, and his photographs tend to investigate the architectural and ideological structures that are created within society. After documenting in minute detail the workings of a publishing house and a hospital, Davis decided to photograph the interiors of America's colossal retail stores in an attempt to uncover the ways humans make meaning in an architectural setting that is designed to go unnoticed. Finding himself frequently escorted off these commercial premises, he shifted his focus from the structures of the stores themselves to the very physical outer limits of their presence: the way they illuminate, alter, claim and degrade their neighbouring communities. (Tim Davis at White Cube, London)

The final paragraph is often about the artist, including an exhibiting c.v. or brief biography. For example:

Philip-Lorca diCorcia has exhibited extensively in the United States, including at the New York Museum of Modern Art and in the Whitney Biennial at the Whitney Museum of American Art, New York, as well as throughout Europe, but neither of these series has yet been seen in England. (Philip-Lorca diCorcia at Gagosian Gallery, London)

and

Josef Koudelka was born in Moravia, Czechoslovakia. In 1962 he started to photograph the gypsies in Eastern Europe, whilst continuing to work as an aeronautical engineer until 1967 when he turned exclusively to photography. He received the Robert Capa award anonymously for his coverage of the Prague Spring (1968) after which he had to flee his country. He was granted asylum in England and thereafter in France, where he became a citizen in 1987. He began work on "The Black Triangle" when he was finally able to return to the country that he had left

twenty years earlier. He has been a member of Magnum since 1971. (Koudelka at Photofusion, London)

These examples were chosen, more or less at random, from a selection I keep for teaching purposes, but it should be noticeable that all of them privilege giving information about the artist and the work over offering judgments— though, of course, they establish that the artist is well respected by including brief and significant biographical details. This should not be a problem for younger artists; it is equally useful to mention where they studied and their current work and interests. The press release can also be usefully sent out as an email. This makes it easier to use an image or images. However, the gallery will still find it useful to keep hard copy available to hand to visitors in the gallery.

PRESS PRINTS

A gallery and artist will select between five and ten images to copy, usually digitally, in order to provide the press with images with which to preview or review the exhibition. It is usual for the gallery to make a selection in advance and not to offer the press a choice of all the images in the show, as there is a danger that the entire exhibition will then appear in print, making it unnecessary for anyone to visit the exhibition itself. Press prints need to be chosen carefully, both for their strength as images and to accurately represent the range of ideas and images in the exhibition. A single strong image can market an exhibition more effectively than anything else.

In a group exhibition, it is important to select press images that represent the full range of the work included in the exhibition and remember that different magazines and newspapers will tend to use images that fit with their particular interests and style. They also have a preference for images that are graphic, dramatic, and attention grabbing. Images that are subtle in tone or content usually do not make good press images since they may not reproduce well. It is also worth making sure that some images are available in black and white or will convert well to black and white, since some newspapers do not use color and will not select an image that reproduces poorly.

The press prints need to be selected at a very early stage in the exhibition process, since there is usually no way of predicting how soon they will be needed. Quarterly magazines, for example, have very long deadlines and publication dates that are unlikely to coincide with the exhibition opening;

they may well need images between four and six months ahead of the exhibition in order to publish the information in an issue that is distributed around the time of the exhibition. As a rule, when they are needed, they will be needed quickly.

Artists loaning a print to a gallery for press purposes should be careful to put their stamp or name, copyright symbol, and contact address on the back, as well as a full caption and "press print only, to be returned to the artist." They should also reclaim the print at the earliest possible moment, since many galleries treat press prints fairly casually. If the print is not reclaimed, it may get damaged, lost, or stolen and next be seen framed on someone's wall. None of these things may seem much of a problem at the time but could be just a few years down the line if the photographer has to try to reclaim a print or if substandard press prints turn up for sale on eBay.

OPENING VIEW CARD

The invitation to a private view or opening party for an exhibition is important because it will reach a wider group of people than the other press materials and because the image selected for it may well come to represent the exhibition and, if well selected, may be widely reproduced. A strong image from an exhibition used as an invitation may give the show a clear identity that makes it easy to publicize.

The most usual invitation is an unfolded card with a full-sized image on one side and printed information on the other; these tend to range from postcard size to A5 (approximately 8 × 5 inches). Some galleries produce folded invita-

Handout

INVITATION CARD

Invitation cards should include all of the following information:

- the artist's or artists' name(s)
- the exhibition title
- photograph(s) with credit
- the curator's credit
- the date and time of the private view
- the start and end dates of the exhibition and opening hours of the gallery
- the gallery address

- a contact email or phone number
- any logos and credits

One of the most important qualities of an invitation to an opening or private view is easy readability; therefore, information is usually kept to a minimum. However, the invitation card is also one of the most attractive pieces of publicity material and is likely to be put on display, so it should last for the whole period of the exhibition rather than just the opening night. This means that including additional information is very helpful. Here are some of the items that you could consider adding to the card:

- A one- or two-sentence subtitle or explanation of the exhibition. If the exhibition title is not self-explanatory, a brief subtitle is useful, such as "portraits by . . . ," "portraits of street children in Brazil by . . . ," "images of a lifestyle," "photographs 1926–1995," "landscapes by . . . ," or "new work by graduating students." The exhibition may need a further explanation and, if so, it should be as brief as possible.

- If a talk or speech is to be given at the private view, include the time of the talk and the speaker's name and title (or a very brief biography). There should be just enough information attached to indicate why that person is speaking. "Director of . . ." or "friend of the artist" is sufficient.

- Travel or access information, if necessary. If the gallery is difficult to find or access, brief but clear information should be included on the card, such as the name of the local station, the numbers of buses, where to park if it is difficult, where the gallery entrance is if it is on a street other than the one in the address, and information about disabled access (for example, "Wheelchair access by prior arrangement" and a phone number; or "the only good wheelchair access is at the back of the building rather than the front"). A small diagram is useful if a street is difficult to find.

- A Web address. This is only a good idea if the web site is kept up-to-date.

- RSVP. This should only be put on cards when access is going to be limited at the door and a guest list is being drawn up. Most people will not bother to confirm their intention to attend a private view unless it is being held, for instance, at a museum or very prestigious venue, and they know they will be excluded if they are not on the guest list. Compiling a list of acceptances is time consuming, so it is only a good idea to request RSVPs when there is a reason to limit the number of guests. If doing so, it is also helpful to add a date, usually about a week before the exhibition opens, by which people should have replied; otherwise the last two days before an exhibition opens will be spent entirely dealing with replies.

- "Admits one" or "Admits two" printed on the card may help to keep numbers down for popular galleries but is only useful if there is someone at the door to check invitations.

- Admission charges (if this applies). Few galleries charge admission, but if there will be one for this exhibition, or if donations are being sought, it should be stated on the card.

	Handout	
EUROPEAN PAPER SIZES IN MILLIMETERS AND INCHES		
Size designation	Size in millimeters	Size in inches
A0	841 × 1189 mm	33.11 × 46.86 inches
A1	594 × 841	23.39 × 33.11
A2	420 × 594	16.54 × 23.39
A3	297 × 420	11.69 × 16.54
A4	210 × 297	8.27 × 11.69
A5	148 × 210	5.83 × 8.27
A6	105 × 148	4.13 × 5.83
A7	74 × 105	2.91 × 4.13
A8	52 × 74	2.05 × 2.91
A9	37 × 52	1.46 × 2.05
A10	26 × 37	1.02 × 1.46

tions, and most will have a recognizable design style or format.

An important factor to consider when designing an invitation is the method of posting. Envelopes are produced in standard sizes, and designing an invitation that does not fit neatly into a standard-sized envelope means that it will require either a too-large envelope, which does not look good, or a specially made envelope, which is costly. In my view it is better to stick with standard sizes. An alternative, which saves both time and money, is to print an invitation that can be sent as a postcard, with space for an address on one side and the invitation on the other. This looks less formal than an invitation in an envelope.

The invitation needs to be mailed between two and three weeks before the opening party. As a general rule, if you send an invitation out too early (over a month ahead), people will forget about it; and if you send it out too near the time the exhibition opens, people will already have made other arrangements for that evening. If, however, you are holding a special exhibition and asking your invited guests to confirm their intention to attend, you need a different timetable. In this case, the invitations should be sent out about a month to six weeks in advance in order to give people time to confirm that they will be attending.

The date for the opening will have been set months in advance, however, and gallery and artist will have let people

know so that they already have the date on their calendar. Galleries tend to favor holding openings on one particular day of the week. When settling on a date for an opening event, it is a good idea to check, insofar as possible, that it will not coincide with other openings.

It is also worth asking the printer the cost for an additional run of the invitation image without the exhibition information on the back. Most printers can do this at no great cost, and it is useful to have a supply of images to use as promotional cards. Any such card must have a full photo credit on the front of the image so that it is not lost when the other information is removed.

PRESS PACK

A press pack, as the name implies, includes more extensive and detailed information about the exhibition, the artist, and the gallery than the press release can cover and is provided to give the press additional material to draw on when reviewing an exhibition.

Larger galleries tend to provide a pack to all members of the press attending a private view. These packs are often beautifully designed and can resemble a child's party bag full of small sponsor- or promo-related gifts such as T-shirts, pens, and CDs.

In addition to copies of all the exhibition material already available in the gallery, a press pack could include an artist's statement and c.v., one or two sample images, an update of information about the gallery, and their latest catalog or brochure. It could also include further information about the artist in the form of an interview or a review of previous work, a copy of texts in the exhibition, or a full caption list.

Smaller galleries might want to avoid the expense of providing a large number of smartly produced packs, but collecting the information together to hand out on request or to selected reviewers will still be invaluable and ensure that reviewers have a great deal of background information on which to draw.

CATALOGS AND BROCHURES

The most enduring legacy of an exhibition is usually the catalog. A good catalog should be, as the name implies, a complete list of the work exhibited, an additional essay or two, and supporting information. Catalogs are expensive and

FIGURE 4.4 Exhibition brochures. Image ©
Tim Roberts

time consuming to produce. For this reason they have tended
to be the domain of bigger galleries and well-established
artists.

In recent years, however, with a fall in printing prices and
more widespread expertise in reproducing photographs, more
galleries have been able to afford to produce small exhibition
catalogs. There are a number of good ways of doing this and
they are of great value to the exhibiting artist, since the small
catalog or leaflet long outlives the exhibition itself and is
invaluable both as a record and as a promotional tool.

Most galleries and curators receive a great number of
unsolicited exhibition applications on a daily basis. Many of
them will hit the wastepaper basket as soon as they are
opened, for no other reason than the gallery has no time to
deal with them. Sending a gallery or curator a small catalog
to represent the work is more immediately compelling than
almost any of the various alternatives including CD or slides.
It takes only a moment for the curator to look at the images
and judge whether they are likely to be of interest to the
gallery. It also at once establishes that the artist is a profes-
sional with a track record of exhibition. If anything is going
to be catch the attention of a gallery and ensure that the work
will receive serious attention, it is this sort of publication.

"Catalog" is usually a misnomer since these publications
tend to be an introduction to the work and a partial, rather
than complete, record of an exhibition. There are as many
different names as forms and uses for this sort of publication;

they can be called catalogs, booklets, pamphlets, brochures, or leaflets. They are not to be confused with exhibition guides, which are usually essentially text based rather than image based and are produced by large galleries as a room-by-room guide to an exhibition.

They can be a collection of cards in a folder or envelope, several pages or several dozen pages folded, stitched, or stapled in traditional book format, or a single sheet of paper with a concertina or other type of fold. Sometimes they have a double function—one side used as a poster and the other as catalog. The type and amount of information included can range from a collection of images with no text to a single image and short statement per artist for a group show, to something much more closely resembling a catalog in every-thing except size. As long as the print quality is good, all of these give a fast and revealing insight into the work.

For a group exhibition, a single image for each exhibitor with caption, an accompanying hundred or so words of text, as well as the name and contact details of the photographer (if appropriate to the type of exhibition) will make an inter-esting publication. If there is time to commission it, a single longer piece of writing may be useful and provide insight into the exhibition. Catalog images need to be selected carefully for their standalone qualities. An image that works in the context of a set of images may not work in isolation. Equally, the image that does work well by itself may not represent the work as a whole. If there isn't an immediate and obvious choice of image for a catalog, the only way to make this sort of decision is by testing out each image to see what works and drawing in other people's opinion. Another option is to print two or more images at a smaller size, although small catalogs usually work best with fewer large images. This careful decision making takes time but is worthwhile, since the image and catalog may well be widely seen and come to represent that photographer in all sorts of contexts.

One of the main considerations in producing this kind of material is time, and timing. It takes many days and weeks to collect and select images, write, edit, proofread, design, and print anything. The planned timetable needs to ensure that the catalog is printed several days before the exhibition opens, at the very latest. If the catalog is small and can be mailed out at no great cost, then it should be produced in time to be mailed with the press release or opening invitation two to three weeks before the exhibition opening. If it is too big or costly to be mailed to everyone on the gallery list, it

should be produced in enough time to send out copies to key critics or clients.

For many photographers, the problem this raises will be that the exhibition content is not finalized when the catalog information is being collected. Unfortunately, print deadlines cannot be postponed, since a catalog that arrives in the last few days of an exhibition is almost worthless as publicity material. Decisions about image and text will have to be made regardless, and a certain amount of ruthlessness may be needed. Student degree show catalogs frequently do contain images that are not in the show, and this is always disappointing, particularly for the curator who visits degree shows as a way of keeping an eye out for emerging talent, since it means the catalog is far less useful as an aid to memory than it would otherwise be. However, it is better to have an image from a piece of work that is not on show than no image. But better still is to commit to showing the work that is in the catalog and ignore the temptation to keep revising the exhibition content right up until the last minute.

Small catalogs are usually given away. It is difficult to sell them and it may be counterproductive to try, since the small sums of money involved may be difficult to collect and more trouble to account for than they are worth. Since the aim is to publicize the photographers and provide a record of the work, it is also counterproductive in that it limits circulation.

Universities, however, will increasingly pay for these small catalogs to accompany degree shows since they act as advertising for their courses. Catalogs can also raise revenue in the form of advertising, although this may primarily come from suppliers already connected with the course or institution.

MAILING LIST

Every gallery will have its own mailing list, which will include artists, press, critics, funders, supporters, and clients, and usually the gallery will deal with most of the publicity. However, a personal mailing list is invaluable, and every artist should have one which they build up over time.

This sort of list includes:

- family
- friends
- work colleagues
- curators who have seen the work
- anyone who has written about the work

- anyone who has bought work
- anyone who has expressed a genuine or informed interest in the work
- anyone whose gallery shows related work or where the artist can realistically see him- or herself showing in future
- other artists working in a similar way, with similar subject matter or techniques (for example, it is useful for a landscape photographer to keep in touch with other landscape photographers and keep them informed about the work)
- (if the work is subject based) any organizations or individuals who work in that field (whether the subject is skateboarding or homelessness, there will be people and organizations motivated to come to an exhibition for what it has to say)

This sort of list has two functions. It is first a list of friends who will be personally supportive and who can be depended on to arrive at a private view in good time and stay late to help clear up if necessary. They can be asked to talk to unknown guests or run out to fetch something and will be there to take the artist out to dinner afterward if needed.

The other part of the list is of people who have been professionally supportive. Keeping them informed means inviting them to every exhibition, and this is a way of building on their support. This is the personalized list no gallery can duplicate, and it is invaluable.

A gallery will usually either ask the exhibiting artists for their list and include it with their mailing or give the artists a number of invitations so they can send them out themselves. If the gallery has the list, it is important that the artist check that the people on it actually receive the mailing. One of the side effects of the new electronic communication technology is that people are less reliant on, and so less careful about, traditional mailing ("snail mail").

ORGANIZING A MAILING

One of the most important things about a mailing list is that it should be kept up-to-date and be appropriate to your gallery or exhibition; otherwise a mailing is a large expense for what will be an inadequate return. Galleries regularly update their own mailing lists, removing names of people who have left organizations or whose invitations have been returned as "moved away." A visitors' book is useful as a way to add to the mailing list names of people who come to exhibitions.

Invitations should be sent out between two and three weeks in advance of the opening night. Unlike press releases, they should not be sent out too far in advance or people will forget about the private view. They can be sent second-class post. Bulk buying envelopes in advance is very much cheaper

than buying in small quantities at the last minute. It is also helpful to organize a production line of sorts.

Galleries, magazines, and membership organizations all have their own mailing lists. They are unlikely to loan their lists to you because of data protection regulations. However, they will sometimes agree to include another organization's mailing with their own in return for a fee or practical help with the mailing. This possibility is worth exploring, although it will depend on the proposed mailings being scheduled for the same time frame.

If you are organizing your own exhibition, and therefore your own mailing, it is worth planning this carefully. Mailings are time-consuming and can be very boring. In one day, two people can insert about 3000 invitations or handouts into envelopes, attach address labels and stamps, seal the envelopes, and pack them up for the post. Many galleries use volunteers who end up putting invitations into envelopes for hours on end. This is a good way to lose their support. In my experience, the best way to do a mailing is to turn it into a social event. Book a long lunch or an afternoon into everyone's schedule, get them to stop their other work, and spend a few hours sitting around the table catching up on news and gossip while they put invitations into envelopes. Nice food helps. Students or young relatives can often be tempted to come and join in. An event like this forges working relationships and breaks down barriers within organizations and groups.

THE AUDIENCE

The aim of publicity is to ensure critical coverage and to bring an audience to the exhibition. But who is the particular audience for your exhibition? How else do you reach them? These are crucial questions with different answers for different types of venues.

Most established galleries have a regular audience or clientele which they have built up over time and who visit the gallery frequently because they are interested in the overall showing policy of that particular gallery rather than in one particular exhibition. So, for instance, they may well attend a private view and be prepared to pay serious attention to the work of an artist they have not previously heard of because they trust the knowledge and taste of the gallery's director or curator. For exhibiting artists, the priority here is to make sure that the marketing is targeted to reach an audience appropriate to their work as well as to the gallery's usual audience. This means bringing their own mailing list and knowledge to the gallery and helping to shape publicity material.

"In this work I tried to show some of the extreme physical exhaustion that professional boxers experience after a fight and the state of internalised reflection that then occurs. Visually it has parallels with Christian iconography, and in mounting the work I considered pursuing this parallel with ornate frames intended to command reverence. I finally decided not to pursue this route but instead to show a triptych that would reference this parallel without being too overt. Still, however, I discovered that the use of a heavy plain frame, when compared with a frameless mount such as Diabond, gave them a sense of claustrophobic tension that seemed to add to the images. The boxers appeared trapped within the boundaries of the frame, as if too exhausted to escape. In this way the frame also referenced the ring in which they'd just completed their trial of endurance." Image © James Tye

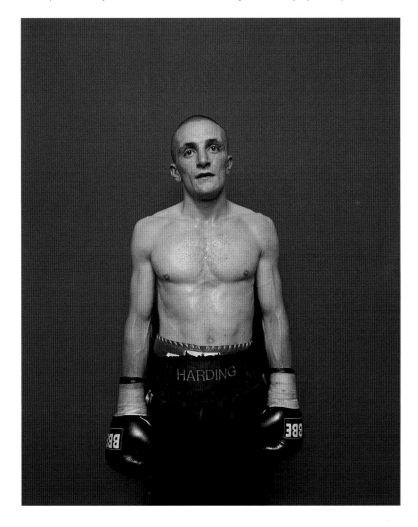

FIGURE 4.5 Harding from the series "Still Standing," 2006.

A gallery in the foyer of a cinema, theater, or hospital or in a cafe or a restaurant has an audience that will be there for other reasons entirely but will enjoy an exhibition as part of their visit. For exhibiting artists the priority in this situation is to make sure that their work will attract the attention of the passing audience and also that they invite an audience of their own to a private view or other event.

It is more difficult to attract an audience to a show in a new gallery, a gallery that has been hired on a one-off basis, or a space that is not usually used as a gallery. An audience

"Residual Portraits" depicts a variety of different public and institutional spaces, which have been personalized by individuals around Britain. They portray how people occupying civic spaces, absent of a personality, stamp their own specific identity upon their environment. Each c-type print in the series was exhibited at the same size, large oversized prints so as to highlight all of the very small details in the scenes and hung together horizontally in a line. It was important for the prints to lack any personality in themselves thus not deflecting from the viewer's appreciation of the persona being portrayed in the scene. The absence of frame and minimal quality of the Diasec frame (aluminum backed and face mounted onto Perspex) allowed the presentation of the prints to be viewed neutrally. Nadia Burns

FIGURE 4.6 250 Renfrew Street, Janitor's Box from "Residual Portraits" series. Image © Nadia Burns

for a new venue will usually take more time and effort to reach than for an established gallery. One possible problem in attracting visitors to any of these venues is that they may simply miss the exhibition because the publicity takes too long to reach them. To get the timing right, the artist should try to secure pre-opening publicity rather than post-opening publicity and to consider opening the exhibition for longer than the usual three to four weeks.

This is also the moment to consider who the audience for a particular venue might be and how to reach them.

Reaching an audience can be through:

- specialist photographic press
- listings magazines
- the gallery mailing list
- local press
- footfall or walk-ins (casual passersby who are attracted by the street presence of a gallery)
- your personal mailing list
- word of mouth

GETTING REVIEWED

In Britain it is notoriously difficult to obtain press exposure for exhibitions of contemporary art. And when you do, it's usually the wrong kind. Unless there's a sensation, a scandal or a silly-season absence of news, many sectors of the mainstream press just don't want to know, and even the most committed of art critics need to be steered, prodded and cajoled—as well as provided with the facts.

> Louisa Buck, from *Moving Targets 2: A User's Guide to British Art Now*

The trouble with acting like an art historian is that it detracts from the job critics can do better than anybody else, and that is to be lively, spontaneous, impressionistic, quick to the present—shapers, in short, of the mind of the moment.

> Mark Stevens, from *Criticizing Photographs*

Artists do not usually meet with press or art review writers, in my experience; this is left to the gallery staff or the director. When I was a reviewer myself, I never wanted to meet with the artist in order not to be swayed by my impressions of that person. But perhaps other art writers have different views on this.

> Deborah Bright, artist, academic and writer on photography

There are very many different approaches to the task of writing about art. Curators, art historians, and critics will all bring different interests and areas of knowledge, as well as different understandings of their role, to their writing about photography. Writer and critic A. D. Coleman, for example, argued in 1975 that the critic should be "independent of the artists and institutions about which he/she writes," whereas curators are likely to see their role as writing in support of the artists they show or are interested in. (From "Because It Feels So Good When I Stop: Concerning a Continuing Personal Encounter with Photography Criticism," in *Light Readings: A Photography Critic's Writings 1968–1978*. New York: Oxford University Press (1979) pp. 203–14.)

Still, a major aim for the artist is to get his or her work reviewed, and understanding who might approach the work sympathetically is part of this. New exhibitors have a tendency to direct all their marketing work toward one or two major critics, hoping to tempt or persuade them into visiting a show of new work and believing that this will lead to critical success. In my experience this almost never happens. Major critics are busy, inundated with demands, tend to have highly specialized knowledge, and as a rule are expected to write about established artists.

Another mistake many new artists make is to think that with sheer volume a publicity mailing will bring in a good response. In fact, publicity targeted more specifically, and followed through with a phone call or email, is more likely

to be successful. One good review or informed media mention will be more useful than a scatter of listings information, and it is worthwhile to focus on how that can be achieved.

So what else can you do? Look at the question the other way around: Is there a critic who *does* write about the sort of work you make? Or do you have a colleague who writes well, understands the work, and might be interested in approaching a magazine on your behalf or writing a review on spec in the hope of placing it somewhere? If you suggest a review and a writer to a magazine, they might accept it if you are able to offer them a package of words and images. At the very least they will consider it.

Marketing exhibitions is about targeting information. One of the key things good gallery publicists learn to do is anticipate the ways in which a particular show could make an interesting article or mention in a particular magazine. They learn to pitch their talk about the work specifically to whomever they are talking to. This is a skill that can be learned through practice.

ATTRACTING A LOCAL AUDIENCE

One of the audiences an artist can reach is a local audience—casual passersby as well as regular visitors, people who have seen a review in a local paper or heard through word of mouth that the exhibition is interesting. Local audiences are sometimes slightly resistant to looking at artwork, feeling perhaps that it is outside their experience to visit a gallery, so it is worth making a particular effort to bring them into the exhibition.

Local papers are often very interested in covering arts events. An initial press release can be followed up with a phone call to the reporter who covers the arts with an invitation to the gallery at a time when the artist or a staff member can take him or her around the show and talk about the work. If time can made, this is well worth doing *before* the show is open—either when it is being hung or even beforehand, by inviting the reporter to the artist's studio or to look at a portfolio—so that an article appears just as the show opens. You probably won't talk to the local press in the same way as to the arts press; in fact, you may need to explain the work in much more detail with the local reporter, and to spend more time at it, since he or she won't necessarily come to the show with an idea of what to write about. The danger here is that not all local papers have staff with any specialist knowledge of the arts, and they may find it easier to write

about the artist rather than the art. This is likely to focus on a story with some slight news value that may be completely irrelevant to the exhibition (such as the artist having won a local prize when he or she was at school or breaking a leg when out taking photographs), so the priority is to try to get the reporter to write about the art. You may want to ask the reporter what sort of information might interest the local audience and shape the conversation accordingly. You may also want to have a ready fund of stories about the making of individual images, explanations of techniques, the reasons for making the work, and so on. It's crucial to remember that this is being aimed at people who probably do not have specialized art knowledge but may well be supportive of local art initiatives and interested in developing their knowledge.

It is also a good idea to take time to go into the shops, wine bars, cafes, or restaurants in the immediate vicinity of the gallery with a press release and talk to the owner or staff about the exhibition. This is not only polite, but also can be very useful. It means, for example, that the gallery is much more likely to get included in local initiatives and marketing events than if it is seen as slightly elitist, as can happen with galleries. It's also a good idea to inform wine bars and restaurants of the date of an opening event so they can be ready for extra visitors. They are going to talk about the gallery whatever you do, so approaching them first makes it much more likely that they will be friendly toward the work. Local word of mouth can be an invaluable way of bringing new visitors to an exhibition and ensuring a friendly reception rather than a slightly suspicious or hostile one.

The exhibition needs to be visible and inviting to people who are passing by. Attracting foot traffic will happen if the street presence of the gallery is welcoming and it is clear to potential visitors that entrance is free and that they will not be pressured to buy work. Many people do find galleries intimidating, and there are number of ways of overcoming this. One of the simplest ways is to leave the main door open. A sandwich board immediately outside can also work well, as can using windows to display work specifically designed to draw an audience in (rather like a restaurant that displays its menu outside). If the gallery is less immediately visible—because it is down a side alley, for example—more thought will need to be given to this, with a sign or poster at the end of the street or planters full of blossoming plants outside the

door or large lanterns in the alleyway. In any of these situations, the gallery has to be careful not to obstruct the way or complaints may cause problems.

INVITING THE ART WORLD

The art world is an important component of any gallery audience. Arts organizations, galleries, arts educators, and artists working in a similar way to those in an exhibition will be interested in attending an exhibition opening and making contact with both gallery and artist. An exhibition is a good time for introductions and for building a personal mailing list. The art world depends on networking, is very self aware, and watches what is happening in and around itself. Word of mouth is usually an important element of this and will bring in as many people in the art world as invitations and reviews.

PRICING, SELLING, AND INSURING WORK

Until the last quarter of the twentieth century, very few photographers could expect to make a living buying or selling prints. The development of the market for both vintage and contemporary photography dates from this period and was led, and is still dominated by, American collectors, although important auctions are now held in Britain, France, and Germany, as well as the United States.

Although photographs have been collected publicly and privately since the invention of photography, they have been collected as much for the information they hold as for their beauty, artistic merit, or authorship. Universities such as Harvard used original prints as teaching tools, and institutions from museums and libraries to the military and business kept photographs as records. As Douglas Crimp points out in his essay "The Museum's Old, the Libraries' New Subject" (1993), it was only in the 1970s that photography began to be reclassified for its intrinsic interest as photography rather than for its informational content and to achieve serious prices in the art market. The Victoria and Albert Museum in London, which started collecting photographs in 1856, is typical of many similar institutions in not having had a designated photography department and curator until the 1970s.

A number of factors contributed to opening up a market for photography between the 1960s and 1990s. Artists like Andy Warhol and Robert Rauschenberg had, by using pho-

tography, blurred the traditional divide between art and photography, making it easier for photography to be revalued. The market itself was growing in strength at a time when most of the world's major paintings had been acquired by museums and were increasingly rarely coming onto the market—the supply of "old masters" was drying up. Popular interest in, and the exhibition of, photography was growing. It also became clear that the problem of the infinite reproducibility of photography could be addressed as artists started to produce limited editions of photographs. The concept of the vintage print, which gave the print made around the time at which the image was taken more value than a modern print, also limited the production of salable photographs from old negatives.

Although there had been sporadic photography sales before this period, the first major sale of photographs in London was in autumn 1971 at Sotheby's. It was entirely devoted to nineteenth-century photography and was designed to be the start of a program of photography sales. Since then the number of nineteenth-century photos available for sale has gradually diminished, and in May 2007 the sale at Christie's in London included no nineteenth-century photographs for the first time since 1971.

The market for the "great masters" of twentieth-century photography also started to develop in the 1970s. Auctioneer Philippe Garner recounts that in 1975 the Photographers' Gallery in London held a benefit auction. Prints by Ansel Adams, Cartier-Bresson, and Robert and Cornell Capa were among those sold. The highest price achieved was £250 (approximately $390) for an Irving Penn print. This was seen as such a high price that it brought gasps from the audience. It was also the first Irving Penn print to sell at auction; the print, which was bought by Sam Wagstaffe, is now in the Getty collection.

The market for contemporary work was slower to develop and only started to establish itself seriously in the mid-1990s. In 1987 Abigail Solomon-Godeau wrote, "The market was and is dominated by painting, and the prices for photographic work, despite the prevalence of strictly limiting editions and employing heroic scale, are intrinsically lower. Nonetheless, the fact remains that in 1980, the work of Levine or Prince was largely unsaleable."

Since then the market for contemporary photography has developed to such an extent that in 2005 "Untitled (Cowboy)," a photograph by Richard Prince, sold for $1,248,000 at

auction. It was the first contemporary photograph to sell for over a million dollars.

However, knowing that photographs are beginning to achieve good prices at auction doesn't help individual photographers to price their work. Pricing artwork is complex, and no standard pricing structures or universal guidelines exist as yet. Prices also vary widely between countries; prices in the United States, for example, are considerably higher than in Europe. Major international events like regular auctions and photo fairs do, however, suggest that prices will start to achieve international parity.

A combination of factors can help a photographer decide print prices, and there are a number of things to take into account:

1. the photographer's reputation and exhibiting record
2. the showing context
3. print size
4. the mount or frame
5. editioning
6. rarity value

(1) Prices build up over time as the photographer becomes established. A young artist cannot expect to sell his or her work at the top of the price range unless there has been great critical attention and market interest for that work.

(2) If a photographer is represented by a gallery, that gallery is likely to have an established range of prices, which in turn depends on the gallery's position in the art world and on their client group. The gallery will want the photographer's prices to fit within that range, which effectively fixes the works' prices since the photographer will not be able to sell the same print elsewhere for a markedly different price. If the photographer is not with a gallery, then there is a great deal more latitude in the price range although, generally speaking, the independent photographer's work will sell for less because he or she does not have the implicit guarantee of a gallery's support for that price.

(3) Although print size is not calculated by the square inch of image size, the same print will sell for more in a larger size than it would in a smaller size. Large contemporary prints do sell for higher prices.

(4) If the print is presented in a frame, it will usually be offered with an option to buy the print either with or without

the frame and two prices will be quoted. The price for the frame will be kept at or near its purchase price. However, a number of contemporary mounting methods entail permanent mounts, meaning that the print can only be sold as it is presented. This includes images dry mounted onto aluminum and Diasec or PlexiPhoto mounts (face mounting using silicone sealants). These are state-of-the-art and expensive methods of presentation, and the price will reflect these production costs.

(5) An *edition* is the means by which the photographer guarantees that only a fixed number of prints are in circulation. Edition prints are usually of the highest quality, signed, numbered, and dated, and the photographer or dealer keeps track of the edition and of sales. In theory at least, the whole edition will be made at the same time, in the same size, and with the same print quality, using all the same processes. Currently, prints tend to be sold in much smaller editions than in the past, when print runs could be upward of twenty-five. Editions of ten or fewer are customary; as they are sold, the price rises as the edition starts to sell out. So the ninth print of an edition will probably cost considerably more than the first print sold from the same edition. It is also acceptable for the photographer to produce two or more editions of the same print by printing at different sizes.

(6) Real rarity value is primarily an issue with vintage or estate prints rather than contemporary prints.

For photographers who have to price their own work, it is difficult to know where to start and, unfortunately, there is no easy way to arrive at a price unless you are working with a gallery that is prepared to advise you.

However, there are probably two good starting points. The first is based on the production costs of the image. How much did the final print cost to produce? Include the costs of printing and mounting as well as labor costs but not additional production costs (like traveling halfway around the world to take the picture), and then multiply this by three or four. This should give a reasonable price range. The second way is to look for photographers and photographic work with which you can make a relevant comparison. This means work of similar genre, size, and production values and artists at the same career stage and position. Look at their prices and relate a price to theirs. This will only work if there is a genuine parity between the work and the artists' positions.

Pricing information is also available on the Internet (see www.artprice.com, for example) and in a number of annual publications. Such information is mostly aimed at collectors, however, and includes prices at the top end of the market, so it is not much help to the less established photographer.

New exhibitors are sometimes tempted to underprice their work in the hope of selling more, and students are sometimes encouraged to overprice work in the hope that they will establish themselves in a good place in the market at the outset of their career.

A gallery will take anything from 20% to 60% commission, and this affects the price you ask for. This needs to be clear in discussion at the outset or you may end up disappointed.

The commission percentage should be in keeping with how much work the gallery will do for their artist. A local restaurant may take only 10% as a token payment. For this they may well have given you only a place to show the work and their enthusiasm for the project. An established gallery will usually take between 40% and 60%, in return for which they should market and promote the work and bring it to the attention of their client group. They will put time and money into the exhibition as well as introduce the work to an existing market.

Most art dealers and galleries are not interested in one-off sales but in building up a list of regular clients who they nurture over time. They know the artist and understand the work and will bring client and work together when it seems appropriate to them.

Sometimes people who want to buy an artwork will approach the artist privately during the exhibition run, hoping to bypass the gallery and buy the work for less. This may be tempting for the artist, who would receive more of the purchase price instead of paying a percentage to the gallery. However, it is a great mistake to do this; the gallery is likely to find out, it will destroy the relationship of trust between gallery and artist, and the gallery will be unforgiving.

GIFTS AND LOANS

One of the problems with valuing photographs is that people outside the industry are often not aware of the value of an editioned print or the difference between a selling image and

an amateur photograph. They will confidently ask for a copy of a print they like or expect a photographer to give prints as presents to their circle of family and friends. This can be quite a difficult situation for the photographer, and on the whole it is a good idea to avoid handing out prints as gifts, except occasionally.

A photographer once asked me if it was standard practice to give a curator a print in return for the curation of an exhibition. In my experience it is not general practice to do this, except in recognition that someone has curated an exhibition exceptionally well, helped the photographer greatly, or formed a close bond. However, it can greatly benefit the photographer to do this since curators look carefully at what other curators choose to show on their walls. Photographers who like each other's work often exchange prints, and this is a great way to build a collection.

A gallery director or owner may also sometimes "borrow" a work to hang in his or her home as a kind of long-term loan. It can be treated almost as a gallery director's "perk" to collect the works he or she likes without paying the artist. A lot of unwritten and unacknowledged appropriation of this kind can happen, and it is very difficult for the artist, who needs the gallery's or the director's goodwill, to ask for the work's return. One answer here is for the artist to produce a contract for a "loan" (based on a standard gallery contract), using the excuse that his or her financial advisor insists that every work from an edition is fully accounted for. This means that the artist at least has a record of the "loan" and a chance of reclaiming the work a year or two down the line when he or she may be in a stronger position to do so.

There are also good reasons to loan or gift work if the artist can be certain that it will be looked after. Once work has been shown it can drop quickly out of circulation and be forgotten. Once work is framed or mounted it can be difficult or costly to store. Loaning a work to someone who is going to put it on their wall saves storage costs and means that the work will continue to be seen. If that person is a curator who invites photographers, curators, and critics to his or her home or office, so much the better since it ensures the work will not be forgotten.

The life of a work after it has been exhibited is often curtailed if the exhibition closes and nothing has been sold and the exhibition will not be shown elsewhere or go on tour. It is worth spending time looking at how an image or set of

images can continue to circulate by being given away, loaned to colleagues and friends, curators or business acquaintances, entered for competitions or group exhibitions or shown again in a different context. Some artists are happy to install an exhibition in their studio after it has been shown publicly and to continue to consider the work for a time while others prefer to pack it away. As long as the artist is clear about the terms of any loan most extensions of the showing of a work are useful and opportunities to negotiate this likely to arise during the preparation and installation of an exhibition.

Case Study Four:
The Digital Gallery

I was the principal academic investigator responsible for developing the digital research gallery at London South Bank University (LSBU). I thought the university should have a digital gallery because, unlike many of the established photography schools, ours had Arts and Media courses that were "born digital." There were no chemical darkrooms here and no tradition of teaching analog photography. We currently run five undergraduate digitally based programs, of which the B.A. (Hons) Digital Photography is one. Of course, the majority of photography courses now includes digital photography, but as far as I know we are the only exclusively digital photography degree in the United Kingdom.

The "digital" in the title expresses a philosophical outlook on photography, not simply that we are using a different technology. We are teaching in a digital age about something that isn't quite photography any more—it's something else but, because we don't quite know what it is, we still call it photography. At LSBU there is a distinct rationale for the teaching of digital imaging, unlike in many other colleges where digital photography is understood as a technological tool and seen as the most recent extension of an existing history of analog photography. What we're saying is that we need to think about digital photography in a different way from the very start of our course. Digital imaging does have a relationship to what is, in a sense, its prehistory of analog photography, but the actual practice of digital photography is something else and probably somewhere between graphics and animation.

So, having gone down the road of making a huge investment in the teaching of digital photography and beginning to enumerate what that philosophy was, it was logical for us to have a digital gallery instead of a conventional gallery.

The opportunity to have a digital gallery was, like many things in higher education, very finance dependent, and I put forward a bid through SRIF, the Science Research Infrastructure Fund, which is a capital scheme for universities to update and extend their technological resources. I wrote a rationale and developed a specification for a digital gallery and was awarded £190,488 for a project entitled "New Media Digital Research Gallery and Archive." The university gave the project a space, which is not ideal in that it is too small for the equipment it contains, although it is located in the reception area of one of the university buildings so it's very accessible.

The gallery consists of a closed network of computers, screens, and speakers. There are fifteen computer hard drives, which are networked to a central piece of software that allows you to upload digital files, distribute them within this network of fifteen computers, and then write a playlist of how you want them to work. So we have nine plasma screens (which are arranged as a wall at the moment), three very powerful data projectors that project onto three screens, and three other LCD screens that are in the reception area outside the space. These three operate as the public noticeboards for what's going on, as well as being part of a program. In addition to the screens, there are three mushroom sound cones, which allow us to play the sound in a very confined space. This effectively means we could have three films playing with three soundtracks, and one could walk into the space where sound is being projected and then out of it and into the next one. In a relatively small space, then, we can have lots of sound related to many different images. We also invested in a series of computer-programmable lights, which allow us to have a time-based lighting sequence across the spectrum. The initial rationale was to obtain the most flexible and variable kind of setup that would be interactive, would allow us to show anything digital, and would also let us connect the system to the Internet so we could program different screens with different web sites. The gallery was designed to have a user-friendly software interface. The first generation software was called Viewflex, and it used a Creston AMX touch screen control panel. Getting that many pieces of equipment to "talk to each other" was a very tall order.

At the time we did the research for the project, no one else we knew was doing this kind of work. Interestingly enough, when we went to look for an organization to work with, we found that the leading edge of this technology was in the

commercial sector, among companies that are basically doing setups for trade shows, some of which are quite gimmicky and novelty led. We found that content management programs (which is what we were seeking) were being used for shops that wanted to replace print advertising with screens or use shop windows with screens. Music clubs, trade shows, and big concert venues were also using audio-visual displays that projected images onto flat screens and even three dimensionally through smoke, or steam, in order to create spectacle. All of these systems needed a computer-based content management system. So the technology we were looking for was not to be found in a fine art or educational context at all, but in the commercial sector.

The technical manager of the university and I went to a firm called TouchVision; they offered us what I thought was a very exciting, user-friendly set of options for a multiple display platform and flexible content management. The actual piece of software we used, Viewflex, involved distributing the asset files onto the hard drives. So in principle, an artist or photographer would be able to come with their files and work out how they wanted to display their work in the space and on which screens. Then they would load up their files, the computer would distribute them to the software that controls the screens, and then they would write a playlist that says "turn screen 1 on and keep it going for five minutes and then stop; bring 2 on and let that run," and so on. The artist would make up a program as one would have done for a slide-tape show. In fact, I began to see the gallery as a digital remediation of slide-tape. In Britain I think slide-tape shows reached a historical apotheosis with the Greater London Council's 100 carousel "cake" which was a multimedia audio-visual display about London (1987). Slide-tape was somewhere between art house cinema and a gallery installation. There were some wonderful examples of what could be done with slide-tape, and I see it as an early version of a time-based media that never managed to get in the gallery on any permanent basis because it was seen mostly as an instructional medium as opposed to an artistic medium. Maybe that's the same position that content-managed digital projection is currently in, because a lot of the software is really marketed for informational use and has too much built-in control for the artist or photographer who needs a lot of flexibility.

Having commissioned the installation for the digital gallery from TouchVision, the subsequent story is one of a struggle with the limits of commercial software in a creative-led

environment. There are two sides to the story, good and bad, that come out of this struggle. We were trying to prototype something new and, although the software promised to do the two things we asked of it—it would take all formats of digital imagery, and we could write the order we wanted our digital assets to play using a graphical drag-and-drop interface—we hadn't quite worked out how it would be used. More importantly, SRIF was a capital project, with no money for ongoing technical support, which we thought would be unnecessary as the software front-end would be sufficiently user friendly.

After the technical commission signed off, a number of the academic staff went on a training course offered by TouchVision, and I then set up some very open-ended digital residencies. These were based on my experience, working at Watershed Media Centre in the 1990s, of how you program experimental exhibition spaces. NODE, an Arts Council–funded new media network, had also recently got going, so I put out a notice to ask if anyone there was interested in a digital residency. A couple of people responded and started residencies, and they immediately ran into software difficulties. Our software (Viewflex) proved not to be very user friendly at all, which I think now is because it was Windows- rather than Mac-based and required a four-stage process of loading files, distributing files, creating a playlist, and then creating a show. It would have been fine in a situation where we had a dedicated technician to work with the photographer/artist, but as a piece of software that had to be fairly non-technical and accessible, it turned out to be very complex and unstable.

The software and the networked configuration worked for those who knew exactly what they wanted their show to look like, but most artists want, initially at least, to experiment with how things look before committing to a final show. However, every time the artist wanted to make a change in the order of screening, he or she would have to reprogram the playlist. The software was written for commercial uses, with very simple instructions to direct a set of screens in retail spaces to play one aspect on repeat on several screens.

In our situation, everyone who came in to create a project in the gallery needed access to technical support; however, the university's own IT technicians didn't have enough time to support the work. TouchVision gave us a good after-sales service and came in and supported several of the exhibitions, but it then became the case that only they could make the software work. This was very much a testbed situation with a developmental arc and teething, and development prob-

lems were something we expected. So, alongside the fact that we have been able to use it continuously as a gallery, we have had this kind of reflection with the company on the problems of the software and how to adapt and change it— which is quite difficult with a commercial company where there is no service agreement in place.

I currently think that the easiest way of showing new media artifacts is to have a separate computer for each programmable element and have a full-time technician. We tried to leap forward and do away with the technician by installing a piece of automated software. One of the potential advantages we saw was that the software could store, program, and manage many exhibitions. This would have the advantage over gallery exhibition where work is put and taken down sequentially; the digital gallery could, by contrast, store twenty to thirty exhibitions, or more concurrently and display them in any sequence. We imagined a display program where the computer would play one show in the morning and another one in the afternoon, or let one play for three days and then change remotely. The potential for the system was huge and would allow us to shift between, for example, a student show and then a research- or Internet-based art project. Again, that program flexibility has come about, but so far it has always required a lot of dedicated technical support.

Being able to show large amounts of work on a rolling program is a great advantage. When I was curating photography at the Watershed Media Centre, there were always many more people than we could ever show. We had three programmable spaces, booked up to two years in advance by a selection committee that had to say no to many good people. In a digital gallery you don't have to say no to anybody, because you can give someone a show for half an hour if you want. It's only time limited, and you can show work 24 hours a day and just keep it rolling. We've never reached that capacity as yet because of the software problems, so in actual practice we've run the gallery more conventionally, in that we create slots, advertise in advance, and show either student work or research work (our funding was in part specifically to show work from academics doing practice research within the subject area of media and communications).

Another way of looking at it is to say that the gallery could display the content of screen-based work, rather than become involved in the installation form, which is the inevitable compromise with a fixed system. Knowing the limits of the

configuration was part of understanding how it could be used creatively. The focus was to see what content people would put into the gallery—whether it was digital stills, video, or sound—and that's still the mission. If anything, it is a remediation of cinema rather than the modernist white cube.

Having worked on the digital gallery for two years, I can now see why no one else has done this as yet because it is still very experimental—which is fine because part of our remit is to experiment with the technology and develop the form through work-in-progress shows. These shows have given us a small number of interesting case studies. That said, it has been harder than we ever wanted it to be and has raised lots of issues that we must now evaluate. We are presently at a point where we are going to change the software. Viewflex software proved intractable, too difficult to use, not user friendly enough, and also required that the files be presented in a certain kind of format, limiting what could be done. It's important to recognize, though, that when we started there wasn't another piece of software around that we could have just got off the shelf. The great irony of our experience is that we might as well have had a bespoke installation set up for each show, as we had to provide support for each artist through the company in order to get the work displayed.

After two frustrating years, we hope that the new software, Panasonic's NMStage, will do the job we want it to. We are determined in the coming year to get where we wanted to be a year ago—which is programming lots of work. Our initial assumption was that computer content management would obviate the need for a technician, which I now see as a common fallacy about technology—the dream of automation, the dream Vannevar Bush had for his Memex Machine. I now think we do need a full-time technician, and we will have to figure out how to fund that position.

I think the gallery could be developed into a teaching resource, which would support the programming of the space by teaching students fairly continuously from two courses. The first would involve our arts management curatorial course, teaching students who want to curate new media. Here we could develop the idea of having an annual new media internship attached to the gallery. The second would be teaching new media students, particularly photography students, to think about the nature of exhibition in general and all those issues having to do with the projection of their work. It's commonly understood that most photography stu-

dents are useless at editing their own work and clueless at understanding what happens when their work goes on the wall as a print. They don't understand about scale, about framing, and about space, and usually they're not taught any of those things. Our degree, like most, doesn't have a unit that's specifically dedicated to exhibition practices, and so we see the digital gallery as helping students with these issues. Using our technology, which is ultimately a big digital slide-tape machine, we could teach timing and editing for narrative. But we could also use the high-definition screens like a light box if students wanted to work with one image. And we could deal with the issue of size because it's completely possible to play with scale when you have a big data projector or a whole wall of screens.

If you think about it as a teaching gallery, then there's the opportunity to get students to exhibit their photographs literally every week. Digital technologies cut out the amount of printing and organization needed, so we could speed up the process by which projects can be shown. So far, our first-year students had their first show after only one semester. They had done one module, and traditionally they'd submit the work either as a digital file on a CD or they'd email the images to a tutor; or, if they were in another photography course, they'd probably have handed in some prints and that would be it. Traditionally they'd be assessed in a closed system, whereas these students—within the time scale of a very pressured semester with a lot else going on—were able to have a show in the digital gallery of the work they'd produced for assessment. Using the digital gallery teaches them to think about the reception of their work because the gallery has a real audience. I think that's a very good way of beginning to see how exhibition shapes the way you work, because you get a huge amount of feedback once you have an audience. The digital gallery can support teaching about the circulation and distribution of the image simultaneously with tutors teaching about the conventions operating within the frame. This is very different from teaching analog photography, which has a strong material separation between the process of producing a print and the process of exhibiting.

One of my initial reasons for developing the digital gallery came from my experience of working at ARTEC, an Arts Council and Camden Council–funded new media project in the mid-1990s, run by Frank Boyd, which was one of the first initiatives for training artists. The training was based on

Macromedia's software, Director. At ARTEC there was all this training and fantastically interesting projects were going on, but very few people saw the output because the Internet was not graphically developed. The only way to see new media was on a CD-ROM played on individual computers. Although there has been the odd experiment with new media installations in London galleries, one can still ask why London doesn't have a gallery dedicated to the exploration of new media. Of course, with greater bandwidth and connectivity online, the very idea of needing a physical space to show screen-based interactive work could seem redundant, but against this there does seem to be mileage in the idea of exhibiting new media in front of audiences in real time and real space.

Exhibiting new media in a dedicated space also has something to do with how you make new media work accessible once it has been archived. The Whitney in New York has a new media curator, Christianne Paul, whose job is to program new media as well as run an online archive of new media work. There are a number of other organizations trying to do that as well—for instance, Professor Beryl Graham with CRUMB at Sunderland University. My thinking now is that museums will develop new media galleries in which there is a content management system for all file formats and where archived materials are shared in a network or database. New media have become naturalized through the PC and the Internet in a way that makes the technological trajectory seem unremarkable, undercutting any historical sense of wonder as well as critical inquiry about the media. Screens are ubiquitous and seemingly without aura, although I believe that the screen retains a huge power to capture attention. A new media gallery would, of course, have multiple screens, sounds, and interactivity, but I think the jury is still out regarding how successful a new media gallery could be in attracting an audience and becoming a focus for showing new media or conventional photography or film work.

In a sense one could say that we have the technology but lack a cultural form. But there is something very powerful about having a very intense set of technologies in a physical space, because there is so much potential for combining image, music, and text—a dream of a post-Barthian semiotext. Multiscreen computer-controlled content management could create such rich media environments. A lot of people have said that, as a space, the digital gallery doesn't feel like anything they've ever been into before, and it's a cross

between a fun fair, some kind of science museum exhibit, a gallery, or a cinema—truly a kind of hypermedia environment. So I think there's something about this media environment that undoubtedly excites people; they immediately get the point and see the potential. Creating environments where you are able to have very rich sensory experiences and which are clearly not in the tradition of a mainstream European gallery really interests me. The dream of the automated programmed digital gallery has powerful appeal in terms of being able to put many different kinds of content into a very rich environment. So if the program were to get support as a gallery, I feel pretty sure it would get a good audience.

Against this, the digital gallery is bit like a chameleon in the way that digital technology can pretend to be another medium. It is here simply a technological platform, a relay system. LSBU is going to put on a David Bomberg show in the digital gallery. Bomberg taught the Borough Road Group at the university. In mounting a digital display of Bomberg, I think of the digital gallery as a kind of rich cerebellum, a space where it is possible to look at a physical charcoal drawing by Bomberg on the wall, while at the same time seeing all the work he ever did on the screens. There is, of course, the question of copyright clearance, but I won't go into that now. Bill Viola is probably the artist who has been most successful in developing the use of plasma screens; with the same richness of resolution as the surface of a painting, he invites the viewer to ponder the difference between the material and the immaterial, the moving and the still. It is now possible to make a screen resemble a print pretty closely. Daniel Meadows recently said to me that in the Tate photography exhibition "The Way We Are" (2007), there was no reduction in quality from the original prints he made in the 1970s, even though they had been scanned and projected for the exhibit and it's obvious that one is looking at a screen and not chemicals on a piece of paper.

Although there are many human perceptual differences in the apprehension of surfaces, I think that the amount of information—that is, screen resolution—will not be the issue for much longer; the issue will be how we understand objects. There is still much industrial traffic between digital photography and photography as a print medium, but I think for most students, their biggest opportunity to circulate their images and possibly make money will be online. I think further technological development of the networked digital

image and high-definition screen is going to radically change notions about the circulation of "photography." Students are quite happy when their work is in print form, but I think for many of them, the natural home of the image is now on screen and in an online environment. A student could now undertake a very successful degree course in photography with no more than a mobile phone and an Internet connection, because right now everything is about the circulation of the instant, real-time image—the total ephemerality as well as dissolution of the photographic image.

Andrew Dewdney

Preparing to Install the Exhibition

I think you get to see more when the pictures are bigger. I always want you to feel like you're in the room with that person. It should look like real life.

Tina Barney, photographer

The whole thing about accessibility can be hugely patronizing. There's a fine line between making an exhibition accessible and patronizing the audience and people fail to recognize it.

John Gill, director, Brighton Photo Biennal

I think it's important that people understand and look at photography in a more abstract way. It's about being able to imagine looking behind the image as if it were three-dimensional.

Rineke Dijkstra, photographer

I want to make your brain work just enough so that you understand and just enough so that you don't understand.

Tina Barney, photographer

Over the years the presentation of the work—by which is meant the choices made in mounting, framing, and displaying the photograph—has become a more important part of the exhibition process.

PRESENTATION AND FRAMING OPTIONS

There are a large number of options for ways to present photographic work. Choosing a presentation method depends on a number of things, including:

- what is most appropriate to the work
- what is most appropriate to the gallery or showing environment
- cost
- image size
- protecting the image from damage
- issues of archiving or conservation of the print

FIGURE 5.1 Photographs propped against the wall to check the hang before starting work. Image © Tim Roberts

- fashions in presenting work
- personal preference
- the weight of the finished piece

There are other decisions to be made also, specifically concerning:

- whether the work needs a border or not
- whether it needs a frame or not

- whether to put the work in a mat or not
- whether to protect the image by sealing it or putting it behind glass
- whether to spray or dry mount the image

When selecting a method of presenting work, the most important consideration is what will show the work itself to its best advantage. This can be a difficult decision and careful thought about the subtle differences in meaning which will be conveyed by the different presentational options is required if costly mistakes are to be avoided. Dark or heavy frames that look good with black-and-white prints can overwhelm delicately colored works. Borderless prints mounted on aluminum may look good on the large white walls of a loft or industrial space but may look lost in a more traditional gallery. Some work looks better with a frame around it because either the subject matter or composition needs a sense of containment or a traditional method of presentation.

It is worth asking advice from gallery, framer, and colleagues. Galleries know what works in their space. Framers are usually particularly good at practicalities, advising on types, color, and width of frame, and sometimes on whether a work is better framed or presented frameless. Colleagues tend to focus on the work and what complements or makes sense with the subject matter or composition.

The space of a gallery can dictate the method of presentation. As a rule, large spaces call for large images and small spaces for smaller images, but this need not be the case in every instance. As long as a large image has enough space around it that it does not appear cramped and has sufficient viewing distance for the viewer to stand back and see the image properly, it may be compelling in a small space. Generally these sorts of decisions are best made in the space itself, where it is quickly apparent visually whether or not something works.

Frames, mats, and borders are all means by which the photograph gains a (breathing) space around it and is more contained and the viewer more distanced. Borderless and unframed work is more immediate and can be more confrontational. Viewers may feel they are intended to be part of the event rather than observers.

A frame also helps to protect the image from accidental damage and environmental pollution, whereas an unframed work is at much higher risk from accidental damage by visitors.

TYPES OF PRESENTATIONS AND FRAMES

Let's review the choices of presentation and frame.

1. On the wall:
 a. unframed, with or without borders, but spray mounted/dry mounted on
 - polyboard/foamboard/foamcore
 - Foamex
 - thick board or medium-density fiberboard (MDF) (block mounting)
 - aluminum
 - aluminum behind acrylic glass/Perspex/Plexiglas/Diasec
 b. unframed and unmounted
 - pinned, taped, pasted, or spray mounted directly to the wall
 - attached with magnets to metal strips on the wall
 - hung from nails with clips such as bulldog clips
 c. framed
 - conventionally with wide mat/mount to the edge of the image and a frame of wood or metal, of any width
 - in a gutter box (about 1 inch deep) in which the image sits unprotected by glass
 - in a box frame (about 1 inch deep) in which the image sits behind glass; the image can be raised slightly from the backboard and seem to float in the box
 - handmade frame with a border of fabric, leather, mirror, mosaic, papier mache, or other material
 d. light boxes
2. Not on the wall:
 - suspended from the ceiling, usually with eyelets and ceiling hooks
 - sandwiched between glass or acrylic (Perspex or Plexiglas)
 - heat sealed
 - individually clipped to the wire or cord
 - as a long roll of unprotected paper
3. And also:
 - on a table under glass
 - on a plinth
 - as a projection
 - in an artist's book
 - on the floor or ceiling

SEALING THE WORK

A Diasec mount is one in which the image is face-mounted to Perspex, which in turn is dry-mounted onto an aluminum backing. The backing has a subframe on its back which gives it extra support and provides the means to hang the piece. This process is irreversible, as the Perspex is stuck directly to the image. It is accepted by museums and is proven acid free. However, the process has only been around since the

1980s, so there is no telling how archivally sound it is. It is also not particularly durable, as Perspex scratches fairly easily (more easily than glass, for example), and if the Perspex is very badly scratched, then the whole thing can be ruined.

When a large image is presented mounted on aluminum but is not protected behind glass or Perspex, it can be protected with a layer of mat sealant. Opinions differ about whether this is worth doing, because a seal is no more robust than contemporary photographic paper and sealing can result in a slight loss of image clarity. A seal will protect the image against, for instance, fingerprints but not against the sort of accidental damage that occurs when the image is dropped or something sharp pierces the surface. At an exhibition I attended recently, visitors with backpacks or large bags were asked to leave them in the cloakroom since the exhibitor had already had a print badly damaged by someone's bag. There may also be problems if there are any inconsistencies in the print such as handling marks or dents in the surface, as the seal will not take properly when applied and will peel off. A seal can be wiped using a special duster which can usually be purchased from the supplier of the seal.

FRAMES

Photography is a system of visual editing. At bottom, it is a matter of surrounding with a frame a portion of one's cone of vision, while standing in the right place at the right time.

John Szarkowski, *The Photographer's Eye* (2007 [1966])

Sometimes not to be able to borrow one piece of work in a group show potentially undermines the whole concept of the show since every constituent work articulates the thesis differently.

John Gill, director, Brighton Photo Biennal

As an artist, I have found it well worth the money to hire a professional exhibition installer, particularly for complex exhibition installations where lighting and sound or unusual hanging requirements are needed. Professional installers can be found through museums or galleries and often work on a freelance basis. They are fast and efficient, bring their own tools, and have ready solutions to technical problems of a given space. They save a lot of aggravation and are worth the investment.

Deborah Bright, photographer

Because works in an exhibition are viewed sequentially, inevitably a narrative is created and the curator's role is to ensure that the context of that narrative supports rather than undermines the work.

John Gill, director, Brighton Photo Biennal

Frames are available in a large range of types, styles, and colors, all of which can be carefully considered. Black, shades of brown, and white tend to be the most popular. White, which was rarely used in the past, is now a popular color for contemporary work. Box frames, which are deeper than the standard frame, tend to suggest that the work is historical, archived or precious, or that the viewer is looking more deeply into a scene.

WORKING WITH A FRAMER

Framers vary a great deal in their levels of skill, knowledge, and the sorts of frames they produce. Some are only equipped to deal with smaller frame sizes or do not dry mount large works. Some are much better equipped for exhibition production than others. Costs vary a great deal too. It is well worth asking around to find a good and reliable framer who has experience producing work for exhibition, understands deadlines, and with whom you can establish a good working relationship. If you use the same framer on a regular basis, you are more likely to get better service, good advice, lower costs, and someone who understands your work and will help out in emergencies and in other ways.

BUYING READY-MADE FRAMES

Because photographs, unlike paintings, tend to come in standard sizes dictated by paper size, it is usually straightforward enough to find a suitable ready-made frame in the smaller sizes—that is, below 24 × 36 inches or 594 × 841 mm. You might think that in looking for a ready-made frame, the priority should be finding one that looks good. However, the most important element is, in many ways, the back of the frame rather than the front. Inexpensive frames can look good from the front but still have a number of problems:

- poor construction and weak corners, which means that being moved around will cause the frame to eventually collapse
- problems in attaching the plates or wire to hang it by, because the wood is too soft to hold a screw
- small metal teeth holding the removable back of the frame in place, which can break and fall off after a time—the fastening system for the back of the frame should be strong
- cheap wood used for the frame, or a poor wood finish, which renders the frame vulnerable to being dented or scratched and its appearance difficult to maintain

If you anticipate reusing frames, then it is worth investing in the best you can afford, because they will look better, will be sturdier and very much easier to use, and will last longer.

Galleries sometimes sell used frames, framers have sales, and the Internet can be a good source for economical frames. But beware of acquiring too many varieties of frames simply because they are reduced in price—a set will always be more useful.

MAKING YOUR OWN FRAMES

Painters often make their own frames and it is possible for photographers to do so as well. However, few photographers take on this task, because it requires a high level of skill to achieve the standards expected for showing photographs. Making frames is a specialized craft skill that has to be learned and requires space, time, and good equipment. It also creates dust, which is the worst possible thing in a photographic environment.

CONSERVATION ISSUES WITH FRAMES

Frames are usually available in a range of materials, the most popular being wood or metal. Increasingly, the key issue in choosing a frame is the conservation standard of the frame. Good-quality modern wooden frames are likely to have been made to conservation standards; cheap frames, by contrast, usually cannot make that claim. That said, it is the backboard that can do the most damage to prints, because of the acids that may leach out of them. To prevent this, there should always be a sheet of acid-free paper between the print and the backboard of the frame to keep them from being in contact.

GLASS AND REFLECTIONS

Acrylic (Plexiglas or Perspex) and non-reflective glass can both be used to cut down on the reflective qualities and glare of glass. Both are very expensive, and most forms of acrylic glass scratch easily and may discolor slightly. New forms of non-reflective glass are currently being developed specifically for photographs, and they are very effective. Unfortunately (from a cost point of view), it is particularly important to use non-reflective glass when displaying very large images, since otherwise they can be impossible to see properly as a whole. With smaller works, viewers can see an image obscured by glare by simply moving their head. Glass must be kept clean

and free from dust and fingerprints, which requires daily checking once installed in an exhibition. In any case, strong sunshine is far from the best environment in which to stand and study a print or exhibition, so most galleries use blinds to create a shaded environment, and they avoid hanging prints in direct sunlight where there is a danger that the print will fade. So non-reflective glass should be used wherever possible, though the cost may sometimes prove prohibitive. It is usually more necessary to use non-reflective glass in galleries where artificial light predominates.

Fillets or spacers

Photographs should not touch glass. A mat will prevent the photograph from contact with the glass, but where the photograph is in a box frame, a fillet or spacer is crucial to keep it at a distance from the glass.

MOUNTING WORK

Spray-mounting can be done by the photographer and is useful for smaller work. It is difficult to spray-mount an image of more than about 12 × 16 inches. Many kinds of spray-mounts and glues will damage the print over time, so if these products are used, the print cannot be sold as archivally permanent.

A dry-mounting press is an expensive investment to make. But it produces a better and flatter result than spray-mounting. Most professional framers can dry-mount large image sizes. The process is permanent, however, and the photograph cannot be removed from its backing if, for instance, the card mount gets damaged.

Foamboard (also called foamcore) is a core of hard foam held between paper. It is softer than Foamex (a brand name) and a bit spongy. Foamex has a solid plastic core and is difficult to dent. It is more durable and more expensive than foamboard.

Spray- or dry-mounting onto foamcore or Foamex are the least expensive methods of mounting and are perfectly adequate for student or one-off exhibition, although they are regarded as being at the amateur end of photographic practice. They are also useful for the display of text panels.

WINDOW MOUNTS OR MATS

Window mounts or mats are used as part of the display of prints in a frame. A window mat consists of two pieces of

(archival) board which hold the print in a sandwich. The print is attached to the bottom layer of board and viewed through a window cut in the top layer. Although the mat protects the edges of the print from most handling damage, the matted print is usually also in a frame and behind glass to protect the surface of the image.

Mats are most commonly used for vintage or smaller prints or prints best shown in a conventional type of display.

The mat has five or six great advantages, both practical and aesthetic:

- Photographs tend to buckle over time as paper and emulsion respond differently to atmospheric conditions. A framed photograph is very hard to view if it is not held flat, as gallery lights will reflect differentially off both the glass and small uneven areas of the emulsion. The mat helps keep the image flat.

- A mat protects the print from damage to the edges and corners, caused by handling.

- A photograph should not be in contact with glass because it will be damaged by the contact. If the photograph starts to adhere to the glass of the frame, it may prove impossible to remove without also removing pieces of the emulsion. The mat keeps the image away from the glass.

- A print in the smaller size range (8 × 10 inches and below) is almost always aesthetically enhanced by a deep border. The window mat or border creates a space around the print and focuses the viewer's attention on the image itself. This is particularly important with very small prints, which might otherwise get lost against distracting backgrounds or in competition with other images.

- The advantage of the window mat over dry mounting is that it is not permanent and can be dismantled if it is necessary to replace the mat or reframe the image. This may be essential, for example, if the print is to be shown in a different context or in another exhibition that is using a different shade or type of mount board. It preserves the print and the print border whole and allows access to the back of the print which may hold a signature or other information.

- A mat announces to viewers, in no uncertain terms, that this image has been considered worthy of serious attention by the photographer or curator, which encourages viewers to look at an image they might otherwise ignore. This is very useful if, for instance, a curator is working with imagery that traditionally might have been thought unworthy of a gallery, such as found photographs, photo booth images, amateur snapshots, and vintage press prints. However, this tactic may be seen as pretentious and as an attempt to inflate the interest or value of intrinsically uninteresting work, so it should be used with care.

- The mat can also be used to emphasize the fact that the print is only an image on a piece of paper and essentially an insubstantial and fragmentary object—in contrast to making it look more permanent and solid, as dry mounting tends to. This is usually achieved by "floating" the whole image, including its border, inside the window mount (as described below).

Boards used for matting prints are available in a range of colors but are generally used in a range between white, gray, and cream. The board should be thick enough to be rigid or it will move or start to sag minutely in the frame. It should be of archival quality, which is sometimes called museum or conservation board, acid-free or rag board. These are usually more expensive to buy than other boards but will not damage the print over time, as other boards will do as chemicals leach into the print.

There are three options in deciding the size of the window in the mat:

- The window is usually cut to be very slightly smaller than the photograph itself (by about $\frac{1}{8}$ inch or 2 mm) so that only the image area of the print is visible. The print is then held in place by the border that is hidden underneath the mat.

- If the print has an unevenly printed edge or is borderless, however, the mat may need to overlap the image itself in order to hold the print flat. This will crop the image very slightly. Usually the loss of image in this situation is so slight that it is not a problem, but if the whole image area has to be visible, the print can be either dry mounted or "floated" as described below.

- "Floating" the whole image in the window means that the viewer sees the border as well as the photograph. This works well when the border itself, or the information on it, is of interest or significance—for example, with small snapshots that have something written on the border, or with Polaroid images, where revealing the border makes it immediately apparent that the print is a Polaroid. Sometimes a border on a vintage print has been damaged in a way that gives a fascinating insight into the history of the image as when, for example, a corner has been folded over like a bookmark. It works less well when it simply looks like a mistake in measurement or an unnecessarily fussy way of framing the image. It will also draw attention to any differences in the shades of white in the image border and the mat itself, so a careful choice of the color of the board is important.

You can cut your own mat, but it is a skill that demands patience and experience so should not be undertaken for the first time just before an exhibition, when time pressure is likely to make the inexperienced clumsy. Most framers cut mats relatively inexpensively as part of the framing service and bring useful experience to the choice of board, color, and window size.

My colleague, Ruth Fuller, sent me this description of cutting a mat:

Having tried several mat cutting systems, I have found the Maped System to be by far the best, producing mounts that are indistinguishable from professionally cut mounts. It is portable and simple to use and consists of a cutter which slides onto a custom-built ruler. There are two types of cutter, one that cuts the window

at a 90-degree angle and one that cuts at a 45-degree angle. The cutters are interchangeable and can be used on different length rulers. The correct type of cutting blade (either 45 or 90 degree) must, of course, be used on the cutter it is designed with.

Use conservation or museum board for archival mounting. These boards are acid free and come in various shades, colours, and thicknesses. There are recommended ways of cutting out the window and instructions usually come with the system. I have always found the following method the most accurate and easiest way of measuring and cutting. It is suitable for cutting a 45- or 90-degree window. Always stand up when cutting; otherwise you can't hold the ruler down firmly and you can't cut straight. It is a good idea to practise on some scrap board before cutting the final board.

Use two or three layers of any kind of board underneath the board to be cut (the cutter will ruin a cutting mat). Make sure the surfaces of the boards are clean. Make sure the blade in the cutter is sharp. A semi blunt or blunt blade will make cutting laboured and will tear the board. Measure absolutely exactly and draw lightly (with a very fine pencil) the size of the window to be cut on the *back* of the board. If cropping the image a little bit is not a problem, make the measurements a millimetre or two ($^1/_8$–$^1/_{16}$ inch) smaller than the image size both lengthways and widthways. This ensures the window will not be too big. Always be very careful measuring and drawing out the window.

Cutting from the back to the front of the board requires that the cutting ruler and blade be placed on the inside of the drawn out window, with the blade pointing outwards, towards the edge of the board. This will ensure that when cutting a 45-degree angled window, the cut will slope from the surface of the board in towards the print.

Line up the ruler and the blade along one edge to be cut, so that the tip of the blade will touch the drawn line when the cutter is pressed down, both at the top and bottom of the line. This may take a few attempts, but is essential for an accurate cut. Holding the ruler firmly in place, press the blade down and lightly score a cut from the top to the bottom of the line. This gives the blade a guide cut. Over-run by around 3 mm or $^3/_{16}$ inch (depending on the thickness of the board) at the top and bottom for clean-cut corners. This over-cut should not show as long as the blade is sharp. Some people can cut a window without an over-cut but most people find it difficult. Keep holding the ruler down, and cut along the line again, this time pressing more firmly. Repeat until the board is cleanly cut through.

Repeat this process on all four sides, and the window should fall out cleanly.

If there are any bits of board that are a little ragged (there shouldn't be!), it should be possible to remove these stray bits with a sharp hand-held knife or scalpel.

To fix the image behind the window mat, acid-free paper can be used to make corners for the photograph which can then be attached to the back of the board using an acid-free archival tape. This method ensures that the photograph is not mounted directly onto the board and can be easily removed and replaced. Self-adhesive linen cloth tape is available to buy; it should have a neutral pH acrylic adhesive of archival quality. This tape is also excellent for hinging the window mount to a backing board.

Mounting corners are also available to buy; the most suitable are made from polyester film (which is completely inert and therefore archival). They should attach to the mount with an adhesive that is chemically stable, long aging and archival. Again these ensure that the photograph can be easily removed and replaced in the mount.

Window mats that are consistent in size, board color, and positioning are one way of making a set of very diverse prints in an exhibition cohere. The visual impact of a single tone of mat will create a strong unifying link among the images and make differences in size, condition, tone, and density seem less noticeable. This works particularly well for unifying a diverse set of black-and-white prints.

Photographs are usually matted and framed in keeping with how they were originally taken—that is, a horizontal image will be framed and presented in a horizontal frame and a vertical image framed vertically. However, this is not always the case, and a horizontal image may be found matted and framed horizontally in a vertical frame. There are three reasons to consider presenting an image this way:

- The image will look very good, possibly because it's a familiar convention in photographic books.
- A vertical frame takes up less running wall space than a horizontal one, so it is one way to include more images in an exhibition if you need to.
- When a show includes both horizontal and vertical images, hanging all the images in a single, standardized way (so that every image takes up the same amount of space) can make a better narrative flow. The eye will move more easily from one image to the next; a row of frames all presented vertically is quicker to "read" and makes better sense on the wall than a set that includes both vertical and horizontal frames.

Conversely, vertical images are sometimes matted and framed in a horizontal frame, although this is much less usual and often less visually satisfactory because the image may appear overwhelmed by the wide borders at each side.

There is no general rule about the size a mat should be, although most are generous because a small mat tends to make the image look cramped in the frame. Even the smallest image usually works well in a large mat, and I have seen vintage 35 mm contact prints in mats at least 2 × 2 feet or 600 × 600 mm. Using a large mat around an image usually works well, unless it is taken to ridiculous extremes. The way to test out what will work is by experimenting with different sizes of card borders before making a final decision.

Large mats on smaller images work well in part because small frames can get lost on gallery walls (unless they are densely packed), and mats help the photograph make more impact in relationship to the wall. Good frames are also an expensive investment, so some photography galleries own a limited range of variously sized frames which they use regularly and with every size of image. This is made possible by the fact that the mat can be cut to fit the frame whatever the image size.

However, there are strong conventions about the positioning of the matted photograph within the frame. Although different sizes of mats work well with almost any size of image, the position of the photograph in the mat in relationship to the frame is not so flexible. The convention is that the left and right borders of the mat are always equal in width but that the borders above and below the image usually differ in their depth.

Generally the border underneath the image is from a quarter to half as deep again as the top border. There is no firm ruling for this, and the decision is usually made by what pleases the eye or by making the left, right, and top borders equal, which will determine the depth of the bottom border, or by the need for consistency across a set of frames that are going to line up along a wall. For instance, if horizontal and vertical frames are placed unevenly in a row across a wall, one way to create a visual consistency may be to line up the tops of the prints (rather than the frames) at the same height across the wall so that the top line of the photographs draws the eye along the wall. This can be achieved by varying the depth of the borders above the photographs because the eye will be held by the darker line of the images rather than the lighter color of the mats.

FIXINGS/MOUNTING HARDWARE

There are a number of options for attaching a frame or mounting an image to the wall. Professional framers often have a preferred method of doing this, appropriate to the weight and type of frame or mount, and they may well provide this without consulting you—unless you make a point of checking it first.

The option you should *not* use is the one you may have at home: picture wire. In a gallery setting, this leaves the picture too vulnerable. The picture can easily be taken from the wall or knocked out of alignment. The wire is also very springy, so it can be difficult and slightly dangerous

FIGURE 5.2 "Fixings," or installation hardware. *(Back row, left to right):* Picture rail hooks, picture cord, screw eyes, strap hanger and J hook. *(Front row, left to right):* Picture hooks, mirror plates, concrete wall hanger, and D rings. Image © Tim Roberts

to use, and because it becomes brittle over time, it can also snap.

However, if you are doing this yourself, you have a variety of choices, both for the fittings on the frame and for attaching the frame to the wall. The choices are:

1. picture rails, hooks, and picture cord used with screw eyes/D rings
2. picture hooks used with screw eyes/D rings
3. screws
4. mirror plates
5. strap hangers used with J hooks
6. metal battens
7. split battens (wooden)
8. concrete wall hangers for use on difficult walls

(1) Fewer galleries use picture rails and picture rail hooks than once did, but in some places they are the only available system. They are often used in old buildings, where the walls are wooden or impossible to drill into without excessive damage. Picture rail hooks come in different sizes and colors and are used with picture cord attached to the frame by two screw eyes or D rings. D rings are considered more secure than screw eyes. When using a pair of screw eyes or D rings, they are best placed at about a third of the depth from the top of the picture frame to provide maximum support. Picture cord is generally used by framers in preference to wire

because it is safer. It is reinforced low-stretch white nylon cord and usually available from good framing shops. It is sold in different thicknesses and by the yard or meter.

(2) Picture hooks can be bought in hardware shops and come in double or single sizes. They are attached to the walls with the brass pins that are provided with them. As with picture rails, they are used in conjunction with frames with screw eyes or D rings and picture cord. The cord should be hidden behind the frame. However, picture hooks are not often used in galleries, as the pictures are easy to lift from the hook or knock out of alignment and do not hang completely flat.

(3) If the frame is slightly deeper than the removable back (that is, if there is a shallow hollow space behind the frame), then the picture can be suspended directly from two screws in the wall. The screws should be placed at about one-quarter to one-third of the way in from the edge of the frame to provide maximum support. This is a quick and perfectly efficient way of hanging work, unless it is a very heavy frame and should probably have more support (such as a strap hanger and J hook). It is not, however, the most secure way of attaching the frame, since it is not hard to lift the frame off the screws.

(4) Mirror plates are small metal fittings that attach to both frame and wall and are very secure. They look rather like a jigsaw piece with a tongue protruding from a square block and can be bought in different metals and sizes from hardware shops as well as specialized framing shops. You use two mirror plates and attach them either at the top and bottom or on each side of the frame. Two screws attach the larger part of the plate to the back of the frame and one screw attaches the smaller "tongue" to the wall. They will hold a heavy picture frame but are visible and rather unattractive, although they can be painted to match the wall and will then be much less obtrusive. They cannot be used on metal frames, although there are metal frames available that have very similar fixings already attached. They also make it impossible to butt the work up closely in a stack of four pictures, for example, since each plate protrudes from the edge of the frame and it is impossible to put the next picture any closer than the end of the mirror plate.

(5) Strap hangers are hidden behind the frame and so look neat and professional. The strap is usually metal and shaped like a belt with a large eyehole shaped like a belt buckle (without a prong) which hooks over either a J hook or a

screw in the wall. They depend on very accurate measurement, since there is only one place for the J hook or screw to go, and if they get out of alignment the picture will be crooked. Strap hangers are very secure and will take heavy frames or light boxes.

(6) Thin metal battens are usually used for hanging photographs that are mounted on aluminum. They will be attached by the framer. Usually there are two parallel battens near, but not at, the top and bottom of the frame. There are two so that the picture hangs flat at an even distance from the wall. Each batten is a squared off and upside-down U shape. One arm of the U is shorter than the other and this rests on screws in the wall. The longer arm of the U is attached to the aluminum backing of the photograph. This hanging method, unlike straps, allows the installer to adjust the horizontal placement of the image after it has been hung, something that is very useful when several images have to be precisely spaced along a wall.

(7) Split battens make it very easy to install the picture. This depends on a single batten that is placed near the top of the photograph and runs parallel with the top edge. The batten is in two pieces with a diagonal join (called a male/female fitting). One side is attached to the wall, with the diagonal cut facing inward toward the wall. The other is on the back of the frame, also with the diagonal cut facing inward toward the back of the image. Once the first batten is attached to the wall, the whole picture can be lifted and slid into place where it is held firmly by the diagonal cut. A second parallel batten at the bottom of the image makes sure that it is held flat, away from the wall. Like the battens on aluminum, it allows some sideways flexibility for positioning the picture on the wall.

(8) Specialty concrete wall hangers are available from good hardware shops and framers. They have several small prongs rather than a single long one and are used on walls that are difficult to drill into.

HANGING

So, you are in the gallery to hang the show. Where do you start? Here is the appropriate sequence of steps:

- collect everything together
- frame all the work if it is not already framed
- place it and decide where everything will be hung

Hanging "Face of Fashion" was challenging. All the photographers came in to do the hang with me, and it was a highly collaborative process. Working with Mario Sorrenti was both a privilege and a learning curve, as working directly with artists should be but sadly isn't always.

Mario was nervous about the hang and it's easy to understand why. There were 25 pictures of varying sizes which needed to go on one wall. He is not experienced at hanging in a gallery as his work is most commonly disseminated through the printed page. There were also a lot of people present (gallery staff and art handlers) which can be off putting when you need to quietly work your way through something.

Previously, Mario and I had worked out a plan over many emails and pdfs and so we knew the pictures fitted on the wall! But of course when you get into the physical space it's often very different. You need a large picture to have impact and the corners (which were quite tight in actuality) didn't really come across as such in the plan so we had to work around that. Also he was opposite Paolo Roversi whose works were very small. We had to make sure that Mario's images didn't overpower Paolo's more gentle Polaroids.

We had a few very difficult hours propping up the pictures where they would have to be double hung but it just wasn't coming together. Eventually Mario said 'lets put everything on the floor' that way we could all look at it as if it was on one flat surface. This was much easier for Mario who not only works primarily for magazines but has always produced collaged diaries so in a way it was replicating those. We got ladders so that we could see from above how it was shaping up. Once this decision was made the actual placing was quite quick. We measured everything out on the floor and then it could just slide up the wall. I say just but it was a very difficult hang and the art handlers showed enormous skill and patience.

The captions then became an issue. If they were scattered around the wall under each picture it would look messy, so we had to very carefully work out a good sight line for them (not too high as to exclude children and people in wheelchairs and not too low). We spent a lot of time on this. One of the most common complaints that museums and galleries get is regarding captions so you have to treat them with as much care and attention as the pictures themselves.

The Head of Exhibitions was very helpful with the captions and eventually—three days later the wall was finished. Both Mario and I were sent home on the final decision of the placing of the captions as we had such terrible colds! The end result was beautiful and the highlight of the show for me.
Susan Bright

FIGURE 5.3 "Face of Fashion" at the National Portrait Gallery, 2007: Putting Mario Sorrenti's photographs on the floor to plan the hang. Image © Susan Bright

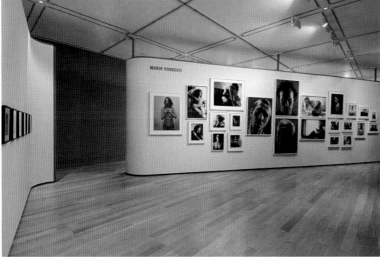

FIGURE 5.4 Installation photograph of works by Mario Sorrenti included in *Face of Fashion*, National Portrait Gallery, London, 15 February–28 May 2007. © National Portrait Gallery, London; photograph by Prudence Cuming Associates Ltd.

Handout

HANGING AN EXHIBITION: THE SEQUENCE

1. Preplan: Look at the work very thoroughly

2. Preplan: Look at the space (and/or floor plans)

3. Preplan: Decide on the amount of work to fit the space

4. Preplan: Group or sequence the work

5. Preplan: Decide on frames and presentation methods

6. Preplan: Check possible hanging methods and state of gallery walls and decide how to hang the work

7. Preplan: Plan a hypothetical hang on paper including the placement of captions and text panels

8. Early preparation: Print, mat, mount, frame, or otherwise prepare the work in good time

9. Final preparation: Check that lighting is fully functioning and replace bulbs as necessary

10. Final preparation: Clean and paint the gallery as necessary

11. Final preparation: Collect everything together (the artwork, texts, tools, hanging plans)

12. Final preparation: Frame all the work if it is not already framed

13. Actual hang: Place it by propping frames up against the wall according to the hypothetical hanging plan, check it works in practice and re-arrange as necessary

14. Actual hang: Hang the work on the walls

15. Actual hang: Put text and captions up

16. Actual hang: Arrange lights

17. Actual hang: Clean frames and glass (if work is under glass) and clean the gallery and gallery windows

18. Before opening: Check that price lists, catalogs, books, visitors' book, etc. are in place

- hang the work
- put the text and captions up
- light it
- clean glass, if work is under glass, and clean the gallery

As noted above, first you collect everything (and everyone) together and check that:

1. the gallery needs to be clean and dust free and should have been repainted if necessary

2. you have all the work (already framed if possible)

3. you have any texts, captions, titles, or printed materials to be placed on the wall

4. you have a list of works and any diagrams, floor or hanging plans you have made

5. you know the condition of the walls and have the right fixings to use

6. you have all the tools you expect to use

7. you have a table or clear surface to work on and a secure place to leave coats and bags

8. you have enough help

(1) The gallery needs to be clean and dust free and should be repainted if necessary. It doesn't have to be immaculate, but you must make sure that dust and dirt in the environment can't get into the framed work. Sweep the gallery before starting work if it is dusty; otherwise the dust will lodge everywhere. Any holes left from the previous show's hang should have been filled and repainted and the paint now dry. Don't attempt to work around wet paint. You can retouch any marks you have made after you have hung the work, but if the whole gallery needs repainting, it must be done well in advance. It is possible, though risky, to repaint piecemeal, just painting the parts of the space that need it. However, unless the paint type and color are exactly the same as the previous coat of paint, the patchwork effect is likely to show in sunshine or under bright lights.

(2) Ideally all the work should be framed before the day of the hang. If the work has not yet been framed, your first task is to frame it. Framing needs to be done slowly and carefully and cannot be rushed. As long as you have enough space, framing can be done by a group of people without experience, provided they are very careful. Always clean glass surfaces with the panel lying flat on the worktable to avoid cuts on sharp edges. If you do cut yourself, walk away from the framing area immediately so you won't bleed on the work or on the mat (although the work should be kept safely packaged elsewhere, anyway, until the frames are clean and ready). Wearing either white cotton lint-free gloves, available from most art and photo supply shops, or inexpensive medical gloves will keep you from smudging the newly cleaned glass. The most crucial part of framing is to make sure that the inside of the glass is spotless before you put the photograph and mat inside, since even a single speck of dust will be highly visible and visually irritating. This means dusting the glass and inside of the frame first and then cleaning the glass with a non-greasy cleaner, either vinegar based or methylated spirits (also called denatured alcohol).

Methylated spirit is a very effective cleaner, but you need to use it in a well-ventilated environment or it will leave you light-headed or with a headache. For acrylic/Perspex there are special spray cleaners/polishers that should be used with a soft lint-free cloth or special paper towels so as not to mar the surface. You don't need to clean the outside of the glass thoroughly (unless it is very dirty indeed) until it is hung, since you will probably get fingerprints on it during the hang. Check that the image is straight in the frame and there are no specks of dirt before finally fixing the back in place. The finishing touch is to label the back of each frame with an adhesive label. This should have on it a copy of the caption information and/or the number of the image that relates to the list of works. This is particularly important if the work is to be hung or taken down and returned without the artists or curator present, or if the show is slated to tour. Unlabeled work is a disaster waiting to happen in these circumstances. If a piece of work is missing for some reason (a late delivery or a broken frame being replaced), you need to make sure you are not going to forget it when you hang the show. It is surprisingly easy to make this mistake. A simple way to remind yourself is to cut a card template to the correct size and write the image number or caption on it and then attach it to the wall temporarily in place of the missing image.

(3) For the hang you need only the texts that are to be attached to the wall—you won't need price lists, catalogs, and so on. Since your first task is simply to figure out where these texts will be placed, it is a good idea to work with correctly sized photocopies at this stage; otherwise you risk marking the text or damaging the corners if the text is not protected behind glass. If you do not have the texts yet, then cut paper or cardboard to the right size and attach it to the wall to represent the text, just as you would a missing image. If you do not have a visual reminder of the missing text, you may either forget to leave space for it or leave too much or too little space. This applies particularly to space for captions, and is very important if you are hanging pictures close to each other.

(4) Keep all the paperwork, floor plans, and lists together in one place—in a clip file, for example—or they will get lost during the day as people move around the gallery with them, put them down to adjust a photograph, and forget to return them to the central worktable. Valuable time can be wasted searching for a missing diagram if you do not do this.

FIGURE 5.5 Trish Morrissey's photographs exhibited at TRACE and hung using bulldog clips. Image © Sian Bonnell

(5) You need to know in advance what type of wall you are dealing with in order to choose the right method and tools for hanging the work. In most galleries this won't be a problem, but just occasionally it is and it helps to know beforehand; the gallery director should let you know. Sometimes a gallery will have a number of different surfaces—brick, plaster, concrete block, painted wood, and so on—and it is helpful to be aware of this in advance, particularly if a wall is old and the surface fragile and so requires a bigger, stronger fixing than you would otherwise use. You also need to check how smooth the wall is and that there is no curve or distortion that would prevent large works from hanging flush to the wall.

(6) Most galleries have a toolkit (use the handout on page 205 to check what you might need). However, many people are hopeless at keeping track of their tools, so, if you can, you should double-check the toolkit in advance to make sure that it has what you need. Bring extra amounts (by about one-third) of everything like nails, screws, mirror plates, and Blu Tack (also marketed as Fun Tak). Such items can easily break or get lost during the hang, and you can lose a lot of time in replacing them. Extra equipment usually comes in handy. Don't accept the reassurances of gallery staff that they have everything, and be ready to bring your own tools to supplement theirs. At one venue, for example, I was told that ladders would be available for a hang, only to find that on the day we needed them they were double booked; so we

had to ask tall students to stand on chairs to place some images (which was both slow and unsafe). I have also worked on an exhibition that involved constant locking and unlocking of over thirty Perspex panels with a single Allen key (or hex key). With nine exhibitors working at different paces, this would have taken a very long time if two exhibitors had not brought in additional keys. If you are buying your own tools for an exhibition hang, it is well worth investing in good ones. A metal tape measure that stays rigid is much easier to use than a cheap one that does not. A two-foot metal spirit (or bubble) level is more useful than a ruler and does two jobs at once.

(7) You may or may not need a table to work on, but it will be a good place to keep the bags, fixings, tools, and paperwork together. It should be placed for ease of access for you and out of the way of anyone else who might be passing through the gallery. Security can be an issue here. Many galleries are open to the public during a hang, and people passing through can be opportunistic thieves if they see an unattended bag, electric drill, or artwork. If you can't close the gallery doors, then make sure that all tools and valuables are hidden from view and that there is always someone in the space. Keeping everything in one place makes it easier not just to keep things together, but to keep an eye on it.

(8) You may well not need help for the whole of the hanging, but it is worth making arrangements in advance for people who can help, if only for part of a day. It is also worth planning this as carefully as possible so you do not keep busy people hanging around with nothing to do just because you will need their help later in the day. Some tasks need as many people as possible to work on them, while others are best done by one or two people. If the gallery has to be repainted, then the more people to do it the better. Framing is slow work best done by several people. Deciding where each image should go is usually best done by one person. Hanging is best done in pairs. One of the nicest things during a hang is to have someone who is not necessarily part of the hanging team but can be called upon to run errands and make cups of coffee, and who will appear with lunch, sandwiches, or biscuits at a good moment.

DESIGNING OR REDESIGNING THE EXHIBITION

Once all this preparation is complete, the first task is to work out the actual hang. In my experience this part of the process

Handout

TOOLKIT

When hanging an exhibition, you may need an extraordinary number of quite varied tools, so get together your own toolkit and/or a shared one. Check to see what the gallery already has on hand about a week before the hang. It is crucial to organize this in advance because you won't have time to shop for the items as you need them. But only take what you need, plus extra supplies of small things like screws and nails.

If you are part of a group show, remember that the group will need more than one of many of the things on this list. If you don't have more than one, you may lose time trying to find out who is using something you need and waiting for them to finish using it! Put your name on all your tools.

It is worth buying good tools when you can afford it. A 2-foot-long level is very useful and can double as a ruler. A good metal tape measure will stay extended if you need it to instead of snapping back and trapping your fingers.

Your toolkit should include some or all of the below:

- Hammer, screwdriver (ordinary and cross head), electric or battery-operated drill (with spare batteries), tape measure, scalpel and Stanley knife, staple gun, pliers, bradawl, large level, set square, steel ruler
- Nails, screws, rawlplugs, extra mirror plates, string (useful for measuring)
- Extension cord if you are not using battery-operated tools (if you need to drill, it is unlikely the drill will have yards of cord)
- Notebook, pencils, cardboard, BluTack or sticky pads, masking tape, and soft rubber (you will need to be able to remove pencil marks you've made to mark where you're hanging the work). A soft brush is useful for controlling dust particles and keeping the workspace clean
- Paint and brushes (for retouching the wall where you've put a screw in the wrong place and have to move it), filler and filling knife, sandpaper
- Cleaning things: Broom, dustpan, and brush (to clean the floor), and solvent for lifting off sticky labels and cleaning glass
- Spares: Light bulbs, etc.
- Find out in advance if you need to bring a ladder (a short ladder will be useful for hanging the work, but you may need a long one for lights or painting the space)
- Anything you may need to repair your own work if it gets damaged in transport or while hanging
- Also you may need to take food and drink if you're putting up work somewhere where the only cafes are miles away, closed at the weekend or in the evening or you don't have time for a proper break—a thermos of coffee will be an enormous treat if you'll be there very early or late
- Basic first aid kit (all galleries should have one but check and take band-aid, cotton wool, and antiseptic anyway—cutting oneself on glass is a possibility)

takes a few hours even if you have made a plan in advance. You need to look again and again at both the overall space and the individual sequence of images and move photographs around until you feel certain that you have a planned hang that will show the work to its best advantage.

You may well have done most of the preparation already; you may have the photographs in sequence and a good idea of which one is to be hung where. However, this will probably be the first time you have looked at all the work together in its finished and framed state and in the actual space, so you need to be sure that what has worked on paper, in discussion, or in your imagination will actually work in the space. You need to allow time to think about the ordering of the images and check every decision.

This is one of the tasks probably best done by the curator alone or with an assistant with whom the curator can discuss different hanging options. It can be done by a group of people as long as that group has some agreed-upon way of making a decision or see their role as assisting the curator in making decisions rather than in arriving at a consensus, since this may never happen. I would advise any curator not to allow the artists to be present for this part of the hang, if that is possible, since the artists are likely to want to privilege the positioning of their own work over the look of the whole exhibition. However, I would also advise artists to be present at the hang, to make sure that their work is shown sympathetically. So a careful negotiation may be necessary, and it is up to the curator to give the show a strong visual coherence and not make compromises just to keep the artists happy.

If you have worked out a hanging plan or a sequence of photographs, then the first step is to prop the photographs against the walls approximately where they will hang according to the plan. Clear your mind of all distraction and walk around the gallery, absorbing the way the images work together and work in the space, to check if the plan works in reality. If you have too many pieces, this is the moment to think about it and decide either to remove some images or to risk a very packed hang. Once you are sure that the whole exhibit physically fits into the space, you can start moving frames around to see what positioning, sequences, and juxtapositions do and do not work. The only rule to remember at this stage is that it is not a good idea to hang work right into the corners of the space or your audience may end up creating a traffic jam there.

The hanging process is both practical and intuitive. On the practical level you need to check that the images fit in the space, that one wall will not look too crowded or another too bare, that the positioning of large or small photographs works as you had anticipated. Does the large photograph draw visitors' eyes across the space? Do the small images look intriguing where they are, or are they going to seem to float in too much space? Are they in danger of being lost against the large works?

On the more intuitive level this is about making sure that images work together. The simplest method of doing this is to move the pictures around and test pairings or sequences by putting them together and making a simple yes/no decision: these two images work well together or they do not. In this way you can build up sequences or decide to isolate particular images or pairings. Although this whole process takes time and decisions are made, tested, and remade, each individual decision can be made quickly because it works on an instinctive level. This is not the moment to alter previous decisions about the underlying meaning of the exhibition; you are simply trying to ensure that the flow from image to image works smoothly and photographs complement each other. So, for example, in an exhibition I worked on recently, two sets of images went together because the tones in them were complementary; one set because the shapes echoed each other; and another because they all used blur. This may seem quite crude, and indeed it is, but it does make the exhibition flow and therefore easier for the audience to move from one image to the next.

If you have not planned the hang in advance, the starting point is, as before, to prop the pictures against the walls so that you can look at them all as you work. Then start by selecting the images that can only go in one particular place. This will usually be for practical reasons—for example, you may have a set of images or a sequence that needs to be kept together and requires a specific amount of wall space and so can only fit a particular wall. Or you may have a single, large image that needs to be kept on its own and that exactly fits or suits one wall. With a group show, it may mean making decisions entirely based on giving all exhibitors a wall on which their work fits without distracting from other exhibitors' work on the adjacent walls. With quiet or contemplative images, it is usually a good idea not to hang them next to very busy or highly colored images. These two factors—making sure the amount of work fits the space as well as

complements the adjoining work—may completely dictate the hang.

An alternative starting point is to select a few key images and place them prominently. Or there may be several key images that need to be evenly spaced throughout the show. Or you may start by choosing the first or last images in the exhibition. The first image may be there to create drama or to set the tone for the whole exhibition. The last may be there as the one that most epitomizes the mood of the whole exhibition. An image may be a popular press or poster image and so placed to be visible from outside the gallery. Doing this gives you a point from which to work even though you may still make changes as the hang progresses.

Once you have about half a dozen images in strategic places, it becomes easier to place the other photographs. Either way, you place certain images in key places first and then work around them. Someone once described this to me as being like a chain-link fence in which you hammer in the fence posts (the strong key images) first and then put in the links. It can also be seen like a piece of writing: within a paragraph one of the important things is the punctuation (again, the strong images), those things that make you pause or come to a full stop. However you choose to think about it, an exhibition does usually have some sort of rhythm underlying the progress from first to last image.

If the images are to be stacked on the wall (that is, hung one above the other), propping them against the wall may not be an effective way of seeing how they will work in the space. An alternative is to use the floor space in front of the wall as if it were a wall and put the photographs flat on the floor to arrange them.

VARIATIONS ON A BASIC SINGLE LINE HANG

Obviously not every hang depends on a single line of images. However, the central line—at 5 feet 1 inch high or 155 cm high—will be the line from which you work, upward or downward, with every variant on the most simple hang.

Using a grid design will "hold" a wall together visually, so a single wall might include some places where the images are stacked two or three deep while at others there is only a single image. This is a fairly formal way to present the work and works particularly well if the photographs, however

diverse in style and content, are all matted in the same type of frame.

If you have decided to stack prints or use a fairly formal grid, then the unifying feature that makes the grid hold together is a consistent space between the images. If the wall includes images of more than one size, these spaces can work in multiples so that, for instance, if all the frames are 20 × 16 inches and have a 3-inch or 7.5 cm gap between them, then you should consider having a 6-inch or 15 cm gap between the 24 × 30-inch frames rather than a 4 inch or 10 cm or 5 inch or 13 cm.

An exhibition design that is not based on a grid (see cover illustration, for example) may look simple and spontaneous, but in fact a dense hang has to be carefully worked out in advance or you will end up with awkward gaps and holes in the overall design. One way to plan it out is to put all the pieces flat on the floor first and then move them around until you have a satisfactory arrangement. Then draw a working diagram to translate it to the wall. Or you can lay the images on rolls of lining paper on the floor and then mark the final design on the paper (by drawing around each frame) and transfer the design to the wall by marking through the paper. In this situation you do not want the gaps between images to be even, but the problem is likely to be fitting larger and smaller works together without creating awkward spaces.

KEEPING A RECORD

Make a record of your final decision about the hang by taking a digital photograph, by making a list, or by numbering the backs of the frames in order and entering this on the floor plan. You will, most probably, need to keep the frames where they are until you have worked out the precise measurements for placing the fixings or mounting hardware on each wall. Once that is done, you should move the pieces away so you won't get dust in the frames when you drill into the wall.

It is important to keep this record and the picture sequence in mind while hanging or to regularly check the hang against the hanging plan (or at least every time you start or finish each wall) to make sure that you are still on track. I once worked with a brilliant young intern who volunteered to start hanging a show while I was out of the gallery. When I came back he had hung the entire exhibition. Everything about the hang was meticulous. I don't think we had ever seen the gallery looking quite so good—except for one thing. We had sixty or so identically framed photographs in the storage

space, from which he had brought only a few images at a time into the gallery. While he hung the whole show to our pre-agreed order, he didn't realize that the calculation of the space between each image was very slightly wrong. So when he completed the hang he had one photograph left over, and there was nowhere to put this one image. What he had done was to start hanging the pictures in order but without double-checking the measurements or checking the hang against the plan. Had he propped the whole set of images against the wall at the start, in their allocated places, he would have realized that he had one too many and redone the calculation before finishing the first wall. This is a very easy mistake to make and could have happened to anyone, but there was no way to rectify it without starting all over again, since the gap between each photograph needed to be closed by a tiny amount. To return to our original plan would have meant rehanging every single image, except for the first and last, which would have taken us an additional day to do. Luckily for both of us, the image was not crucial to the sequence of the exhibition. We compromised and hung it over the reception desk just outside the gallery, and no one else knew of the near-disaster.

Thinking about how to present work well is time consuming but rewarding. Good presentation can make a great deal of difference to the way a photograph looks and need not be prohibitively expensive. The most important consideration is to suit the method of presentation to the image itself. A photograph can suffer if the presentation is unnecessarily elaborate or costly. Looking at the way photographs are presented in exhibitions and working with a good framer is the best way to keep in touch with the changing methods of presentation currently available.

Case Study Five: Exhibiting Your Work Online

Figure CS 5.1 Screenshot of the Flickr interface: a single image from the photostream of photography student Triin Q. © Reproduced with permission of Yahoo! Inc. 2007 YAHOO! and the YAHOO! logo are trademarks of Yahoo! Inc.

Observe how under each image posted on Flickr, there is a space for other members to respond and discuss the image. To the right-hand side we can see a list of Flickr groups to which the student has also posted her image, in order to share her work with others engaged with self-portraiture. Note also that above the image there are a number of options for interacting with the image, whether viewing it at different sizes or posting it to your blog for discussion (if you have one).

Until recently, establishing an online space to present your work was both technically challenging and potentially costly, especially for emerging artists. Web hosting and domain registration required financial commitment, and unless you were a whiz at web design, you would have to pay for the creation and maintenance of your web site by a professional.

Today, the World Wide Web is a very different place. While having your own portfolio at your very own web address is still an option, there are a large number of alternative online spaces and communities where you can exhibit your work with minimal cost and technical expertise. Web sites such as Flickr, Photobucket, Blogger, LiveJournal, YouTube, MySpace, and Facebook are popular online spaces that rely on the participation and content of its users to create a space for sharing and collaboration. Here, the web site works as a kind of software for users to organize everything from videos, audio files, and images, to links and personal commentary. However, beyond merely displaying and sharing content, these online spaces allow users to form social networks and communities around the digital media they produce.

FROM GALLERY TO SOCIAL MEDIA

These sites form part of a larger mosaic of technologies known collectively as "Web 2.0." The expression was coined in 2004 in response to the growing sense that the Web was being shaped according to new practices and values. It was noted that successful web sites were no longer being built as static repositories of information; instead they were beginning to resemble dynamic, interlinked applications to assist collaboration and sharing among users. For these reasons, Web 2.0 is sometimes also referred to as "social media," "the participatory web," or the "read/write web."

PHOTO SHARING

More recently Victor Keegan of *The Guardian* wrote, "It is difficult to know these days whether the Internet is re-inventing photography or vice versa." Keegan was responding to the rising popularity of Web 2.0 online applications that were enabling more sophisticated ways of photo sharing—namely, the process of uploading, publishing, and sharing images online, publicly or privately. While photo sharing itself was not new, the conventional form of the online static image

gallery was being transformed and becoming increasingly automated and seamless.

In the older online model of photo sharing, images were organized on a single page into a formal sequence or grid, arranged by series for the visitor to passively view. The image gallery was a formal arrangement for the display of images across personal online albums, professional portfolios, and gallery web sites. While it was possible for visitors to leave comments in an online guestbook or via an email address, the experience was mainly a passive one. As photo sharing becomes more collaborative, these image galleries become sites for active participation and dialogue between the image authors and visitors to the site. This is enabled by interface tools that allow visitors to comment directly beneath the image, to link to the image, to send to a blog, or to subscribe to online updates (called a "feed") of that photographer's images.

WHAT DOES THIS MEAN FOR PHOTOGRAPHERS?

Aside from the ease with which these sites allow you to construct and update your online portfolio, photo-sharing sites allow your work to be seen by a potentially larger and more diverse audience. Those who may be put off from visiting a rarefied or geographically distant gallery space have the opportunity to engage with your work from the comfort of their home or office twenty-four hours a day. The communities that form around these sites provide a rich source of opinions and technical information and reflect a commitment to a diverse variety of photographic practices which is fascinating to explore.

It is important to emphasize this difference in audience and context. Photo-sharing sites tend to blur the distinction between professional and amateur by providing an open platform for participation and discussion. Enthusiastic hobbyists share their latest studio portraits with commercial photographers; newlyweds create online galleries for wedding guests to contribute their snapshots to; and students, artists, backpackers, and companies all use these spaces to display their work in what can be a very casual and playful environment.

Additionally, tools are available for people to give immediate feedback on your images in a very public way, bringing you in direct contact with the people viewing your work. Consider how this may differ from the way you might interact with the network of people surrounding a gallery, which may

consist of a familiar audience that attends openings, talks, and events programs and meets socially. Some photo-sharing sites allow you to further control access to your images by allowing different users or user groups different levels of access to your images.

FLICKR.COM

Flickr is a popular example of a Web 2.0 photo-sharing application. Launched in 2004, the site currently has over 8.5 million registered members, and during peak times serves 12,000 photographs per second to visitors. Flickr is known for its active and experimental users who enthusiastically share and explore one another's photos.

Flickr has a number of tools to allow you to organize and publicize your images online. You can use Flickr simply as a space for exhibiting your images, organized into series or sets, as an inexpensive and self-managed alternative to commissioning your own online portfolio. However, by using such features as tagging, commenting, groups, and contacts, you can use it as a space to publicize your work and possibly find new opportunities for its dissemination and exhibition.

When you sign up with Flickr, you can choose to have a free account or a paid (Pro) account. With a free account, you have access to all of its features but are limited to creating three edited sets from your images, uploading no more than 100 MB/month, and a maximum of 200 images visible at any time. At the time of writing, if you upgrade to a Pro account, for U.S. $24.95/year, you can have unlimited uploads, unlimited sets, and unlimited storage. Other photo-sharing sites have free and paid accounts as well, and it is important to research the limitations of each platform.

Uploading your images to Flickr is very simple: you can send images via email directly from your computer or your camera phone. This is a popular feature for many people who use Flickr to publish "moblogs"—streams of images documenting their daily lives, captured from their phones. Alternatively, you can use Flickr's upload page to publish and notate batches of images. There is also a range of standalone applications you can install on your computer to help you further automate the process.

When you visit your Flickr page, by default your images appear as a "photostream," a sequence of images displayed in the order in which you uploaded them. You can change their order via the Organizr, a tool that allows you to further

collate specific images into sets or collections (a grouping of sets). You may wish to curate your work into sets by theme or series, or leave them as an unordered sequence, depending on your photographic practice. Some photographers have used the site in a very fluid way to get feedback on work in progress, perhaps in preparation for an offline exhibition; others present their work as a tightly edited static sequence, to be re-edited and reconstructed every few months.

When you sign up, you are given a unique web address which you can give to others to help locate your work online. It is a good idea to customize your address, as it will look something like this initially: http://www.flickr.com/photos/ 8817539@N04. This is best done in your account settings, and will allow you to set your address to something more memorable such as http://www.flickr.com/photos/yourname. This is the link you will give to others in order to publicize your work.

However, many more people will access your work by merely stumbling upon a link, searching via a keyword, or following image links between various sets of contacts. Flickr's concept of tagging is central to its success. Instead of imposing a categorizing system, the interface allows authors and users to add "tags" or keywords associated with an image. For example, an image of a landscape may have content-based tags such as "sunset," "tree," "valley," or "summer," as well as other tags describing its location. By adding tags to your images, you enable Flickr users to find your work more easily and also create a system for retrieving selections of your own image collection. As soon as you begin to tag your images in this way, you may notice the number of people viewing your photographs increasing, as you allow your work to be found through the variety of search options found in the Flickr interface. This system of open-ended labeling has been celebrated as a more intuitive and nuanced way of ordering content online, as opposed to taxonomies imposed from the top down.

By tagging your images, your online portfolio shifts from being a site for aesthetic contemplation to a space for creating and maintaining social networks. Flickr has been coined "the MySpace of photo sharing" and invites you to add other people as contacts to your profile to make it easier to track one another's images. Users can also form groups around a common interest; each group has its own central page, an area for discussion, and a group pool of images. Current groups include "Art Studio," a group where artists share and

document the studios, bedrooms, spaces where they make their work; "Camera Toss," a group devoted to the technique of allowing an image to be captured while the camera is in motion; and "Social Documentary Photographer," a group of over 5000 photographers who have contributed over 53,000 documentary photographs to their shared pool of images.

Recently, Flickr groups have been a way for institutions such as the Tate to invite participation in their exhibitions. "How We Are: Photographing Britain" is a show that invited members of the public to submit images to be shown on screens inside the exhibition. Elsewhere, the BBC has used Flickr as an interface for its audience to contribute their images to its varied projects using the group photo pool feature.

Currently, the Flickr community has uploaded over 100 million photos. With so many images tagged and easily searchable, the site resembles a massive image database. This has attracted the attention of clients of stock photography web sites, who may need a particular image to illustrate a piece of journalism, or for an ad campaign. There are reports of increasing numbers of Flickr users being contacted by parties keen on licensing an image they have seen on the web site, with a *Boston Globe* photo editor recently paying U.S. $150 for an image he discovered searching Flickr. Elsewhere, Ranjit Bhatnagar's work was discovered by a curator for the Metropolitan Transport Authority, New York, for a series of light boxes in Brooklyn's Atlantic Avenue subway station. Here, Flickr was the interface for the discovery, selection, and editing process for the show. Encouraged by these success stories, new photo-sharing sites are emerging which specifically allow artists to sell their work online, and others try to court media organizations to lure them away from commercial stock photography sites toward the work of their contributors.

The emergence of these large databases of user-generated images, video, and sound has also drawn the attention of other artists keen to appropriate, remix, and reconstruct new work from the content they find online. In particular, Net Artists have found Flickr's open programmable interface a rich space to design online work that reconstructs and remixes images from the Flickr archive. Elsewhere, video DJs (VJs) mine content online to use in the audio-visual spaces they create. While every image you upload to Flickr is automatically copyrighted to its creator (you), there are options in the interface to allow you to license your work using Creative

Commons licensing. With a Creative Commons license, you maintain your copyright but allow people to copy and distribute your work, provided they give you credit, dependent on the conditions you specify in the license. Here, the materiality of the digital image allows your work to be potentially recontextualized, republicized, and reworked by others, giving your images a new life beyond their original context.

Exhibiting your work online is materially very different from a physical space where issues of scale, texture, sequencing, and lighting all come into play. In a Web 2.0 context, the way in which you categorize, locate, and license your images all contributes to the way in which a viewer may stumble upon your images in a virtual space. Online, your work has the potential to reach a wider and more diverse audience, not necessarily connected with a gallery space or genre of work. While Flickr is just one example of a popular photo-sharing site known for its particularly active community, many more are emerging to suit the different needs of artists and photographers. Take your time to research the one that suits you.

Websites:

http://www.flickr.com

http://www.creativecommons.org

Katrina Sluis

Hanging the Exhibition
and the Follow-Up

FIGURE 6.1 "Lebanon 2006." Image © Simon Norfolk
"For me the most important element of exhibiting is that the technical quality of the print has to be very good indeed so that the viewer is not distracted by anything at all, like dust or scratches. Framing decisions are just part of that." Simon Norfolk

We rarely buy directly from artists. Primarily we buy through galleries.
Katherine Hinds, curator of photography, Margulies Collection at the
Warehouse, Miami

John Swannell's exhibition of his Nudes at Hoopers Gallery (November 2006) was very successful but also highlighted market differences between the U.K. and U.S. The prints at Hoopers were selling (unframed) for £1800 + tax. One month later one of the signature prints of the exhibition sold at auction in New York for

$19,000! This has resulted in an increase in the price for this print in the U.K. but it will be well under the U.S. price.

Helen Esmonde, director, Hoopers Gallery, London (*www.hoopersgallery.co.uk*)

The most expensive single photographic image to date is "The Pond—Moonlight." It was taken by Edward Steichen in Mamaroneck, New York, near Long Island Sound, in 1904, when the photographer was in his mid twenties. A print of the image was sold during a special auction at Sotheby's in New York on February 14 (2006) as the Metropolitan Museum of Art "deacquisitioned" material from the Gilman photography collection, which it bought in 2005. There are only two other prints of the image, one still at the Met and the other at New York's Museum of Modern Art.

American Photo 2006

I'm delighted photographers can now make a living from selling their work, but I can see that, unless you are sure of yourself, you might get swayed by the market. Collectors buy indiscriminately now.

Stephen Shore, photographer

In an overcrowded market there is increasing pressure to stand out: online picture sales are on the increase; micro-stock sites, selling low-price amateur images, are just the latest digital phenomenon undermining the professional market. Developing your own approach and signature style is more important than ever.

Ed Barber, photographer

They (the dealer and collector) advance by entrepreneurial means the work of art and the career of the artist through exhibitions, color reproductions and loans. And at this point, artists' solicitude for their work can become indistinguishable from its promotion. As artists become, in a sense, their own curators the museum curator is forced to narrow his ideas to those that are agreeable to the artists' reading of their own art. This constitutes one more problem for the curator who might want to control his show.

Lawrence Alloway, *Artforum* (May 1975)

The record of astuteness in selecting the exhibitions for Limelight was matched in depth only by the lack of any tangible response in terms of sales. A good sale for an exhibition might consist of two prints, usually at $25 each—another stark comparison to today's extravagant activity in the photography market.

From "Helen Gee and the Limelight: A Pioneering Photography Gallery of the Fifties," *Inside the Photograph* (Bunnell 2006)

The art market is very entertaining but also short-lived. Something that is hip now might be forgotten about two years later.

Dr. Inka Graeve Ingelmann, head of the Department of Photography and New Media, Pinakothek der Moderne, Munich

Whether or not you hang the exhibition yourself this should be a very rewarding moment when months of preparation finally pay off and the work suddenly looks at its very best. It's a time for being careful and precise but also for double

checking that all the decisions which have been made work in practice or, just possibly, recognizing that a decision needs to be revisited and changed. The most important element here is allowing enough time to do this well.

THE ACTUAL HANG

Before starting to hang the work, you need to keep a few guidelines in mind:

- As his rule for photography, photographer David Steen follows the carpenter's motto he learned as a teenager: "Measure twice and cut once." This is true of hanging photographs. The secret is in the preparation: good preparation saves you time; get it right and you are fine. If you fail to check your measurements at every stage, you will still be in the gallery at midnight filling the holes you drilled in the wrong places!

- The first rule of hanging an exhibition is not to hang the work too high. This is a mistake often made by first-time exhibitors and tall people. The standard height for hanging exhibitions is much lower than you would expect. One reason to keep photographs low is that while tall people can bend their knees to be at the right height to look at the image, small people, people in wheelchairs, and children simply cannot see above a certain height. Most exhibitions follow a hanging-line height of about 5 feet 1 inch, or 155 cm. The hanging line is an imaginary, invisible line that runs around the space at this height. You use this as a central line in the exhibition along which the main visual emphasis of the exhibition is focused and on which the images are centered.

 The hanging line is not to be confused with the vertical alignment you select when hanging a single row of photographs. When hanging a single row of photographs you need some method of making the row cohere. You can choose to line them up at the top, at the bottom, or through the middle. If all the frames are the same size, the row will look neat but if, for example, some images are landscape and some portrait, you need to decide on one of the three options. As a general rule, lining up the middle of each frame is pleasing and looks less regimented than if the images are aligned at the top or bottom (see illustration, figures 3.3A–C on page 120).

- Do not hang photographs right into both sides of a corner or your audience will be bumping into one another and this will break their concentration. Most people leave space on both sides of a corner, but it is possible to hang work into one side if you have to and leave the other side free of images. However, if the corner is an outside corner—that is, if hanging work to the corner leaves the edge of the frame at or protruding past the edge of the wall—then do not hang work to the edge because it is too vulnerable; someone passing by may bump into it and damage it.

- When planning the hang, the positioning of the captions must be preplanned. Because captions are small, it is very tempting to leave them until after all the images are installed. However, in a close, tight hang it may be difficult to place them consistently. An inconsistent placing of captions (when, for example, one image has a caption underneath it and the next has a caption to one side) not only looks obtrusive

and messy but distracts viewers from the work because they have to think about finding captions instead of concentrating on the images.

• In many buildings, particularly older buildings, the floor and walls may have shifted very slightly out of true. So during the hang it is very important to constantly check what you are doing by standing back and looking at the work from a distance. If you rely on a spirit (or bubble) level for a straight line and work close up to the wall on which you are hanging the images, it is perfectly possible to hang an entire row of photographs that are perfectly lined up according to your level and then step back and discover that from left to right they appear to vary very slightly either up or down the wall. Even a deviation of a tiny amount from one side of the wall to the other will be very noticeable. If you step back from the wall and check from the middle of the room after each picture has gone up, then you can make small adjustments as you go along. This is one of the times in a hang where it is useful, and usual, to get several people to have a look. At the end of the day, you have to trust your visual sense rather than the spirit level.

• For most exhibitions with a set of images that are to be regularly spaced, you also need to decide before starting how much space to allot between each image. This is another task usually best done by eye. For a single line of photographs, it will usually be somewhere between two and six inches or five and fifteen centimetres. The decision depends on the size of the individual images, whether they need to be closely grouped or need space around them, and how much space you have: Is it better distributed between the images or at the edges of the wall? Too much space and the images will seem to float disconnectedly. Too little and they will crowd each other. Large images need more space around them than small images. Once you have made this decision, it will help the overall coherence of the exhibition if you keep this spacing consistent throughout. So, for example, two walls of different length will have a different number of images on them but will look consistent because the spaces between the images are the same on each wall.

FINDING A HANGING METHOD

There are many different ways to hang the work once all the decisions about what goes where have been made. Most people who hang exhibitions regularly have their own favored method, and you will probably develop your own over time. Some people, usually those with a great deal of experience, can hang an exhibition entirely by eye without measuring anything, though I would not recommend this to anyone who has not hung an exhibition before. Many people like to work with one photograph at a time, placing each photograph on the wall before drilling the holes for the next. In my experience this is when tiny mismeasurements can accumulate so that over an entire wall, the hanging can end up being inconsistent. The better way to approach a hang is to measure and mark up a whole wall at a time.

My method is to first decide which images are to be hung on which wall and the approximate spacing between each

FIGURES 6.2 and 6.3 Hanging the show.
Both images © Tim Roberts

image. Then, to hang one wall at a time, I measure and mark up (in pencil) one entire wall for the drill holes before starting to hang the work. As long as you have a good rubber eraser, you will be able to remove this line once the work is in place. Although the math can be complex and it can take time to mark it all up, once this is done the actual hang is very quick. This method also has the advantage that one person can do everything, although two people will probably be needed to actually lift and position the images on the J hooks or screws.

This is also one of the stages of the hang when the work is best done by one person. Two people trying to do the same calculations will pretty inevitably make a mathematical tangle. The important thing is to check it visually when it is done and before starting to drill. It will be fairly obvious that the pencil marks on the wall are in the wrong places if the spaces have not been calculated accurately.

Let us take a hypothetical example. Suppose we are to hang a straight line of five 30×40-inch framed landscape photographs on a wall that is 20 feet or 608 cm long. They are large images and will be hung quite close to each other in order to keep a tight sequence and to fit them all onto the same wall. I am using J hooks and strap hangers, two of each per frame. Each strap hanger eyehole is 10 inches or 25.5 cm from the top of the frame. Each J hook is 2 inches or 5 cm deep and has two screw holes, one directly above the other. I will therefore attach the hooks by the top screw hole and make the second hole from that, so all measurements will work from the top hole.

I start by placing the frames by eye before I work out the exact measurements, and move them around until I decide that they look best with a gap of about 6 inches or 15 cm between each frame and a very slightly larger space at each end of the wall.

Then I do the math to establish where to drill holes for the J hooks. I do this either on graph paper or write it out clearly, step by step as I do it, in order to keep track in case I need to revise it, refer to it, or adapt it for another wall. I need to work out three things:

1. the accurate placing of the frames across the wall and the exact size of the spaces between them

2. the height of the horizontal line where the J hooks will be fixed

3. the exact position of each of the ten J hooks on that horizontal line

(1) To work out the spacing of the frames across the wall, I first make an exact measurement of the width of the wall,

even if I have a floor plan. An error of even an inch on the plan will wreck the design, so it is worth remeasuring the wall to be certain. It measures 240 inches or 610 cm. Then I measure the width of each picture frame and total these measurements (5 frames × 40 inches = 200 inches or 505 cm). Having already determined that the amount of space between each image should be 6 inches or 15 cm, I total that (4 frames × 6 inches = 24 inches or 60 cm) and add the two totals together (200 + 24 = 224 inches or 505 + 60 = 565 cm). Next I subtract this total from the overall width of the wall, which leaves me with the amount of additional space between the edge of the images and the end of each wall (240 − 224 = 16 inches or 610 − 565 = 45 cm). Assuming you want the images centered on the wall, you divide this measurement equally, which allows 8 inches or 22.5 cm at each end of the wall.

(2) My next calculation is about height. I need to decide the right height for the J hooks I am going to use to hang the work. I want the center of the images (which are 30 inches or 76 cm high) to be at the standard height of 5 feet 1 inch or 155 cm from the floor. However, the strap hanger eyeholes and J hooks are the crucial part of this equation. The eyehooks are 10 inches or 25.5 cm from the top of the frame—that is, 5 inches or 12.75 cm above the center of the image. So the line for them will be at 5 feet 6 inches or 167.5 cm above the floor. However, the 2-inch-deep J hook means that the actual line to drill the holes will add 2 inches or 5 cm to this, so the J hooks will be 5 feet 8 inches or 172.5 cm from the floor.

(3) The next step is to work out where on the pencil line to mark the drill holes for the J hooks. Each frame is 40 inches wide, and the two eyeholes are 10 inches in from each end. So the space between J hooks inside the frame is 20 inches (40 inches − 10 inches − 10 inches = 20 inches or 51 cm). The space between the J hook on the right of one frame and the one on the left of the next frame is 26 inches or 66 cm (10 inches + 10 inches + the space of 6 inches between the two frames or 25.5 + 25.5 + 15 cm). So the pencil line for the J hooks is marked with a small X for each drill hole at the following intervals from left edge of the wall to right edge: 18 inches, 20 inches, 26 inches, 20 inches, 26 inches, 20 inches, 26 inches, 20 inches, 26 inches, 20 inches, and 18 inches = 240 inches or 45.5, 51, 66, 51, 66, 51, 66, 51, 66, 51 + 45.5 = 610 cm.

Once all this has been worked out and double-checked by eye and with a measuring tape, I draw my pencil line right across the wall at the height of 5 feet 8 inches. I have a 1 × 2-inch piece of wood that is about 6 feet long or 25.5 × 5 ×

152 cm and has a completely even end which I use to do this. I put a small mark on it at the height of my line, and use it to make a series of marks along the wall which I then join up with the help of a metal ruler or spirit level. Other people may use a plumber's line or measure up from the floor at regular intervals to do this.

Once I have my pencil line, it is straightforward to mark the screw holes along it at the intervals already worked out. Still, I need to double-check it all before drilling the screw holes and attaching the J hooks. Once all the J hooks are up, the images are hung from them.

This sounds complicated and harder than it is in practice. However, I find it easier to work it all out in one long series of sums rather than to do it piecemeal and make each calculation as the hang progresses. The great pleasure of this method is that all the images go up in one short burst of activity, and you should feel a warm glow of achievement.

PUTTING CAPTIONS AND TEXT UP

Captions should be easy to add once the exhibition has been hung, as long as space has been left for them. The important thing to remember is that they should be uniform in their type and placement. They are best positioned immediately underneath the images and lined up either with the left-hand side of the frame or the right. The aim is to make them as unobtrusive as possible. Stacking them to one side is not a good option, since to read them the viewer moves away from the image and breaks concentration.

Both text and captions, when mounted on card, can be attached with the various types of strong sticky pad available from art suppliers and stationers. Blu-tac should be avoided as it is not very secure, leaves a mark on the wall, and can deteriorate under gallery lighting. The other option is to make captions on clear sticky-backed acetate which will adhere directly to the wall.

This is also the time to install any large vinyl lettering you may have ordered to spell out the title of the show or the names of the artists and which goes directly onto the wall. This is usually straightforward to do and is similar to the old-fashioned Letraset. This type of lettering can be ordered from specialty sign-makers, with size, color, font, and spacing specified. To use this carefully position the top sheet in the right place, mark up the leading corners first, and then transfer the letters to the wall by rubbing them lightly. The result

should be carefully checked from a distance before being firmly rubbed down, since they can be repositioned once, if handled very carefully.

CHECKING THE LIGHTS

Lighting in galleries is crucial to the exhibition hang. Photographs should usually be evenly and uniformly lit without hot spots, reflected glare, or shadows. The aim is to use the lighting to draw the audience's attention to the images and to leave dead space less well lit or in shadow. Lighting can be used to create an atmosphere or mood for the exhibition and, although the convention is usually to aim for an unobtrusive overall effect, it will occasionally be used theatrically, as in "Twilight" at the Victoria and Albert Museum where the lighting duplicated the lilac glow of evening. It will also need to be subdued for some exhibitions where the photographs are vulnerable to light, such as vintage or nineteenth-century works.

Most galleries use a combination of spotlights and floods that can be positioned along tracks. These may be tungsten or halogen, and their angle can be altered by hand. In most galleries this means rearranging the lights with each new show, since the installation is likely to differ every time. Each photograph needs individual attention, and a walk around the gallery to check the lighting will soon tell you if each image is evenly lit. Working on the lighting takes time and can only be done when the installation is complete. You will probably need long ladders to reach the lights, and the efforts of two people, one of whom stands by the image and checks that moving a light onto one image works and, for example, will not cause the next to suffer from reflected glare as a result. The person handling the lights needs to wear thick cotton gloves or use a cloth to alter his or her position, as the bulbs get very hot.

When photographs that generate their own light (such as slide projections, light boxes, or LCD panels) are displayed along with framed photographic prints in group shows, the exhibition space will need to be carefully considered to show both kinds of photography to advantage. This may necessitate using screens to shield some images from light spill or turning one area into a darkened space in which to view these works.

CLEANING UP

The last task is to clean up. It may be necessary to rub out pencil lines and marks, refill any drill holes made in the

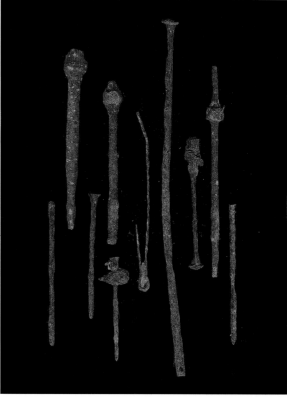

```
       (undefined object)                    (undefined object)
         Harrington 1989                       Harrington 1989
      collection Chuck Leaning             collection Chuck Leaning
          scanogram 2005                       scanogram 2005
```

FIGURES 6.4A–6.4C From "Collections: Bullets to butterflies—the naming of parts." All three images © Gina Glover
These "scanograms" are from a larger series made from collections of artifacts from a World War II U.S. airbase in Northamptonshire. When the airbase was given up by the military, these artifacts, which include electrical and other bomber parts, were turned up when the land was plowed in the 1960s. Gina Glover borrows her approach to making the images and showing the work from the classification conventions of museum display to make connections between this "amateur" collection of Chuck Leaning and the collecting choices made by museums. She comments: "This work is part of a much larger piece called 'Site/Transition' and one of the issues I had to think about when approached to show it as part of a group show was whether I should do so or whether to wait until I was able to show the entire piece. In the end I showed it and was very pleased that I had done so because in the process I resolved the piece and, perhaps, took it further. I was able to learn from the experience of seeing it exhibited and received an offer of a further exhibition as well as a small commission for a new piece for the gallery."

wrong places, and use a small paintbrush and white paint to retouch any marks that cannot be removed with a rubber eraser. Then, once the paint is dry, it is important to sweep or vacuum to get rid of the dust. The last task is to dust and then clean the outside of any glass picture frames which will, almost inevitably, have acquired a few fingerprints during the hang.

FIGURES 6.4A–6.4C *Continued*

(undefined object)
Harrington 1989
collection Chuck Leaning
scanogram 2005

THE PRIVATE VIEW

The private view is usually held the evening before the exhibition opens to the public. This event has different names in different countries, and is also known as the opening, the artist's reception, or the vernissage. Vernissage comes from the word *vernis*, which is a clear varnish that was applied to a painting a day or so before the exhibition opened to the public in France. Press, critics, curators, collectors, sponsors, friends, colleagues, and family of the artist and gallery are invited for a preview of the work. It is the moment at which the work "goes public," and it is possible that more people will see the work on that evening than during the whole of the rest of the exhibition period.

In Britain this is one of the most important moments in the whole exhibition schedule. However, practices vary internationally, and in the United States and France, for example, the opening reception is of far less significance and, if there is an opening, the event may well be open to the general public rather than to selected cognoscenti.

A gallery can usually predict, to a degree, who will attend a private view, and they should take responsibility for introducing the artist to collectors, curators, and other artists and gallerists. For the artist it is potentially the most important and most stressful event of the whole process of exhibiting. It should also be the most rewarding. It is the evening when work may be sold, and when the artist may make important contacts, may be offered an opportunity for publication or future exhibition, and may receive useful positive or negative feedback.

However, a private view can be unpredictable, and it is also possible that none of these things will happen. The artist may have spent an enjoyable evening talking to friends and colleagues about the work and received some thoughtful and positive comments—and nothing more. But an apparent absence of response may be misleading: the artist should be aware that opportunities from a private view may be very slow in coming or, when they are offered, may not seem to be linked with the exhibition. This is because, for example, a curator may be considering the work for an exhibition being planned but will hold off from saying anything until he or she has had time to think further about it. Equally, a curator may only remember the work much later, when planning a new exhibition. An ex-student of mine once told me he had been disappointed that nothing had developed from his private view and, in trying to respond positively, I mentioned that a colleague had said to me that his was the only work she found really interesting in the group exhibition. Two months later she offered him some lecturing work.

Private views are usually timed to catch people in the arts at the end of their workday so that critics and curators drop in on the exhibition before they go home and still have time to go on somewhere else. Most private views are over by about 9 p.m. This can leave the artist and gallery staff with a sense of anti-climax and facing an empty evening if they have not made arrangements for after the opening. Some galleries regularly book a table somewhere local for a meal after the private view, and it is a good idea to plan the rest of the evening in advance.

It is also an occasion on which there may be speeches or at least a few words of introduction, explanation, or thanks. These can be difficult because galleries often have poor acoustics; the audience is moving around and is in mid-conversation, at the bar, or in the process of arriving when speeches start. Although it may be necessary to say a few words of introduction or thank you, as a general rule talks at a private view should be kept brief and light-hearted. An in-depth artist's talk is better planned for another occasion when, even though it may be less well attended, the audience is comprised of people who are seriously interested in the work.

Many galleries use their own staff to work the bar at private views. Although this is economical, it also means taking the staff away from what they should be there to do—which is to network, make introductions, and promote the work. It is worth considering hiring special staff for the occasion. One gallery I know regularly uses the same small team of young actors. They are not expensive, they are experienced enough to be fast and efficient, and they know the gallery visitors and can talk to them about the work; they also clear up during the evening and wash up before they leave. This not only frees up gallery staff to circulate but means they don't have to face the washing up the next morning. Crucially too, the bar staff are very good at creating a relaxed atmosphere, breaking the ice when visitors arrive and making introductions when necessary.

The gallery should also be ready to spend time briefing anyone who will promote or review the exhibition. I have, for example, walked around the gallery with a celebrity who opened the exhibition to the public. She had a short radio slot to talk about the exhibition the next day, but I knew that she would not have the time to do further preparation, so our conversation would be a dress rehearsal for her radio talk. I prepared by selecting a short list of key images I knew could be talked about on the radio without elaborate description; we discussed these and I gave her photocopies of both the images and the additional information I had about them. The next day on the radio she talked about the overall exhibition theme and then gave examples drawn from our discussion and notes of the previous evening. It was short but to the point, and it drew visitors to the gallery because she had something specific and interesting to say.

At a private view it needs to be clear who the gallery staff and artist are so that any visitor can ask questions of them.

This is important but it is very often forgotten. A "meeter and greeter" at the entrance can be helpful here, so that there is clearly someone hosting the event. Bar staff should be able to offer to make introductions if necessary. It can be difficult to achieve visibility elegantly. Labels are a simple answer, although they have to look smart and professional rather than thrown together at the last minute. Lapel pins or flowers look good. It is quite useful to differentiate between gallery staff and artist, so labels for staff (the bureaucrats) and a flower for the artist (the creative one) are one way of doing this!

For a curator, a great deal rests on making good relationships with artists, and meeting them at a private view is a very good way of informally gauging whether one might develop this. This is not simply about the work on show but about the artist's other work and approach as a whole. I have been at an exhibition where I wanted to talk to one of the artists, not because I had any very definite exhibition in mind but because I could see how an exhibition could be developed that would include the piece of work on show, and wanted to find out if the artist had other work on the same theme. I couldn't find anyone who was obviously the curator or artist, and in the end I went away clutching my catalog with its contact address in it. In fact, I never used it because it needed that conversation to spark my interest. The artist never knew about it, but she had missed an opportunity.

The artist's task is to be prepared for the evening, to be ready to promote the work. This is a celebration of an artist's work, not a party being thrown for the artist at which he or she can relax, drink too much, or catch up with old friends. Instead, it's more like something between a job interview, being an actor at the first night of the play, and playing host at a dinner party. It is a curious thing that artists at a private view are expected to be positive, light-hearted, and rather urbane, showing nothing of the difficulty, raw emotion, or soul searching that may have gone into the creation of the work. I have twice now stood in front of images that very nearly cost the photographers their lives and listened to them recount their experience for my entertainment while marveling at their detachment. As I see it there are two reasons for this expectation. One is very practical and simply that a private view is a busy promotional event so artists cannot risk becoming too emotional about their work, even with friends, or they will not adjust to talking to collectors or

critics about the same work. The other is that this is the point that the work is being launched into the world, so the maker needs to be able to step back and let go of his or her connection with it.

If anyone shows real interest in your work, ask for his or her card or address, or ask if he or she would like to be put on your mailing list and receive an invitation to your next exhibition. Make sure that the staff know you would like to be able to contact anyone who shows an interest in your work.

Here are some things you can do to prepare for the private view:

- Make sure you leave yourself enough time to be relaxed and looking and feeling good at your own private view. If you have hung the exhibition in good time, you should have the day of the private view free. Treat it as a holiday and arrange to do something else that day, preferably something enjoyable and relaxing that has nothing to do with work.

- Talk to the gallery beforehand about their plans for the evening and the timing. It can be a long evening, but they may insist that you are there early or, conversely, may be happy for you to be a little late.

- Find out whether the gallery has a plan for after the opening. Some galleries will arrange a post-event dinner while others will not. If nothing is planned, then make your own arrangements to spend the rest of the evening with friends: either book a table at a local restaurant or wine bar or find somewhere nearby where you can sit and have another drink or coffee. Of course, you won't know in advance how many to expect in your party, so you should check that there will be plenty of room at the time for which your reservation is made, since the wine bar that is empty at 6 p.m. may not have room for a group at 9 p.m. Tell everyone in advance, arrange a time, and draw a map if necessary.

- Eat beforehand if possible, because one of the difficulties for most people is the temptation to drink too much and, since you are likely to be there longer than anyone else, this can be a disaster. If you can avoid drinking anything alcoholic for the first hour or so, it will help. Having a glass of something that looks alcoholic but is not, such as mineral water with a slice of lime, stops enthusiastic bar staff from filling your glass time and again.

- If you are nervous, get yourself some support. You may find that there is a sympathetic member of the gallery staff who will look after you well during the evening, make useful introductions, and whisk you away from the people who are determined to monopolize you for the whole evening. If you think this is not a possibility, then brief a friend. Ask him or her to be "on duty" and prepared to talk to you when you are left alone but then abandoned when a potential client of the gallery wants to talk to you privately. If you think you need to, also warn your friends that you may be preoccupied and distracted! You do need to make sure that you are available for new people to talk to you, rather than locked into conversation with an old friend.

- Be prepared to stand near your work and hover if necessary, especially in a group show. Visitors will talk to you about the work if you are there but may well not want to search you out if you are not.

- If you are the sort of person who finds it difficult to talk about your work, make sure you have some specific things to say about it. People at a private view may well not have seen a press release or other text and will ask a range of questions, so do not forget basic information about places and circumstances, an interpretation, and some technical comments. If you have a couple of humorous anecdotes about the taking of the photographs or stories about particular images, so much the better. Most people ask straightforward questions and do not expect deeply complex or soul-searching replies, although some may go straight to the heart of the work.

- If you are part of a group show, you will also be asked about the work of the other artists and should be able to speak briefly about it and make an introduction.

- Be prepared to ask what visitors think of the work and listen to what they say in response. If people are really showing serious interest but you keep getting interrupted, consider suggesting that they come back for a chat on a specific day when you'll be there.

- Always thank people for coming to the exhibition.

- Make sure you have follow-up materials sorted out and accessible. You need a list of works/price list, a visitors' book (good comments are really useful—you may get one good one and twenty-five bad, but that should be fine), and some cards or address labels and some way of getting other people's addresses/phone numbers. If people do seem seriously interested, tell them you'd like to add them to your mailing list for future shows—and do it.

SALES

Traditionally a private view is when work sells. However, the private view is not the time or place for a hard sell. As a rule, people know which images interest them and they need support and possibly encouragement in making a choice rather than to be pushed into buying work. The gallery's priority is likely to be to create an ongoing relationship with people who buy work, in the hope that they will return to the gallery in the future and buy again.

A member of the gallery staff should be responsible for sales at a private view, and that person should be very aware of this role and on the lookout for possible openings for sales. Conventions around this vary but, in my view, it looks more professional if the artist does not do the actual selling. Most people are not good at selling their own work, and some are too prone to giving work away or dropping the price under pressure.

If you are putting on your own group show outside the gallery system, there are several ways you can deal with sales, and it is important to sort this out in advance of the

private view. A member of the group may have a flair for selling and enjoy the challenge, in which case my preferred option would be to ask them to handle all sales during the private view and relieve them of all bar duty in return. If no one volunteers, this is probably a task best shared by two people who can support each other during the process.

This does not mean that the artist has no role in selling the work. Most people buy work because they like it but may feel unsure of their taste and the whole area of the investment value of contemporary photography. Talking to the artist about the work, about the circumstances in which it was made, and about its meaning for the artist will provide reassurance for the buyer. Buyers like to be able to say that they have met the artist and to quote them directly. A good anecdote about the circumstance in which the image was made is useful, and this sort of conversation can lead to a sale. If this happens, the artist should be ready to hand the prospective buyer over to a member of the staff who will deal with the mechanics of the transaction.

One of the awkward issues that may come up is that people who have seen and liked some of the work may try to cut out the gallery by buying directly from the artist and so save themselves the gallery part of the costs. This is absolutely not done, and the artist's reputation will suffer badly if they agree to such a request.

The gallery needs to have at the ready red dots to indicate when a work is sold and a receipt and/or sales agreement system. Usually a gallery will want payment for a work then and there, unless they know the would-be purchaser well—although some galleries do offer various payment options for impoverished but enthusiastic buyers. A receipt or sales agreement will include name, address, and contact details of the gallery or person selling the work, along with the price, title, print type, and edition number of the image. It should be dated and signed. It is a good idea to include arrangements for collection or delivery of the image to prevent later confusion.

Print Sales at The Photographers' Gallery is an influential player in determining the continued growth of photographic collecting. The aim of Print Sales is to be the first point of call for anyone wanting information on collecting photography, and in doing so to build the confidence of a new generation of collectors. This is achieved by offering expert advice to anyone creating or developing a collection and by striving to provide opportunities for emerging photographic talent.

The Print Sales department actively promotes approximately 40 photographers in two main groups. Featured photographers, who are contemporary and emerging photographic talent working in the UK, and established photographers who already have an international reputation. Print Sales will highlight new bodies of work by promotions at the gallery, on the website and collector and corporate presentations. In addition to this a selection of the work is shown at prestigious photographic fairs such as Paris Photo. Other work is also held on consignment and although not actively promoted it is sometimes included in both presentations and displays to gauge peoples' responses.

Represented photographers are selected in a variety of ways. In some cases they are approached after their work is seen exhibited, for example at an institution or a final year show or at events such as Rhubarb-Rhubarb photo festival. Weekly the team review submissions sent digitally, and are also fortunate to be introduced to a vast spectrum of photographic talent by our programming team who curate our main gallery spaces.

As part of the oldest photographic gallery in the UK Print Sales is and has been associated with a large number of photographers many of whom are still represented. This reputation allows the department to ask for sole UK representation but does not mean that a photographer cannot be exhibited elsewhere. Only that Gallery permission is requested.

Due to the nature of photography and so that the client may see the quality of the prints most stock is for sale. For practical reasons this is often in portfolio box sizes (from 12 × 16 inches to 20 × 24 inches) and plan chests (up to 29 × 47 inches). Framed examples of large format prints are kept for viewing so a client may see the quality and scale of the work. Often the photographer's choice of frame is highly influential on a client's choice, however, there is a range of framing options on display.

The process of editing a new series of work is very important and is usually finalised before we consign the prints. The number and selection of prints we take from each new series is dependent on each body of work. We would usually have digital or if published, book reference of the prints we were not holding at the gallery.

Editioning of photographs is a relatively new aspect in photography resulting from the growth of the photographic gallery art market. We do not have a policy on editioning photographs but do offer advice to photographers based on the work they produce. Ultimately it is the choice of the

photographer. When setting prices there are various things to take into consideration. The photographer's reputation, the condition of the print, if it's an iconic piece or a vintage print, whether it's signed. The time and cost of producing the print is also an important consideration, especially for new photographers.

Since the early 1970s when important museums like MOMA began to collect photographs seriously, auction houses started regular sales, commercial galleries started to specifically exhibit and sell photographic prints, the market for collecting photographs has increasingly grown. Photography is now acknowledged as a form of art along side the more traditional mediums. This recognition, along with a proven increasing market value has created a growth in people's confidence in investing in photography, so sales have increased.

Collectors, Museums, corporate companies and individuals all buy photography. Perhaps they have been taken by a print that they have seen, they follow and have been interested in a photographer's body of work for a long time, they would like to start an art collection. Sometimes it may be for an investment but it is equally likely to be for pleasure. Print Sales does have a regular client base, some have been visiting the Print Sales for many years. We also have a good passing trade. Our website is a useful tool for sales but if possible the client will come into the gallery to view the print before purchasing it.

Photography is a very competitive field and it is very difficult to make a living from selling fine art prints. However there are a number of steps you can take to make sure your work receives the best response. The presentation, quality and condition of your portfolio should be of the very highest standard. It is advisable to have edited your work carefully and have a general idea of the editions and price structure. Before approaching galleries attend portfolio reviewing events so as to gain feed back from professionals. Most photography galleries are privately owned. The director's interest in photography will influence the type of photography being promoted, it is therefore important to research the gallery before approaching it so that you can gauge if your work would be of interest.

Katrina Moore, Print Sales,The Photographers' Gallery.

AFTER THE PRIVATE VIEW

What is the artist's role while the exhibition is open to the public? Most people have a sense that after the opening night their work is done. The exhibition is safely installed and there

seems little to do. The attention of the gallery staff may well move on to the next exhibition, and the artist may want some time to recover from all the preparations. In fact, there is still a lot to do and this is a good time to do it.

Once the excitement of the private view is over, there is a curious period of limbo for the artist waiting to see how the work will be received. For some it may be tempting to hang around the gallery, engaging visitors in conversation, while others may want to walk away and start work on a new project. It is worth talking to the gallery beforehand about this. Galleries differ in their attitude to having their artist around during the show, and while some encourage it, others do not. The answer is usually to arrange regular times to be in the gallery and available to talk with visitors.

This can also be a period of creative exhaustion for artists, and they should be prepared for it. The long buildup to an exhibition is over, the rewards may not yet be visible, and suddenly the world seems flat and dull. Artists may feel a lack of interest in their own work and need to remotivate themselves to follow through the opportunity that an exhibition represents. A student was expressing feelings that are all too common when he said to me, "I've been a bit down and thinking it's all a lot of hard work with little chance of getting anywhere." Sometimes, too, artists experience feelings of loss when the work, which was private to them, is suddenly out in the public domain or experience other emotions that are difficult to resolve.

It is important to recognize that these feelings are temporary, that this is about being tired rather than blocked, and that the desire to make work will return. In *The Artist's Way* (1992), her useful book on creativity, writer and filmmaker Julia Cameron talks of the "recognizable ebb and flow" of the artistic process. She points out that "In a creative life, droughts are necessary" and speaks of a time "between dreams" when "we feel we have nothing to say, and we are tempted to say nothing." For many people this will be true of this moment between finishing or exhibiting one piece of work and waiting for the impetus that will lead to the next.

Whatever the artist feels, this is not the time to be absent from the gallery and the work but to remain in touch and see through the follow-up to the exhibition launch. In fact, there is quite a lot of exhibition-related work still to do, and this may be the perfect time for a kind of creative housekeeping. All of this should have been planned in advance. For those who do feel that they are in a creative limbo—and by

no means will everyone feel this—it may be a positive way of keeping engaged with the working process.

Ongoing tasks at this stage include the following:

- continuing to promote the exhibition with follow-up phone calls
- giving an artist's talk and undertaking educational work with local schools and colleges, if that has been planned
- updating mailing lists with new contacts
- collecting financial records and completing the actual expenditure budget
- saying thank you
- documenting the exhibition
- compiling a record and possibly an evaluation report
- making a detailed plan to take the exhibition down, transport it, and store it

Many critics and reviewers dislike private views and want to look at the work without distraction. Reminder phone calls about an exhibition can be made in the days immediately after the exhibition has opened and may be very productive, especially if the artist can be present in the gallery to talk to the critic.

In the same way, this may be a good moment to get in touch with local schools and colleges and remind them that the gallery is open and that the artist will be available to talk to students by arrangement or at particular times.

This is the time to add new contacts to mailing lists. The budget will also need to be balanced. This means collecting all receipts and drawing up an actual budget. At the end of this, the artist should have both an estimated and actual budget for comparison. This will prove invaluable for estimates for future exhibitions.

This is a good time to write or phone to thank people, and it is a useful way to spend time in the gallery if there are few visitors. If sponsorship has been raised, it is a particularly good idea to phone the sponsor a day or so after the private view to thank them personally and also to give some appropriate feedback. This could be, for example, about visitor figures or the way in which their sponsorship was used or appreciated. An anecdote will make it more personal, and it may be a good idea to invite the sponsors to drop in to the gallery for a drink and tour of the show if they did not attend the private view. Sponsors appreciate being appreciated, and this sort of response from an artist may ensure future support and the development of a valuable working relationship.

It's also the time to deal with sales and plans to take down the exhibition. Dealing with sales may require sending a

formal receipt of purchase and making or confirming arrangements for the buyer to collect the work or for it to be delivered once the show has been taken down. The original packing materials may well have disappeared or been damaged and need to be replaced. Taking the exhibition down may need little planning or may need careful arranging if another show is to be hung on the day this one comes down. You should plan to leave the gallery very clean and tidy, and you may be required to fill and paint the holes you made when hanging your work.

DOCUMENTATION AND EVALUATION

The documentation and evaluation of an exhibition are important for several reasons:

- You need to keep a record for your own reference and c.v. As unbelievable as it seems at the time, you may well have forgotten basic details of the exhibition (such as dates and names of co-exhibitors) by the time you need to quote them.
- You need to keep a record to show to galleries, critics, curators, or publishers and to use when giving a talk or lecture about the work in the future.
- It will be useful when looking for promotion, sponsorship, or funding in the future.
- It will be useful as a visual record of work that is on tour, on loan, sold, or in storage.
- It will be useful to keep track of work sold.
- It may be useful for insurance purposes.
- Galleries are sometimes fairly short-lived, and many galleries are poor record keepers. Do not assume that you will be able to ask them for information in a few years' time.
- The evaluation should provide you with concrete evidence of what works and what does not. It will be a useful reference for every exhibition in the future and help you analyze and use the experience you have gained.

Documentation and evaluation are two different, though related, processes. Documentation involves keeping a fairly detailed record of the whole exhibition as it is presented to the public. Evaluation is a summary and analysis of every stage of the exhibition process. It is more complex to compile and involves assessing each element of the process, reviewing what worked and what did not, so that the exhibition's lessons become the basis from which the artist can determine what steps to take and what to avoid in the next exhibition plan. Although every exhibition situation is likely to vary considerably, keeping track of them will give the exhibitor enough information to work from in planning further showings.

Crucially, the documentation is made to be shown to other people, whereas the evaluation is made for the artist's personal use, so the two should not be confused. However, it is worth compiling them at the same time and keeping them together, simply because it will be easier to make both records simultaneously.

Many students will have compiled and written reports of this sort in school or college and perhaps not appreciated how useful it is to continue this process into their professional practice. However, this is the time to adapt student work. For example, records can be kept in note form rather than as continuous prose, as long as the notes are so not terse as to be impossible to understand in the future.

Documentation of an exhibition could consist of the following:

- the invitation, press release, and any catalog or brochure
- images of the installed exhibition and of individual photographs
- a copy of the artist's statement (if this does not exist, then make brief factual and personal notes about the photographs)
- a list of the works with print sizes and complete caption information
- a price list and list of works sold
- copies of press response and reviews, a reference to media coverage such as a mention on a particular TV or radio program
- audience responses, either a copy of the visitors' book or perceptive remarks taken from it and any thoughtful comments made to you directly by visitors or reported by gallery staff
- visitor numbers, if available

Copies of printed materials should be collected together at an early stage. These can disappear at great speed once the exhibition is open, especially if it is a successful exhibition. Additional copies of anything with a printed image of yours on it will be very useful when approaching curators and galleries in the future, so make sure you have thirty or more of these. The artist's statement will be useful both as an aide memoire and as text for future applications for exhibition or sponsorship.

Documentation of the exhibition should be completed as soon after the exhibition opens as is possible, when the gallery and work look their best and also as a record, just in case of accidental damage to, or theft of, any of the work during the exhibition. When photographing the exhibition for documentation, it is important to photograph the whole space

in a long shot and then move closer and, rather than just photographing each image individually, photograph groups of images. A photograph of an entire wall or set of images will provide a useful reminder of how the images worked together. If an exhibition is to tour or be shown in another venue, this will also be a better way of demonstrating a possible hang than sending a list.

Good reviews will always be useful support for future exhibition applications. However, your work may not get reviewed, and in this situation you can use comments made by visitors. These can be taken from a visitors' book or written down when made to you or reported to you by staff. The private view may also bring insightful or positive comments. This may seem a poor substitute for a glowing press review, but on a personal level it can be just as rewarding, since it will tell you how your work is reaching your intended audience. It is also valuable feedback to pass on to funders or sponsors, since it reassures them that their input is appreciated by the people on whose behalf they fund exhibitions, rather than just by an elite of critics and curators.

Some galleries keep count of visitor numbers. This can be a good statistic to obtain simply because it is the sort of information funders and sponsors like. If the gallery does not keep a record, you can do this yourself by making a count while you are there and producing an estimate for the whole exhibition period from this. If you do this, you may well need to be able to substantiate the figure, so do not be tempted to inflate it and be ready to explain how you arrived at it!

An evaluation report should include:

- an evaluation of the practical workings of the exhibition, using estimated and actual copies of the timetable, budget, sponsorship/funding applications (successful and failed), a list of press materials, pricing and sales, plans and decisions on the framing and presentation of work, notes on the hanging, resources needed or used, the private view, working relationships, timing, and any thoughts or observations on the processes that may not fit neatly into these categories
- an evaluation of the work itself, a summary of the concept and realization of the exhibition, the way it was shown, and how it was received

These two aspects of the exhibition are separated out here only because the first is practical and fact based and the second subjective and personal and may need a different sort of approach and analysis.

The conventional way to write an evaluation report is to divide the information into three parts, organized chronologically:

1. an account of the aims and planning of the exhibition
2. an account of the implementation of these plans
3. an account of the outcomes, achievement (or not) of the exhibition aims, and lessons learned

To do this the exhibitor needs to start keeping detailed notes of discussions and decisions at the beginning of the process. This is in itself a learning process and may help the artist to make good working decisions. The planning will include all the elements above and also any aims of the exhibition (to reach a wider audience than has been achieved by previous exhibitions of the artist's work, for example), which may well shift during the exhibition's development. Keeping track of these sorts of shifts is invaluable, because it will help the exhibitor learn to become more realistic when making future exhibition plans.

However, if this hasn't been done or it doesn't suit the artist's way of working, it may be simpler to undertake the entire process once the exhibition is complete by considering items of the planning and implementation together and then adding a list of outcomes and lessons learned.

So, for example, the estimated and actual budget would be put together and notes made to the effect that, for example, the contingency fee was spent because the framing costs had been written in without tax, that extra help had to be hired because the workload was underestimated, or that additional print costs had been incurred because of a last-minute change in the size of prints. Note any of the items that were not adequately costed, either because the initial estimates were not accurate or because of unexpected decisions, events, or accidents.

It is also always revealing to evaluate the timetable, especially where small deadlines, when missed, have had a disastrous domino effect. Timetabling is always one of the hardest bits of pre-exhibition planning to get right, and lessons learned here are invaluable. The following examples happened during exhibitions I worked on; making a note of them during an evaluation procedure means that the time they took will be accounted for in my future timetabling. On one exhibition, a writing deadline slipped which meant that the printer's deadline was missed. The printer was unable to

reschedule printing the brochure until just before the exhibition opening. This did not seem to be a big problem until it became clear that the brochure, intended as pre-exhibition publicity, could not be included in the mailing. Since sending it out separately would double the mailing costs, it was not sent out and huge piles of unused brochures haunt me to this day. On another, the turnaround on printing the invitations did not allow enough time to proofread the text. Inevitably a date was wrong and, because it was not noticed until after the invitation had been printed, it meant that the entire print run had to be redone at additional cost and the mailing cost more because it was late.

As part of this analysis, it is important to list the practical outcomes of the exhibition, such as a record of sales, further opportunities in the form of offers or contacts made which might lead to inclusion in a book or exhibition, reviews, offers of residencies or teaching, or additional sales. All sorts of opportunities might result from an exhibition, and it is useful to take note of this at the time. As I know from my work as an interviewer for the Oral History of British Photography archive (part of the National Sound Archive held at the British Library), for instance, interest in interviewing a photographer is often triggered by a successful exhibition.

Along with the practical outcomes, the exhibitor will most probably want to know how the exhibition was received and gather a response to the work on a much more personal level. If the private view has been too busy for much reflection, the gallery doesn't have a visitors' book, and the gallery staff do not actively seek out comments from visitors, the exhibitor may feel he or she has received an inadequate amount of feedback. Did the audience like and understand the images? If there was a theme or concept, was it successfully conveyed? Does the work engage? These things can be difficult to assess, relying as they do on subjective criteria as well as informed opinion. People are often reluctant to offer comment, and the exhibitor may need to take an active role in seeking out feedback from colleagues and visitors. This can be difficult and painful to do, particularly if the result is adverse or unhelpful criticism, so asking for feedback can feel very risky. Ways of initiating feedback include arranging an informal viewing in the gallery for invited visitors, followed by a discussion or lunch locally. A more formal artist's talk can also achieve this, especially if it includes a chaired question-and-answer session. From these the exhibitor can make notes about the sorts of comments given and, if necessary, post-

pone their consideration until the exhibition can be reviewed with more detachment than may be possible when the exhibition is still a recent event.

The temptation is probably to chuck all this material into a large box or folder, forget about it, and move on to the next project. However, it is worth setting up a good filing system with your first exhibition so that it can be added to every time the work is shown. This is probably something best not done electronically, because you are dealing with the actual documents. But nor do you want to use a scrapbook, because it looks unprofessional. A large concertina folder or section of a filing cabinet will be easy to access, to keep work in, and to add to as necessary.

IN CONCLUSION

This book has aimed to empower readers by examining the processes that go into creating an exhibition so that they can make informed decisions about these processes. Much of this is about common sense, about understanding the conventions of exhibiting, and about allowing sufficient time in the process to plan ahead and not be rushed into decision making.

We live in a time when exhibition practice and exhibiting conventions are changing rapidly, with the booming interest in the arts, particularly photography—and we can expect continuing change in these conventions. But, as László Moholy-Nagy said in 1947, "The enemy of photography is the convention, the fixed rules of 'how to do.' The salvation of photography comes from the experiment" (From exhibition text Albers and Moholy-Nagy: From the Bauhaus to the New World at Tate Modern, 2006).

So, hopefully, knowing the rules allows serious artists to experiment and to take risks with the way they show as well as make work. In the end, artists must acquire enough knowledge and experience to take control of the process, to find curators they can trust and enjoy working with, and find an exhibiting mode that suits them and suits their work.

Bibliography

a-n newsletter, *www.a-n.co.uk* (publishers of useful "Fact Packs").

Badger, Gerry (2003). *Collecting Photography*. UK and USA: Mitchell Beazley.

Barker, Emma (ed) (1999). *Contemporary Cultures of Display*. The Open University Press, with Yale University Press.

Barrett, Terry (1996). *Criticizing Photographs: An Introduction to Understanding Images*. California, London, and Toronto: Mayfield Publishing.

Barthes, Roland (1977). Rhetoric of the Image. In *Image-Music-Text*. London: Fontana Press.

Benjamin, W. (1973). *Illuminations*. Translated by H. Zohn. London: Fontana.

Buck, Louisa (2000). *Moving Targets 2: A User's Guide to British Art Now*. London: Tate Publishing.

Buck, Louisa, and Judith Greer (2006). *Owning Art: The Contemporary Art Collector's Handbook*. London: Cultureshock Media Ltd.

Bunnell, Peter C. (2006). *Inside the Photograph. Writing on Twentieth Century Photography*. New York: Aperture,

Burgin, Victor (1982). Looking at Photographs. In *Thinking Photography*. London & Basingstoke: The Macmillan Press.

Cameron, Julia (1992). *The Artist's Way: A Course in Discovering & Recovering Your Creative Self*. London & Basingstoke: Macmillan and Pan Books.

Crimp, Douglas (1993). *Photographs at the End of Modernism in "On the Museum's Ruins."* Cambridge, MA, and London: The MIT Press.

Duffin, Debbie (1991). *Organising Your Own Exhibition: The Self Help Guide*. Sunderland: AN Publications.

Edwards, Steve (2006). *Photography, A Very Short Introduction*. Oxford and New York: Oxford University Press.

Fogle, Douglas (2003). *The Last Picture Show*. Minneapolis: Walker Art Center.

Greenberg, Reesa, Bruce W. Ferguson, and Sandy Nairne (eds) (1996). *Thinking about Exhibitions*. London and New York: Routledge.

Haacke, Hans (1984). Museums: Managers of Consciousness. In *Art in America*, no. 72 (February 1984), 9–17.

Hall, Stuart (ed) 1997. *Representation: Cultural Representation and Signifying Practices.* London, California, New Delhi: Sage Publications.

Haworth Booth, Mark (1997). *Photography: An Independent Art.* London: V&A Publications.

Jaeger, Anne-Celine (2007). *Image Makers, Image Takers.* London: Thames & Hudson.

Janus, Elizabeth (ed) (1998). *Veronica's Revenge: Contemporary Perspectives on Photography.* Zurich, Berlin, and New York: Scalo.

Karp, I., and S. D. Levine (eds) (1991). *Exhibiting Cultures: The Poetics and Politics of Museum Display.* Washington, DC: Smithsonian Institution Press.

Marien, Mary Warner (2002). *Photography: A Cultural History.* London: Laurence King Publishing.

Miller, Russell (1997). *Magnum: Fifty Years at the Front Line of History: The Story of the Legendary Photo Agency.* London: Secker & Warburg & Random House.

Noble, Laura (2006). *The Art of Collecting Photography.* London: Ava Publishing.

O'Doherty, Brian (1986). *Inside the White Cube: The Ideology of the Gallery Space.* Santa Monica: Lapis Press.

Sandeen, Eric J. (1995). *Picturing an Exhibition: The Family of Man and 1950s America.* Albuquerque: University of New Mexico Press.

Solomon-Godeau, Abigail (1991). *Photography at the Dock.* Minneapolis: University of Minnesota Press.

Szarkowski, John (2007). *The Photographer's Eye (Introduction to the Catalog of the Exhibition).* Originally published in 1966. New York: Museum of Modern Art.

Wilhelm, Henry (1993). *The Permanence and Care of Color Photographs; Traditional and Digital Color Prints, Color Negatives, Slides and Motion Pictures.* Iowa: Wilhelm Research (available online).

Wilson, Rhonda (1993). *Seeing the Light, A Photographer's Guide to Enterprise.* Nottingham: Nottingham Trent University.

Glossary

The range of choices for printing has never been greater and, with new papers and technology regularly appearing on, and disappearing from, the market, the terminology can be confusing. Much of what is shown in galleries is digitally printed, though often originated from film, which can make for further complications.

www.wilhelm-research.com is a good information source for issues of printing and print permanence.

www.secol.co.uk is the site for Secol Ltd who provide archivally sound materials including negative and print storage envelopes.

C-41 C-41 is the standard process for printing from color negative film and a traditional darkroom method.

C-type A chromogenic print also known as a type C print, or color coupler print. It is a color print made from a color negative and can be hand printed. A chromogenic paper is one with three emulsions which respond to cyan, magenta, and yellow which are added by three dye couplers during the development process. The image is full color and now more stable and permanent than earlier versions and thought to last 50 to 75 years with careful treatment.

Cibachrome Cibachrome (Ciba-Geigy, Swiss) and Ilfochrome (Ilford) are the brand names of processes used to print from color transparency using azo dyes in the paper. They use a positive to positive dye destruction process. Each of three emulsion layers is sensitive to one of cyan, magenta, or yellow and the print is developed, bleached, and fixed. It is one of the older modern color processes, in use since the early 1960s.

Contact print A contact print is a print made when the negative and printing paper are in contact. The distinguishing

feature for film-based images is that negative and positive are the same size and no enlargement has taken place. Platinum, palladium, and albumen prints are all made as contact prints. Contact prints are usually of good quality for this reason and although a small 35 mm contact is primarily useful as a record, working tool, or for its historical interest the quality of the tones and sharpness of a contact print from a large plate camera will be exceptionally fine. Digital contact prints can also be made.

Cyanotype This is a process invented in the 1840s and mainly used subsequently by scientists and architects (the blueprint). It is now used by contemporary artists. It is based on iron rather than silver and produces prints in a range of blue tones.

Digital print A "digital" print can be a confusing term since it indicates the method of printing rather than the camera used or material on which the image was generated (it should not, for example, be used as caption information. A caption will name the type of digital print shown). So, both film-based and digitally generated images can be scanned through a computer and printed digitally on a wide variety of papers. When digital printing was first introduced prints were unstable and prone to fading. Now most commercial digital prints are more stable. However, even top of the range home computers often produce prints which will fade because the available papers and inks are not designed for exhibition. Giclee, inkjet, iris, and lambda prints are all names for types of digital print.

Duratrans Duratrans is the brand name for an enlarged color transparency, made from a negative or transparency, suitable for use in light boxes, and made by lightest, lambda, or by hand.

Dye-destruction print This is another name for Cibachrome and Ilfochrome prints.

Dye-transfer print This is one of the older color processes and is difficult, slow, and expensive but reasonably permanent. It is a development of the carbo process and uses three separation negatives, photographed through red, blue, and green filters and a system of gelatin molds. The materials for this have been discontinued.

Gelatin silver or silver gelatin print This is the standard type of black-and-white paper used for printing for most of the twentieth century and the term includes a wide range of different types of paper base, tone, texture, and finish. Silver

gelatin papers were introduced in 1882 when they started to replace albumen printing. The paper is coated in silver halides suspended in gelatin. In the darkroom the paper is exposed to a negative held in an enlarger and then put through baths of developer, stop, and fix before being washed and dried. The emulsion or paper coating can also be purchased, under various brand names, in liquid form for photographers who wish to experiment using different papers and surfaces.

Giclee This is a type of inkjet print. The word *giclee* is French in origin and means "to spray."

Inkjet This is one of the most frequently used types of digital printing methods. The image will either be made on film and scanned into a computer or downloaded from a digital camera. Inkjets spray ink very finely onto the paper. The paper can be selected from any paper which will take the process—glossy, matte, watercolor, or canvas, for example, and the name will depend on the paper or process used.

Iris This is essentially a brand name for a high-quality inkjet print made on a machine made by Iris Graphics (of Bedford, Mass.).

Lambda Lambda (Durst) is a brand name for a printing device which produces C-type prints from a digital image file. See also Lightjet by Oce Corp. Continuous printers use RGB scanning lasers.

Photogram This is a process of making a unique print without using a camera and one of the earliest forms of print-making still used today. Objects, usually translucent and often textured, are placed directly onto light-sensitive paper and then exposed to light. The resulting image is dependent on the amount of light which has reached the paper. A photogram is easily recognized by the two-dimensional nature of the image whether it is an early black-and-white print by Fox Talbot or a color image by one of the many contemporary photographers who use this process. However, the photographer may use one of several different papers or developing processes and credit or caption the print by the process used (silver gelatin, dye destruction, etc.) rather than as a photogram.

Platinum/platinotype/palladium print Platinum printing is a process which was introduced in the late nineteenth century and went into decline from the 1930s when manufacturers stopped producing the printing paper, apparently because of a huge rise in the price of platinum. Palladium could be used instead and has similar qualities. The process

has been revived more recently but is highly specialized and complex because it uses a contact process and digital inter-negatives and has to be prepared by hand so is not widely used. It has a rich tonality controlled by emulsion mix and paper choice.

Polaroid The Polaroid, first produced in 1947, and later available in both black-and-white and color is known because it is an instant print and for its highly recognizable format and rich tones. The black-and-white image does produce a negative from which prints can be made but the color Pola-roid is an unique image. Polaroid is frequently used by artists from Walker Evans onwards. The available size of prints ranges from small to very large high-quality prints and always requires a Polaroid camera. Polaroid camera backs are widely used as a proofing medium.

Toning There are a wide variety of different chemical pro-cesses which can be used to intensify the color, sharpness, or contrast of a print. The most common of these is sepia but they also include gold chloride and selenium. Toning for permanence includes selenium, gold, and thiocarbamide. Toning prints has been a part of darkroom practice since the invention of photography and can be misleading for the casual viewer since, for instance, a modern sepia-toned silver gelatin print, if subtly made, can resemble a nineteenth-century printing process such as gum bichromate or an albumen print. There are also a number of different types of dyes, from domestic vegetable-based food dyes to commer-cially produced dyes, which can be used in the same way as toners but will only color the print rather than intensify it. These usually do not produce the subtle effect of toners.

Xerox or xerograph/photocopy Artists such as Helen Chadwick have used photocopying machines for large-scale artworks. Although Chadwick used an office copier it also had a toning device so she was able to produce intensely blue works.

Blue chip A blue chip artist is one who has a secure market for his or her work and a market history. The work will most probably have a place in the history of art and have been extensively exhibited, published, and written about. It will be held in major collections, both museums and private.

Edition Issuing editions is one way of limiting the number of prints from one image. An edition will be of prints which are all the same size and are numbered, dated, and signed. In recent years edition runs have tended to be small, consist-

ing of perhaps ten or twelve prints with the price increasing as the number of prints available for sale diminish so that, for example, the seventh print from an edition of eight will cost considerably more than the first and second prints.

Estate print An estate print is one made after the death of a photographer by his or her estate. It may have an estate stamp since it cannot be signed. It will sell for considerably less than an original print but should be of very high quality since the estate will be concerned with maintaining the reputation of the photographer.

Exhibition print This is a print made specifically for exhibition and should usually be the best possible print to be made from that negative. It may well be dated and signed and will sometimes be mounted and in the original frame.

Vintage print A vintage print is one made within a relatively short time of the making of the original image and is usually, though not always, worth more than a non-vintage print from the same negative. Although there is no exact definition of the time involved, because of the difficulty in establishing the exact date when a print was made, a vintage print is usually made within five years of the making of the negative. It is valued because of its authenticity and because it may well have been made by the photographer or under his or her instruction and have closer links both with how the artist saw the original image and with the print materials appropriate to that time.

On this issue auctioneer and connoisseur Philippe Garner says:

A precise dating is not the only issue. Different criteria regarding print quality and desirability apply to different photographers. One must ask many questions. Was the print made by the photographer? Was it made by someone else? Was it approved by the photographer? Is it signed? Is it stamped? Is it annotated? Does this matter? Ultimately a print has an intrinsic object quality or it doesn't. This will not always be determined according to whether it was printed the day the negative was made or a week later or a month later or a year. . . . If you are interested in a particular photographer then you must investigate his career and practices and establish your own criteria as to which prints really matter. There is often a consensus. The guidelines that might apply to, say, Edward Weston might not apply to a photo-journalist.

(*Photographie International*, no. 29, juin-juillet-aout 2002)

Acknowledgments

The source of quotations not made directly to the author are listed below:

Ed Barber (*Design Week*, July 2007); Tina Barney (*Image Makers, Image Takers*: Jaeger 2007); Victor Burgin (*Looking at Photographs*, 1982); Rineke Dijkstra (*Image Makers, Image Takers:* Jaeger 2007); William Eggleston (*Image Makers, Image Takers:* Jaeger 2007); Colin Ford (*PLUK* no 10, Jan/Feb 2003); Ori Gersht (*PLUK* no 28, Jan/Feb 2006); Dr Inka Graeve Ingelmann (*Image Makers, Image Takers:* Jaeger 2007); Reesa Greenberg (*Thinking about Exhibitions*, 1996); Mark Haworth Booth (*Photography: An Independent Art*, 1997); Katherine Hinds (*Image Makers, Image Takers:* Jaeger 2007); Rudolf Kicken (*Image Makers, Image Takers:* Jaeger 2007); David LaChapelle (*Image Makers, Image Takers:* Jaeger 2007); Kay Larson (*Thinking about Exhibitions*, Greenberg et al. 1996); Michael Mack (*PLUK* no 31, autumn 2006); Mary Warner Marien (*Photography: A Cultural History*, 2002); Mary Ellen Mark (*Image Makers, Image Takers:* Jaeger 2007); Jeremy Millar (*PLUK* no 14, Sept/Oct 2003, p. 39); Brian O'Doherty (*Inside the White Cube*, 1986); Mari Carmen Ramirez (*Thinking about Exhibitions*, Greenberg et al. 1996); Sebastiao Salgado (*Image Makers, Image Takers:* Jaeger 2007); Stephen Shore (*Image Makers, Image Takers:* Jaeger 2007); John Stathatos (exposed 02 January–April 1998); Thomas Weski (*PLUK* no 12, May/June 2003); Max Wigram (*PLUK* no 9, Nov/Dec 2002).

Thanks to:

This book owes a very great deal to Nadia Burns and Tim Youles whose practical help and support were invaluable. My grateful thanks also to Deborah Bright for her support and comments on the manuscript. And to Simon Norfolk for his last-minute troubleshooting.

Thanks are due to all my colleagues at PARC (Photography and the Archive Research Centre at the London College of Communications), especially Val Williams, who always inspire.

And thanks, too, to all my students who have shaped this work and reminded me of how hard it can be to start exhibiting.

Stevie Bezencenet, Monika Bobinska, Sian Bonnell, Anne Braybon, Susan Bright, Caroline Brown, Mac Campeanu, Paul Carter, Keith Cavanagh, Sarah Cave, Zelda Cheatle, Robin Christian, Duncan Caratacus Clark, Marcella Colaneri, Hannah Collins, Lorna Crabbe, Arno Denis, Andrew Dewdney, Jo Dorrell, Christina Dunhill, Helen Esmonde, Jennifer Eudicone, Jane Fletcher, Ruth Fuller, Philippe Garner, John Gill, Gina Glover, Roger Hargreaves, Dominic Harris, Roger Hooper, Mike Ingleheart of Frame Factory, Islington, Astrid Kruse Jensen, Kathy Kubicki, Ashley la Grange, Brigitte Lardinois, Grace Lau, Hannah Liley, Alison Marchant, Michael Marten, Graham Marks, Theo Marson, Jenny Matthews, Georgina McNamara, Anne McNeill, Leila Miller, Katrina Moore, Michael Newgass, Simon Norfolk, Todd Pacey, Senga Peckham, Jane O'Sullivan, Pat and Julian Pollock, Nicole Polonski, Bob Pullen, Carole Rawlinson, Paul and Esther Rowley, Valentine Schmidt, David Scull, Mira Shapur, Taiseer Shelbi, Hetty Shirley, Katerina Sluis, Cherry Taylor, Roma Tearne, Esther Teichmann, Jim Thorp, James Tye, Biff Vernon, Alexandra Willett, Sally Williams, Val Williams, and Gary Woods.

Alison Marchant would like to thank and credit Dr Judith Rugg for the contextualizing references to her work quoted here.

Leila Miller is a photographer and recent M.A. graduate of the University of Westminster

Esther Teichmann is an artist currently undertaking research for a Phd at the Royal College of Art

Sian Bonnell is an artist who runs TRACE gallery in Dorset

Professor Andrew Dewdney leads the Digital Media department at London South Bank University

Katrina Sluis is Senior Lecturer in Digital Media, London South Bank University

Index